Eight Thirteenth-Century Rolls of Arms in French and Anglo-Norman Blazon

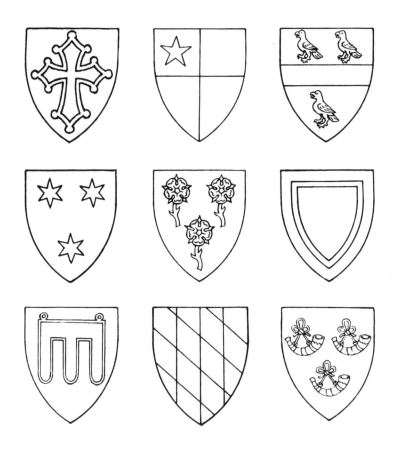

Eight Thirteenth-Century Rolls of Arms in French and Anglo-Norman Blazon

Edited with an Introduction and Notes
by Gerard J. Brault

The Pennsylvania State University Press
University Park and London

Library of Congress Cataloging in Publication Data

Brault, Gerard J comp.
 Eight thirteenth-century rolls of arms in French
and Anglo-Norman blazon.

 Bibliography: p.
 1. Heraldry--France--History--Sources. 2. Heraldry
--Great Britain--History--Sources. I. Title.
CR157.B7 929.6 72-1065
ISBN 0-271-01115-7

The shield heading each section of this book was selected at
random from the roll in question and is based on a design by
C. W. Scott-Giles, Fitzalan Pursuivant of Arms Extraordinary.
The frontispiece is a composite of these shields and does not
represent any particular roll.

To the memory of Charles H. Livingston

Contents

Preface 1

Introduction 3

I The Bigot Roll (*BA*) 16

II Glover's Roll, St. George's Version
 Copy *a* (*Ba*) 31
 Copy *b* (*Bb*) 35

III Walford's Roll
 Charles's Version (*C*) 38
 Leland's Version
 Copy *a* (*Cl*) 46
 Copy *b* (*Cd*) 57

IV The Camden Roll (*D*) 68

V The Chifflet-Prinet Roll (*CP*) 77

VI The Falkirk Roll, Thevet's Version (*H*) 86

VII The Nativity Roll (*M*) 94

VIII The Siege of Caerlaverock (*K*) 101

Table of Proper Names 126

Preface

True heraldry, i.e. "the systematic use of hereditary devices centred on the shield,"[1] is known to have existed as early as the second quarter of the twelfth century. Until recently, its development as an art and as a science, and its expansion throughout Europe had been studied chiefly on the basis of the depictions of shields on seals, manuscripts, sculpture, and other comparable surfaces with relatively little scholarly attention being accorded to blazon, the manner of describing coats of arms.

The present volume is an outgrowth of the author's study of the language of heraldry as it is recorded in the earliest blazoned rolls of arms, or lists of names accompanied by descriptions of armorial bearings, and in contemporary literary sources.[2]

During the course of that study, examination of the manuscripts upon which the published texts of the earliest blazoned rolls of arms were based revealed that the latter could not be relied upon. The author was able to incorporate a large number of corrections and notes into the complete glossary of these rolls which constitutes a major part of *Early Blazon*.[3] At the same time, it was evident that a companion volume providing the texts in question edited in conformity with modern scholarly standards was also needed. Such an edition had been called for, as a matter of fact, by Sir Anthony Wagner, Garter King of Arms:[4]

What is now most needed is the publication, in a single volume or series, of reliable texts of all the English rolls. Genealogical and other

1. Anthony Richard Wagner, *Heralds and Heraldry in the Middle Ages. An Inquiry into the Growth of the Armorial Function of Heralds,* 2nd ed. (Oxford: Oxford University Press, 1956), p. 12.

2. *Early Blazon. Heraldic Terminology in the Twelfth and Thirteenth Centuries with Special Reference to Arthurian Literature* (Oxford: Clarendon Press, 1972).

3. This book also covers related topics like heraldic art and pre-classic blazon, literature and heraldry, heraldic flattery, canting and symbolic arms, allusive arms, plain arms, Arthurian heraldry, and history and heraldry.

4. *A Catalogue of English Mediaeval Rolls of Arms* (Oxford: Charles Batey for the Society of Antiquaries, 1950), pp. xxxii-xxxiii.

elucidation is indeed desirable, but the publication of texts need not, probably should not, wait for it. Such explanatory material could be set out as well or better in a subsequent consolidated index or dictionary. Once the texts are readily available the number of effective students can increase and by their labours the edifice of heraldic knowledge can be built.

It is a pleasure for me to acknowledge here the continued interest shown in my work by Dr. Thomas F. Magner, Associate Dean for Research and Graduate Study, at the Pennsylvania State University. Through his good offices I received a grant covering typing costs and editorial assistance in the final phases of this project from the University's Central Fund for Research. Mrs. Mae Smith was, as usual, a cheerful and conscientious typist, and Mrs. Linda Emanuel, a candidate for the Ph.D. degree in the Department of French, provided valuable assistance in proofreading the typescript. I am pleased to note here, too, that my sister, Sister Gerard Marie, S.A.S.V., volunteered precious vacation time, during a visit home from her mission in Japan, to help me alphabetize the Table of Proper Names.

Several years ago, Miss Peggy Berman, at the time a graduate student at the University of Pennsylvania, made transcripts for me of the British Museum and Oxford copies of the *Siege of Caerlaverock* and I wish to thank her again for her skillful work. Professor Ruth J. Dean provided timely encouragement by securing microfilm copies of pertinent manuscripts for the University of Pennsylvania.

I owe a debt of gratitude to my wife Jeanne and to my children Frank, Anne Marie, and Sue, and hope to repay them in kind for the consideration they have shown to a scholar with notions about self-imposed deadlines.

Finally, I have the honor of dedicating this volume to one of the leading philologists and textual critics this country produced in the field of medieval French and whom it was my privilege to know as a colleague and friend on the faculty of Bowdoin College in the years I was just beginning my research efforts.

Introduction

Scope and Utility of the Present Edition

No one has done more than Sir Anthony Wagner to focus attention on the value of rolls of arms:[1]

> For the study of heraldry the Rolls of Arms are cardinal. Only one mediaeval source compares with them, the seals — for arms on monuments and the like are relatively too few and scattered to come into comparison. Seals have this superiority, that they show crests as well as shields, which English, unlike continental rolls, do not do before the latter half of the fifteenth century. It may be argued also that as the owner's personal mark of authentification, made, presumably, under his own superintendence, a seal is likely to give his arms more accurately than a roll. But against these factors must be set two points of first importance in which rolls have the advantage. They give colours and many of them give blazons. For us they have the further advantage that they are much more readily accessible, seals being scattered in very many collections through the length and breadth of the land. It is worth adding that the rolls give many coats attributed to persons who never existed or never used arms — saints, worthies, preheraldic historical characters, and kings of the distant lands of the travellers' tales. The fifteenth and sixteenth centuries were the heyday of this fashion, but it goes back to the thirteenth.
>
> Arms were used by knights in war and tournament and so became associated with the nobility or knightly class before their secondary use on seals and otherwise for civil purposes led to their adoption by women and ecclesiastics, citizens, and peasants. At certain times and places the view was strongly held that for persons not noble to use

1. Anthony R. Wagner, *A Catalogue of English Mediaeval Rolls of Arms* (Oxford: Charles Batey for the Society of Antiquaries, 1950), pp. xvii-xix. Hereinafter referred to as *CEMRA*. Quoted by permission of the author and the publisher.

arms was improper, arms being *insignia nobilitatis.* One of the purposes of heraldic visitation in England was to enforce this view, while in practice taking nobility (in England synonymous with gentry) to include established citizens and lesser landowners, irrespective of origin, who had obtained a grant, confirmation, or allowance of arms. In some continental countries, however, matters took another course and burgess and peasant arms achieved legal recognition at the price of depriving arms generally of any status of ensigns of nobility.

The detailed history of these trends, which have importance in social history, remains largely to be worked out. When this is done it will, I venture to surmise, be found that while seals may record merchants' and other arms importing no claim to nobility — as their design, resembling that of merchants' marks rather than heraldry, sometimes suggests — the inclusion of a family coat in a roll of arms implies in England that its owners belonged to the knightly class, had either inherited or attained gentility. If this view were found acceptable, conclusions of interest might be drawn from the rolls' actual scope. It may be found that the general rolls give us selected lists of the great men of their several dates such as we should find it hard to compile on a comparable basis from other sources. It may even be found that occasional rolls give not all those present as a muster roll would, but a selection made with definite intention.

Now and then a roll will give some scrap of historical information not otherwise known. The headnote of the Stirling Roll gives a short account of an otherwise unknown forcing of a passage across the Forth by the advance guard of Edward I's force on the 30th of May 1304. The Carlisle Roll gives the names and arms of thirty-five German lords of the Eifel region who came in the train of the Count of Jülich to fight with Edward III against the Scots in 1334. The succession of Knights of the Garter in their several stalls given by Bruges' and Writhe's Garter books seem not to square entirely with our other evidence and because of their early date must be seriously reckoned with.

The use of heraldry in ascertaining genealogies has of late been somewhat disparaged by its own professors. But until the rolls are more completely edited and indexed the point can hardly be brought to a fair test. I am myself more disposed to believe that similarities and differences of arms can help us much more than they have so far done in ascertaining or disproving conjectured kinships and identifications. Occasionally, even, a roll of arms may give us a direct statement of a relationship otherwise unknown, as that established by the Galloway Roll between *Syr Gy de Ferre* and *S. Gy de Ferre le neveu.*

For the development of heraldic terminology between the thirteenth

century and the fifteenth the blazoned rolls are the chief — almost the sole — source. How far they have linguistic interest for others than heralds I do not know: but it is worth remarking that for the common charges, weapons, tools, and the like, rolls of arms often afford us the rare resource of a contemporary delineation to explain an obscure or obsolete name.

But when all is said the rolls will be loved best for none of this, but for their beauty. It is here only of the painted rolls we speak and of those preserved in original or at lease in facsimile. Nor is the workmanship equal even of this minority. Some of our surviving originals are, to speak truth, poor things. But at their best how splendid and rich and various and satisfying they are!

While most of the texts we publish here have appeared in earlier editions, a number of these with excellent genealogical and historical notes, not one is without serious defects and several not infrequently provide mere approximations of what the copyist actually wrote.

The monumental edition of the Matthew Paris Shields, Glover's Roll, and Walford's Roll, which appeared in 1967, deserves special mention here.[2] While "a new standard for the editing of heraldic documents"[3] has unquestionably been set, collation of London's transcript of *Cl*, the basis of his edition of Walford's Roll, against the original in the Bodleian Library at Oxford reveals errors in nearly every blazon, sometimes several. It is certain that London, who died eight years before *Aspilogia II* went to press,[4] would have eliminated these errors had he had an opportunity to correct the proofs of his text. However, the unreliability of his edition of the roll in question, which mars an otherwise magnificent scholarly contribution, necessitates inclusion here of even such a recently-published text.

The Manuscripts

Persons unfamiliar with the manuscript tradition of the rolls of arms will be surprised to learn how few of these have survived in original or even in contemporary copies. Of the 127 rolls listed in *CEMRA*, many in several copies, only 48 were actually copied in the Middle Ages, the remainder being known only through transcripts of originals and copies made by

2. *Rolls of Arms. Henry III. The Matthew Paris Shields, c. 1244-59,* ed. Thomas Daniel Tremlett. *Glover's Roll, c. 1253-8, and Walford's Roll c. 1273,* ed. Hugh Stanford London. Sir Anthony Wagner. *Additions and Corrections to A Catalogue of English Mediaeval Rolls of Arms* (London: Printed at the University Press for the Society of Antiquaries, 1967) [*Aspilogia II*].

3. *Aspilogia II*, p. x.

4. *Aspilogia II*, p. ix.

heralds and others at a later date, notably during the sixteenth and seventeenth centuries.

Although only two of our texts (the Camden Roll and the *Siege of Caerlaverock*) are edited on the basis of contemporary manuscripts, all preserve to a remarkable degree the language in which they were written. By the second half of the thirteenth century, Anglo-Norman differed markedly from the French spoken and written on the Continent and had, moreover, evolved away from its parent dialect, Norman French. However, it would be a serious error to assume that it did not maintain a decided consistency and logic all its own. Like Law French, which it resembles in many ways, it persisted as a viable medium for communicating technical information down through the Middle Ages and even later times. Full particulars concerning the terms utilized in the rolls in question are provided in *Early Blazon*, but much work remains to be done before the dialectal or individual characteristics of each roll can be accurately determined.

The manuscript sources of the six English rolls presented here and their several versions and copies have all been described in great detail in *CEMRA*, and similar information concerning the two French lists has been published by their respective editors. It will suffice to list the manuscripts which have served as the basis for our edition together with a few brief observations. Readers are referred to the principal editions listed under each item below for identification of individuals mentioned in the rolls. The sigla used to designate individual manuscripts are derived from those used in *CEMRA* and *Aspilogia II*, or in various publications by Dr. Paul Adam-Even, to identify rolls which at times survive in more than one version.

Thanks to Professor Ruth J. Dean, microfilms of all these manuscripts were obtained for the University of Pennsylvania and are deposited in the Charles Patterson Van Pelt Library, Philadelphia, Pennsylvania 19104. In a number of cases, a Xerox print of the films in question facilitates consultation by scholars.

1. *The Bigot Roll (BA)*. Paris, Bibliothèque Nationale, fonds français 18648, fols. 32-39. Copy made in the seventeenth century of a lost original, the latter having been at one time part of the famous Bigot Collection. Edition by Dr. Paul Adam-Even, "Etudes d'héraldique mediévale. Un Armorial français du milieu du XIIIe siècle. Le rôle d'armes Bigot – 1254," *Archives Héraldiques Suisses* (1949), 15-22, 68-75, 115-121. According to Dr. Adam-Even, the Bigot Roll was composed on the occasion of the campaign in the county of Hainault led by Charles, Count of Anjou and brother of King Louis IX of France, against Count John of Avesnes and his allies in the summer of 1254. The late French

scholar believed that the roll was written in the dialect of Picardy (p. 17). Many of the proper names have been very badly garbled by the copyist, but Dr. Adam-Even succeeded in identifying most of the individuals mentioned. Regrettably, his own transcription of this important roll is exceedingly poor and cannot be used.

2. *Glover's Roll, St. George's Version, copy a (Ba)*[5] *and copy b (Bb)*.[6] Copy *a* is in London, British Museum, Add. MS. 29796. Facsimile made in the sixteenth century of a lost original, presumably thirteenth century. It is a long strip of vellum containing 54 painted shields in rows of two with Anglo-Norman and sixteenth-century English blazons below each coat. One of the seventeenth-century Hatton-Dugdale facsimiles preserved in the Society of Antiquaries in London (MS. 664, Vol. I, fols. 23-24)[7] resembles this copy in every particular although there are some very slight orthographical variants. On the other hand, copy *b*, which is preserved in London, British Museum, Ms. Harl. 6589, fol. 11 *b*, is in blazon only and is signed by Nicholas Charles, Lancaster, and dated 1607. Charles states that he made his copy from a roll owned by Richard St. George, Norroy, and it is reasonable to suppose that the latter roll was the basis for copy *a* and for the Hatton-Dugdale facsimile as well (*Aspilogia II*, p. 96). Neither copy *a* nor copy *b* has been edited before although a portion of the Hatton-Dugdale facsimile is reproduced as Plate II in Anthony R. Wagner, *Heraldry in England* (London: Curwen Press, 1949) [*The King Penguin Books*, 22]. St. George's Version of Glover's Roll is dated "soon after 1258" by Wagner (*CEMRA*, p. 7) and London (*Aspilogia II*, p. 90). It has only one-fourth as many blazons and is, consequently, less important than either Cooke's Version or Harvy's Version, which are found in copies belonging to the College of Arms or to Sir Anthony Wagner, but attention has been drawn by London to the value of its unique variants (*Aspilogia II*, pp. 94-96). These are also considered separately under each item of his edition of Glover's Roll.[8]

5. Referred to in *CEMRA*, p. 7, as III. A, and in *Aspilogia II*, p. 90, as III (*a*).

6. Referred to in *CEMRA*, p. 7, as III. B, and in *Aspilogia II*, p. 90, as III (*b*).

7. Referred to in *CEMRA*, p. 7, as III. C, and in *Aspilogia II*, p. 90, as III (*c*).

8. The basis for London's edition of Glover's Roll in *Aspilogia II* is the Wagner-Wrest Park manuscript, which represents Cooke's Version and which is listed in *CEMRA*, p. 5, as I. A, and in *Aspilogia II*, p. 89, as I (*a*). For Harvy's Version, see *CEMRA*, pp. 5-6, and *Aspilogia II*, p. 90 (the latter provides a different classification for one of these manuscripts). I have not been able to obtain photographs of the Wagner-West Park manuscript nor of any other owned by the College of Arms or by Sir Anthony Wagner. A number of blazons in a fourteenth-century manuscript known as Grimaldi's Roll also stem from Glover's Roll; see *CEMRA*, p. 7; *Aspilogia II*, pp. 90-91, 96. N. Denholm-Young, *History and Heraldry 1254 to 1310* (Oxford: Clarendon Press, 1965), pp. 41-45, makes a number of interesting observations about Glover's Roll and the individuals named in it, Simon de Montfort in particular. See my review of this important book in *Speculum*, 41(1966), 318-320.

3. *Walford's Roll, Charles's Version (C)*.[9] London, British Museum, MS. Harl. 6589, fol. 12-12 *b*. Copy made by Nicholas Charles, Lancaster, and dated 1607. Edition by W. S. Walford, "A Roll of Arms of the Thirteenth Century," *Archaeologia*, 39 (1864), 373-388. As suggested by Max Prinet, "Armoiries françaises et allemandes décrites dans un ancien rôle d'armes anglais," *Le Moyen Age*, 2e série, 15 (1923), 224, and London in *Aspilogia II*, p. 99, the version first published by Thomas Hearne in 1715 is to be preferred over Charles's Version, although I do not believe it would be easy to show that the language of the latter is more "modern" (London suggests the fourteenth rather than the thirteenth century).

Leland's Version is preserved in two manuscripts. Copy *a* (*Cl*)[10] is in Oxford, Bodleian MS. Top. Gen. c. I (3117), Lelandi Collectanea, Vol. I, pp. 897-905, a manuscript known to Wagner, *CEMRA*, pp. 8-9, and Prinet only through the edition in *Joannis Lelandi Antiquarii de Rebus Britannicis Collectanea cum Thomae Hearnii Praefatione Notis et Indice*, I (London, 1715), pp. 897-905; 2nd ed. II, pt. 2 (London, 1770), pp. 610-616. Copy *b* (*Cd*),[11] made in the sixteenth century, is in Dublin, Trinity College, MS. E. 1-17, fols. 9-10 *b*, and may have been the work of Bartholomew Butler, Ulster King of Arms. Wagner and London propose the date *c*. 1275 for the original of both versions. *Cl* is the basis for London's edition of this roll in *Aspilogia II* but variants in *C* and *Cd* are also discussed by him, item by item.

4. *The Camden Roll (D)*. London, British Museum, Cotton Roll XV. 8.[12] Thirteenth-century original consisting of a long strip of vellum, the face featuring 270 shields in 45 rows of six identified by name, the dorse providing blazons corresponding to 185 of these. According to *CEMRA*, p. 17, the painted shields are probably *c*. 1280, but "The blazon on the dorse is somewhat later." In his "Additions & Corrections to *CEMRA*" published in *Aspilogia II*, Wagner adds: "Dr. C. E. Wright and Professor Francis Wormald inform me that the writing on the dorse is in an early-fourteenth-century hand" (p. 266). However, Professor Denholm-Young, *History and Heraldry*, has recently questioned this relative chronology: "If the blazon is admitted to be French, it could be contemporary with the painting, as thirteenth-century northern French hands of this type are more advanced in appearance than English hands of the same date, from which they are not otherwise easily distinguishable" (p. 62). This speculation stems in large measure from a single observation by James

9. Referred to in *CEMRA*, p. 8, as I. A, and in *Aspilogia II*, p. 97, as I.
10. Not listed in *CEMRA*, p. 9, this copy is referred to as II (*a*) in *Aspilogia II*, p. 97.
11. Referred to in *CEMRA*, p. 9, as III. A (unplaced copy), but in *Aspilogia II*, p. 97, as II (*b*).
12. *CEMRA*, pp. 16-17.

Greenstreet who first published "The Original Camden Roll of Arms," *Journal of the British Archaeological Association*, 38 (1882), 309-328. Greenstreet wrote: "The date of the writing on the back (the series of entries of blazon being evidently unfinished), though of about the same time as that on the face, may be somewhat later. One reason for thinking so is that where the name of the King of Scotland, with the description of his arms, should be set down, a blank space is left. This indicates the date of the explanatory French blazon to be a period subsequent to the assertion of Edward's claim to suzerainty over Scotland, namely close upon A.D. 1286" (p. 310).[13] I am personally inclined to be as skeptical about attempts to date a hand with such precision as I am about efforts to show that the language of a particular document is 25 or 30 years younger or older than another (see above). I see no valid reason for not assuming that the blazons of the Camden Roll are contemporary with the painted shields of this compilation, that is to say, *c.* 1280.

In a forthcoming article, I show that the Camden Roll, like the Dering Roll, is based on a copy of the Heralds' Roll.

5. *The Chifflet-Prinet Roll (CP)*. Besançon, Bibliothèque municipale, Collection Chifflet, MS. 186, pp. 145-154. Copy made in the seventeenth century by Jules Chifflet. The original from which this copy stems was dated 1285-1298 on the basis of internal evidence albeit with some hesitation by Max Prinet, "Armorial de France commencé à la fin du XIIIe siècle ou au commencement du XIVe," *Le Moyen Age*, 31 (1934), 1-49. Prinet also conjectured that the compiler of this roll was a native of Picardy: "Malgré les libertés que Jules Chifflet a prises avec le texte qu'il transcrivait, il a laissé subsister, dans sa copie, quelques formes dialectales qui permettent de croire que l'auteur du recueil était un Picard" (p. 4). This edition is without a doubt one of the finest available to scholars of medieval heraldry from the point of view of textual as well as of genealogical and historical reliability. Prinet's text, however, is marred by a number of minor inaccuracies and one inadvertent omission (the blazon for *CP* 107, Tibaut de Mathefelon). More significantly, however, Dr. Paul Adam-Even later discovered three other copies of this roll of arms unknown to Prinet. Two of these, both seventeenth-century manuscripts,[14] merely provide rows of shields with a few accompanying names. The third, however, constituted the essential link enabling Adam-Even to propose a stemma and a more precise date for the lost

13. On the circumstances involved here and their importance for determining the date of Girart d'Amiens' Arthurian romance, see my article entitled "Arthurian Heraldry and the Date of *Escanor*" *Bulletin Bibliographique de la Société Internationale Arthurienne*, 11 (1959), 81-88.
14. Identified by Adam-Even, p. 2, n. 2, as Paris, Bibliothèque Nationale, nouvelles acquisitions 6889, fol. 259, and Lille MS. 506, fol. 165.

original. According to the late French scholar, the latter, a blazoned rolls of arms, was compiled by a herald in the retinue of Robert II, Count of Artois, on the occasion of a military excursion into Flanders in June, 1297. A copy of this manuscript was utilized at the end of the fifteenth century by Joannet Fauquet, herald at the court of German Emperor Maximilian I, to illustrate a treatise on heraldry entitled *Enseignements notables servans aux rois d'armes, hérauts et poursuivants.* The latter came into the possession of a certain Dr. Höfflinger of Vienna in 1933 and was later examined by Adam-Even, who announced his discovery in an article entitled "Rôle d'armes de l'ost de Flandres (juin 1297)," *Archivum Heraldicum,* 78 (1959), 2-7. In this article, Adam-Even suggests that the thirteenth-century original, now lost, was known to Chifflet and utilized by him as the basis of his copy. The late French scholar was also able to restore a number of blazons missing in the Besançon manuscript and to show that the description of the Mailly arms in that copy is a conflation of blazons for Mailly and Preuilly. Unfortunately, the present whereabouts of the Höfflinger manuscript are unknown and we only have Adam-Even's transcript of a few items to judge its merits. While the terminology and phrasing of these blazons ring true, their orthography has been modernized to such an extent as to render them almost useless for our purposes. Our policy being to utilize only those manuscripts we have been able to examine in person, we have been obliged to limit ourselves to an edition of the Chifflet-Prinet Roll based on the Besançon copy alone. However, Adam-Even's discoveries have enabled us to make one major modification in the text and, above all, to situate this important roll of arms in its proper perspective. I now provide, for whatever utility it may have, Adam-Even's transcription (p. 4) of the incipit of this roll as it is preserved in the Vienna copy: *Vechy les noms des princes et les armes des vassaux des chevaliers, des barons qui fierent en l'ost de Flandres de par monseigneur le roy de Franche l'an de grace M II C et XCVII le mois d'aoust.*

6. *The Falkirk Roll, Thevet's Version (H).*[15] London, British Museum, MS. Harl. 6589, fol. 9-9 *b.* Copy made by Nicholas Charles, Lancaster, and dated 1606. According to the latter: "This Rolle was brought from Paris in France by Andrew Thevet, Cosmographer, and was taken out of the Treasory Chamber at the pallace in Paris aforesayd where the recordes are kept in the yeare 1576. At Paris 10 of Septembre." Edition by James Greenstreet, "The 'Falkirk' Roll of Arms," *Jewitt's Reliquary,* 15 (1875), 27-32, 68-74. Another version, represented by a copy made by Robert Glover, Somerset, *c.* 1585, formerly Wrest Park MS. 16, fols. 1-5, now

15. Referred to in *CEMRA,* p. 28, as I. B.

belonging to Sir Anthony Wagner,[16] offers important variants. Both texts were published in an excellent but relatively scarce parallel edition by Henry Gough, *Scotland in 1298* (Edinburgh, 1888), pp. 129-159. On the battle in question, see, in addition to Gough's fine study, Denholm-Young, *History and Heraldry*, pp. 103-111. The latter has proposed the following genesis for the two versions of this roll: "The suggestion is that the Harl. MS. is a copy of a roll made by Lord Percy's herald Wauter le Rey Marchis who was in Percy's retinue at the battle (Percy is no. 99 on the roll) in the fourth brigade with Earl Warenne's reserve. The other version, using the archaic *Wa* for *Ga*, might have descended, as did the owner of the Wrest Park MS. itself, from Reginald de Grey, who is no. 61 upon the roll, in the King's brigade. Now Grey, baron of Wilton and lord of Ruthin (succ. 1265, d. 1308), had been justiciar of Chester and has been described as 'the young Prince's mentor' in 1297, when he was Regent of England. It is safe to assume that he, like Percy, would have a herald, and quite possibly that his descendant at Wrest Park had inherited her copy of the Falkirk Roll as a family treasure, i.e. the one using the old-fashioned Anglo-Norman spelling" (pp. 108-109).[17]

7. *The Nativity Roll (M).*[18] London, British Museum, MS. Harl. 6589, fol. 10. Copy made by Nicholas Charles, Lancaster, and dated 1606. Edition by James Greenstreet, "The 'Nativity' Roll of Arms, *Temp.* Edward I," *Jewitt's Reliquary*, 15 (1875), 228-230. Greenstreet assigned the lost original of this roll "to some year, inter 1300-1312, but I incline to think it dates a year or two earlier than the close of Edward I's reign" (p. 228). *CEMRA*, p. 35, lists the date as "*c*. 1300 or a little later." Denholm-Young, *History and Heraldry*, has argued in favor of a date "in the first week of September 1306, 1307, or 1308 The Nativity Roll could thus be for a Round Table at or near Lanercost, where the king was staying in September 1306 For lack of evidence no more can be said than that this was probably a Round Table or jollification during a lull in the fighting in September 1306, 1307, or 1308" (pp. 117-118).

8. *The Siege of Caerlaverock (K).*[19] London, British Museum, Cotton

16. Referred to in *CEMRA*, p. 29, as II. A.
17. See also *Aspilogia II*, p. 267.
18. Referred to in *CEMRA*, p. 35, as copy B. It should be noted that the event in question took place on the Monday before the Nativity of Our Lady. A seventeenth-century copy of this roll owned by Sir Anthony Wagner and referred to in *CEMRA*, p. 35, as copy C, would appear to be closer, in format at any rate, to the lost original which was probably written on a long strip of vellum.
19. Referred to in *CEMRA*, p. 30, as I. The name of this castle is sometimes given as Carlaverock. The form I use is that preferred by Nicolas, Wright, and Wagner. The official guide-book published by Her Majesty's Stationery Office also bears the title *Caerlaverock Castle* (Edinburgh, 1952). This excellent pamphlet was prepared by B. H. St. J. O'Neil.

Caligula A. XVIII, fols. 23 *b* — 30 *b*. Original manuscript containing a contemporary account of the capture of Caerlaverock castle, co. Dumfries, by King Edward I in July 1300, and featuring blazons of 106 coats of arms. Editions by Nicholas Harris Nicolas, *The Siege of Caerlaverock*, *in the XXVIII Edward I, A.D. MCCC* (London: J. B. Nichols and son, 1828), and by Thomas Wright, *The Roll of Arms of the Princes, Barons and Knights who Attended King Edward I to the Siege of Caerlaverock, in 1300* (London: John Camden Hotten, 1864). In neither edition is the text or accompanying English translation satisfactory by modern standards. The numerous copies of this celebrated poem are listed in *CEMRA*, pp. 29-32; for the tricked and blazoned copies of the arms only, without the text, dating from Tudor and later times, see pp. 32-34. Somewhat at variance with the venerable British Museum manuscript is the textual tradition represented by the Glover copies which feature, in addition, illustrations of 90 banners, 16 shields, and a stylized sketch of the castle of Caerlaverock surmounted by seven banners (*CEMRA*, pp. 30-31). While each of these sixteenth and seventeenth-century copies has its own peculiarities, these are relatively minor, and I have elected to cite Oxford, St. John's College MS. CLXXIV[20] in the notes justifying a number of proposed emendations to the text of the British Museum manuscript. As for the Hatton-Dugdale facsimile executed in 1639 (London, Society of Antiquaries MS. 664, Vol. I, fols. 2-6 *b*. Roll 2),[21] I have shown elsewhere that the text is quite close to that found in the Glover copies whereas the illustrations are the work of a rank amateur who made several elementary mistakes when he attempted to reproduce the banners and shields blazoned in the poem.[22] Professor Denholm-Young has conjectured that this work, referred to as a *serventois* (v. 257), was composed to celebrate Sir Robert Clifford's key rôle in the siege and that the author may have been a Flemish minstrel named Philippe de Cambrai, known to have been present at the Feast of the Swans in 1306.[23] I have discussed these suppositions in my article entitled "Heraldic Terminology and Legendary Material in the *Siege of Caerlaverock* (*c*. 1300)," *Romance Studies in Memory of Edward Billings Ham*, ed. Urban Tigner Holmes (Hayward, California, 1967), pp. 5-20 [*California State College Publications*, No. 2]. On the language of this poem, see the *Notes* following the text.

20. Referred to in *CEMRA*, p. 31, as II. B.
21. Referred to in *CEMRA*, p. 32, as III. A.
22. "The Hatton-Dugdale Facsimile of the Caerlaverock Poem," *Scriptorium*, 24 (1970), 47-50 (pls. 14 and 15).
23. "The Song of Carlaverock and the Parliamentary Roll of Arms as Found in Cott. MS Calig. A. XVIII in the British Museum," *Proceedings of the British Academy*, 47 (1962), 251-262. Nicolas' suggestion (pp. iv-vi, 368) that the poem was composed by Walter of Exeter was laid to rest by Wright (p. vii). A few blazons in *K* were studied by Max Prinet in his article "Les Armoiries des Français dans le poème du siège de Caerlaverock," *Bibliothèque de l'Ecole des Chartes*, 92 (1931), 345-353.

Editorial Principles

The present edition is by no means intended to supplant entirely earlier publications which must still be consulted for data relative to the individuals mentioned in the rolls. It has the advantage, however, of bringing together in convenient fashion widely-scattered documents many of which are not readily accessible and two of which have never been published. Our main effort being to present reliable texts, only manuscripts examined in person by the author or in clear photographs were utilized for the present edition.

Since the turn of the century, editors of Old French and Anglo-Norman texts have subscribed to certain conventions which have been largely ignored by heraldic specialists. These include the omission of all diacritical marks except the acute accent used to indicate a stressed final *e* (*bendé, esquartelé*) and the cedilla to show that a *c* is pronounced like an *s* (*escuçon*). When editing poems, the diaeresis is employed to show diphthongs as an aid in scansion.

Abbreviations and numerals not infrequently lead to scribal errors. Also, it should be realized that each copyist tends to develop individual habits in this regard. For these reasons, a complete list of abbreviations and numbers follows each section, the object being to justify the choice of one solution instead of another. In solving abbreviations or in writing out numbers appearing as figures, we have, whenever possible, adhered to the principle that the most frequently used form is to be preferred. Except in these circumstances, then, and in cases – always clearly noted by us – when emendations were made to correct obvious scribal blunders, the texts have been reproduced exactly as they appear in the manuscripts with all their orthographical peculiarities.

Selected Bibliography

Adam-Even, Paul. "Etudes d'héraldique médiévale. Catalogue des armoriaux français imprimés." *Nouvelle Revue Héraldique,* NS 1 (1946), 19-29.

Adam-Even, Paul, and Léon Jéquier. "Un Armorial français du XIIIe siècle, l'Armorial Wijnbergen." *Archives Héraldiques Suisses,* 65 (1951), 49-62, 101-110; 66 (1952), 28-36, 64-68. 103-111; 68 (1954), 55-80.

Ancient Rolls of Arms. Charles' Roll of the Reigns of Henry III and Edward I. Ed. George J. Armytage. London: John Russell Smith, 1869. (= St. George's Roll.)

Ashmolean Roll. Oxford, Bodleian Library, MS. Ashmole 15A. Unpublished manuscript (*CEMRA*, pp. 57-58).

Aspilogia I. See Wagner.

Aspilogia II. See *Rolls of Arms.*

Barron, Oswald. "The Parliamentary Roll of Arms." *The Genealogist,* NS 11 (1885), 108-116, 174-182, 238-244; 12 (1886), 59-62, 133-136, 206-211, 268-282.

Barstow, Allen M. "A Lexical Study of Heraldic Terms in Anglo-Norman Rolls of Arms, 1300-50." Unpublished Ph.D. dissertation, University of Pennsylvania, 1970. Ann Arbor: University Microfilms.

Boutell's Heraldry, revised by C. W. Scott-Giles and J. P. Brooke-Little. London and New York: Frederick Warne & Co., 1963.

Brault, Gerard J. *Early Blazon. Heraldic Terminology in the Twelfth and Thirteenth Centuries with Special Reference to Arthurian Literature*. Oxford: Clarendon Press, 1972.

——. "The Hatton-Dugdale Facsimile of the Caerlaverock Poem," *Scriptorium*, 24 (1970), 47-50 (pls. 14 and 15). Reprinted in *The Coat of Arms*, 11 (1970), 76-81, with one of the two plates featuring a different folio of the facsimile.

CEMRA. See Wagner.

Charles's Roll. See Walford.

"Copy of a Roll of Arms (of the Reign of Edw. III) in the Possession of Stacey Grimaldi, Esq., F.S.A." *Collectanea Topographica et Genealogica*, 2 (1835), 320-328. (= Grimaldi's Roll.)

Dean, Ruth J. "An Early Treatise on Heraldry in Anglo-Norman." *Romance Studies in Memory of Edward Billings Ham*. Ed. Urban T. Holmes. Hayward, Cal., 1967, pp. 21-29. [*California State College Publications*, No. 2.]

Denholm-Young, N. *History and Heraldry 1254 to 1310. A Study of the Historical Value of the Rolls of Arms*. Oxford: Clarendon Press, 1965.

Dering Roll. See Greenstreet.

D'Haucourt, Geneviève, and Georges Durivault. *Le Blason*. Paris, 1949. [*Que sais-je?*, 336.]

Early Blazon. See Brault.

Godefroy, Frédéric. *Dictionnaire de l'ancienne langue française et de tous ses dialectes du IX^e au XV^e siècle*. 10 vols. Paris, 1881-1902.

Gough, Henry, and James Parker. *A Glossary of Terms Used in Heraldry*. 1894; rpt. Detroit: Gale Research Co. 1966.

Greenstreet, James. " 'Guillim's' Roll of Arms as an Ordinary." *The Genealogist*, 1 (1877), 323-327, 355-362.

——. "Planche's Roll." *The Genealogist*, NS 3 (1886), 148-155, 240-244; 4 (1887), 17-22, 197-203; 5 (1888), 173-179. (= The Heralds' Roll.)

——. "The 'Segar' Roll of Arms as an Ordinary." *The Genealogist*, 4 (1880), 50-58, 90-97.

Greenstreet, James, and Charles Russell. "Dering Roll." *Jewitt's Reliquary*, 16 (1875), 135-140, 237-240; 17 (1876), 11-16, 209-212; 18 (1877), 23-28, 89-92, 171-175.

Grimaldi's Roll. See "Copy".

Guillim's Roll. See Greenstreet.

Heralds' Roll. See Greenstreet (= Planché's Roll.)

Hope, W. H. St. John. *A Grammar of English Heraldry*. 2nd ed., revised by Sir Anthony Wagner. Cambridge: Cambridge University Press, 1953.

London, H. Stanford. "Some Medieval Treatises on English Heraldry." *Antiquaries Journal*, 33 (1953), 169-183.

Mathieu, Rémi. *Le Système héraldique français*. Paris: J. B. Janin, 1946.

Papworth, John Woody. *An Alphabetical Dictionary of Coats of Arms Belonging to Families in Great Britain and Ireland*. London: T. Richards, 1874. Rpt. as *Papworth's Ordinary of British Armorials*. Introduction by G. D. Squibb and Sir Anthony Wagner. London: Tabard, 1961.

Parliamentary Roll. See Barron.

Pope, Mildred K. *From Latin to Modern French with Especial Consideration of Anglo-Norman. Phonology and Morphology*. 1934; rpt. Manchester: Manchester University Press, 1966.

Rolls of Arms. Henry III. The Matthew Paris Shields, c. 1244-59. Ed. Thomas Daniel Tremlett. *Glover's Roll, c. 1253-8, and Walford's Roll, c. 1273*. Ed. Hugh Stanford London. Sir Anthony Wagner. *Additions and Corrections to A Catalogue of English Mediaeval Rolls of Arms*. London: The University Press for the Society of Antiquaries, 1967. [*Aspilogia II*.]

Segar Roll. See Greenstreet.

St. George's Roll. See *Ancient.*

Tobler, Adolf, and Erhard Lommatzsch. *Altfranzösisches Wörterbuch.* 1 Berlin, 1925-.

Veyrin-Forrer, Théodore. *Précis d'héraldique.* Paris: Larousse, 1951. [*Arts, styles et techniques.*]

Wagner, Sir Anthony. *A Catalogue of English Mediaeval Rolls of Arms.* Oxford: Charles Batey for the Society of Antiquaries, 1950. [*Aspilogia I* or *CEMRA*.]

――. *Heralds and Heraldry in the Middle Ages. An Inquiry into the Growth of the Armorial Function of Heralds.* 2nd ed., Oxford: Oxford University Press, 1956.

――. *Historic Heraldry of Britain.* London-New York-Toronto: n.p., 1939.

Walford, W. S. "Two Rolls of Arms of the Reign of King Edward the First, with some Prefatory Remarks by Charles Spencer Perceval." *Archaeologia,* 39 (1864), 389-391, 399-417, 441-446. (= Charles's Roll.)

Wartburg, Walther von. *Französisches Etymologisches Wörterbuch.* 1 Bonn-Leipzig: n.p., 1922-.

Wijnbergen Roll. See Adam-Even.

I The Bigot Roll

[34 a]

1. Vualeflans de Flakeraing, l'escu vert a trois bandes d'argent de travers. Baneres et Alemans.
2. Vueris del Dunei, l'escu d'or freté de gueulles. Baneres et Alemans.
3. Gerars d'Isemborc, l'escu de gueulles a l'aigle blanc. Baneres et Alemans.
4. Gerars de Quepeni, l'escu d'or a deus bastons de gueulles de fuires au lambel vert. Baneres et Alemans.
5. Seclin, quens[1] de Wistesale, l'escu d'or a une cuisse de gueulles. Baneres et Alemans.
6. Le comte Sauvage, l'escu songié d'argent et de noir. Allemans.
7. Le comte de Quenare, l'escu d'or a l'aigle d'azur a deus testes. Alemans.
8. Le comte Aioul des Mans, l'escu blanc a un lyon de gueulles a la keue forkie au lablel d'asur. Alemans.
9. Le comte Pelu, l'escu de gueulles a un lion blan a la keue forkie. Alemans.
10. Le duc de Baviere, l'escu noir a l'aigle d'or. Alemans.
11. Le duc de Soave, l'escu noir a trois lions d'or rampans. Alemans.
12. Le duc de la Roche, l'escu d'azur a l'aigle d'or. Alemans.
13. Le marquis de Misse, l'escu blan a une aigle noire. Alemans et Baneres.
14. Bistars li Lufirs, l'escu blan a l'orle de geule. Baneres et Alemans.
15. Le comte de Guerle, l'escu d'azur au lion d'or a billettes d'or semees. Alemans.
16. Li sire Vuinguerose, l'escu de geule a l'aigle blanc. Baneres et Alemans.
17. Li sires de Luselborc, l'escu burelé d'argent et d'azur a un lion de geules rampant coroné d'or. Alemans.
18. Gerars, ses freres, le porte au lambel d'or. Baneres et Alemans.
19. Le conte de Cleve, l'escu de geule a un escuchon d'argent. Ruyers.
20. Henry de Cleves le porte au lambel d'azur. Rujers.
21. Le comte de Holandre, l'escu d'or a un lion de geules rampant. Holandois.

1. The abbreviation *qus* is superscribed between the words *de* and *Wistesale*.

22. Le duc de Limborc, l'escu blan a un lion de geules rampant a le keue forkie. Rujers.
23. Le comte de Vilers, l'escu d'or au lion noir rampant a le keu forqie. Rujers.
24. Vualerans, ses freres, de Vilers le porte a un baston de geules en beslive. Baneres et Rujers.
25. Li conte de Viane le porte autretel. Rujers.
26. Le seignur de Vasenbergue, l'escu de geules au lion blanc rampant a le keue forkie. Baneres et Rujers.
27. Li sires de Ripesee, l'escu blanc a un escuchon de geule. Baneres et Rujers.
28. Li sires de Drestre, l'escu d'or a deus bastons noirs de travers.[2] Baneres et Rujers.

[34 *b*]
29. Gosuins de Borne, l'escu de geule a trois kevrons d'or. Baneres et Rujers.[3]
30. Gieres de Fauquemont, l'escu d'or a un lion de geules rampant a billetes de geules semees. Baneres et Rujers.[4]
31. Li quens del Quatre Ponts, l'escu burelé d'or et noir a un lion de geule rampant. Rujers.
32. Arguelms d'Olehaun, l'escu de geules a cinc sautors d'argent. Banneres et Rujers.
33. Haude de Saintirs, l'escu de geule a dis tortiax blans. Baneres et Hasbinons.
34. Guillaume de Hamale, l'escu blanc a une faisse de geules endentee. Baneres Hasbinons.
35. Robers de Geust, sires de Limene, l'escu blanc au lyon de geules rampant a cokilles d'azur semees. Baneres et Habingnons.
36. Valerans de la Monjoie, l'escu d'argent a un lion de geules rampant au lablel vert. Baneres et Habingnons.
37. Amauris de Chepillen, l'escu d'or a trois estriés noirs. Banneret et Habingnons.
38. Li quens de Loz, l'escu burelé d'or et de geules. Ardenois.
39. Arnox de Serke, l'escu d'or a une bende de geules a trois koquilles d'argent en le bende. Baneres et Ardenois.
40. Gilles[5] de Hurges, de geules a deus liepars d'argent passans coronés d'or. Banneret et Ardenois.
41. Li sires de Houfalize, l'escu d'azur a une croix d'or a croisettes d'or semees. Baneres et Ardenois.
42. Le comte de Namur, l'escu d'or au lion noir a un baston de geules en beslive.
43. Le duc de Braibant, l'escu noir au lion d'or rampant. Brabainchoms.
44. Li sires de Purrewés, l'escu de gueulles a la faisse d'argent. Baneres et Brabanchons.

2. *de (Travers) ou triers.*
3. *baneres et Alemans rujers.* The third word was crossed out by the scribe.
4. *semees baneres et rujers.* Between the first and second words, the scribe wrote three letters then crossed them out.
5. *Milles (ou Gilles).*

45. Henris de Baudesen, l'escu vert a trois fausses lozenges[6] d'argent au kief estakié d'or et de geules. Baneres et Brabanchons.
46. Pierres de Marbais, l'escu d'or a une faisse d'azur a trois cokilles d'argent en le faisse a trois oiselés de geules u kief. Baneres et Brabanchons.
47. Li sires de Bridas, l'escu de geules a trois sautoirs d'argent deus deseur et un desox. Baneres et Brabanchons.
48. Li castelains de Broseles, l'escu de geules a un sautoir d'or. Baneres et Brabanchons.
49. Tienes d'At, l'escu de geules a un sautoir d'argent. Baneres et Brabanchons.

[37 b]
50. Henris de Birbais, l'escu blanc a une faisses de geules. Braibanchons.
51. Reniers de Goisencourt, l'escu ecartelé de geules et de noir a une molette d'or u quartier de geules. Braibanchons.
52. Adans de Montferrant, l'escu d'or au lion noir rampant coronné d'argent. Braibanchons.
53. Guautiers de Hoingreng, l'escu d'azur au kief d'argent a la bordeure de geules endentee. Braibanchons.
54. Hams de le Vost, l'escu de geules a trois fuelles de trumel blanque. Juines Baniere.
55. Esteul de Seillers, l'escu de geules a trois pilirs d'argent. Baneres et Holandois.
56. Li mareschax d'Alseque, l'escu burelé d'or et de geules au lion d'argent rampant. Baneres et Ruiers.
57. Li sires de Briederode, l'escu d'or a un lion de geules rampant au lablel d'azur. Baneres et Holandois.
58. Tieris d'Esterlinghen, l'escu d'or au lion de geules au lablel blanc.[7] Baneres et Holandois.
59. Gerars de Landerode, l'escu echeketé d'or et de geules. Baneres et Ruyers.
60. Seclin de Borneham, l'escu d'or a une faisse de geules fretee d'argent a trois oiselés de gueules u kief. Baneres et Ruyers.
61. Henrys de le Leke, l'escu bendé d'or et de geules en beslive. Baneres et Ruyers.
62. Jehans Presins, l'escu bendé d'or et d'azur de travers a sautires de geules en l'or.[8] Baneres et Holandois.
63. Gerars li castelains de Houdequierke, l'escu bendé d'or et de geules de travers. Baneres et Ruyers.
64. Li conte de Huineberghe, l'escu de geules a un lion burelé d'argent et d'azur rampant coronné d'or a un pui vert et a une ghelingue[9] noire desus le pui vert. Alemant.
65. Alegre de Hostade, l'escu de geules a l'aigle blanc. Alemant.

[32 b]
66. Le senescax de Rostelers, l'escu blanc a trois fleurs de lis de geules. Beneres et Braibenchons.

6. *faisses lozenges.*
7. Most of this word is a blot.
8. *en lorle.*
9. *une ghelinde ghelingue.* The second word is deleted.

67. Rassekins de Lindekerque, l'escu de geules a trois lionchiax d'or rampans. Baneres et Braibenchons.
68. Li sires de Huissemale, l'escu d'or a trois fleurs de lis de geules. Baneres et Brabanchons.
69. Arnox de Huissemale, l'escu de geules a trois fleurs de lis blanques. Baneres et Braibanchons.
70. Li sires d'Audenarde, l'escu bendé d'or et de geules de travers. Baneres et Braibanchons.
71. Rojers de Enghien, gheronné d'argent et de noir croisette d'or en le noir.[10] Banneret et Brabainchons.
72. Vuautiers d'Ainghien, ses fiex, le porte au lablel de geules. Baneres et Braibanchons.
73. Gherars d'Ainghien,[11] ses freres, l'escu gheronné d'or et de geules croisette d'or en le geules. Baneres et Braibanchons.
74. Godefrois de Louvain, l'escu noir au lion blanc rampant coroné d'or. Baneres et Brabanchons.
75. Henris de Gumgniegny, l'escu de geules a une croix d'argent endentee. Baneres et Ruyers.
 Chist chevaliers que j'ay nommé portent tretost baniere et sont Alemant et Ruyer et Avalois et Holandois et Habingnon et Wistefalois et Braibanchons. Chist après sont bachelir a tostes ches partyes.
76. Aidelames de Ramestaing, l'escu de geules a cinc gans d'argent.
77. Godefroy de Flasqueraing, l'escu vert a trois bendes d'argent de travers au lablel d'or. Alemans.
78. Vuinemans[12] d'Esguiemes, l'escu eschequeté d'or et d'azur a le bordeure de geules a un quartier d'ermines. Alemans.
79. Vuinant, ses freres li aisnel, le porte entier. Alemans.
80. Henris de Guimegny li Soulas, l'escu de geules a le crois d'argent endentee a lablel d'azur. Alemant.
81. Guinemens d'Aquimegny, l'escu d'azur a le crois d'argent endentee. Alemans.
82. Gerars de Vuastime, l'escu d'or a une molette de geules perchie au lablel d'azur. Holandois.
83. Ernox d'Hamequerke, l'escu d'azur au lion d'argent rampant. Holandois.
84. Ernise de Holain, l'escu ondé d'or et de geules a deus faisseus d'argent encastelees desox et deseure. Holandois.
85. Alebert de Leuch, l'escu ondé d'or et de geules as besans d'argent es geules. Holandois.
86. Seclinng de Benteham, l'escu blanc a une cuisse de geules. Westefalois.
87. Guilliaumes de Wain, l'escu vairié d'argent et d'azur a le bordeure de gueules. Habingnons.

10. *croisette dor le noir.*
11. *Gherars dainghien.* Between these two words, the scribe wrote three letters then crossed them out.
12. The scribe first wrote *Que* then deleted these letters and began the blazon as it appears here.

[33 *b*]

88. Godefroi de Hartaing, l'escu burelé d'argent et d'azur a trois tortiax de geules. De le terre de Namur.

89. Clarenbax de Repen, l'escu blanc a une faisse d'azur a un lioncel de geules passant u quartier. De le terre de Namur.

90. Ernox de le Hamaide, l'escu d'or a trois haimades de geules au lablel d'azur. Flamens.

91. Gerars de le Hamaide, l'escu d'or a trois haimades[13] au lablel d'azur besandé[14] d'argent. Flamens.

92. Morel de Harvaing, l'escu d'or a une bende de geules a sis mellettes de geules. Hennuyer.

93. Fastres de Harvaing, l'escu d'or a une bende de geules a sis mellettes de geules au lablel d'azur. Hennuyer.

94. Juames de Harvaing le porte au lablel vert. Hennuyer.

95. Jehans de Harvaing, l'escu d'or a une bende de geules a sis mellettes de geules au lablel d'azur freté d'argent.

96. Gilles de Busengnies, l'escu bendé de geules et de vair a molettes d'or en le gueules. Hennuyer.

97. Goldescax de Moriaumés, l'escu bl . . . a une molette de geules u

98. Guautiers de Moriaumés, . . . tee au lablel d'as

99. Otes de Rionvuel, . . . res et Braibanchons.

99 *bis.* Vuatiers . . . de g

99 *ter.* Mai

[38 *a*]

100. Jehans Gravetiax, l'escu d'ermine a une faisse noire a deus listiax noirs un desox et l'autre deseure. Braibenchons.

101. Guautiers de l'Escluse, l'escu d'azur a un kief estakié d'or et de geules. Braibanchons.

102. Arnox de Hodemake, l'escu bendé[15] d'or et d'azur de travers au lablel de geules. Avalois.

103. Robers Briseteste de Cokerel, l'escu[16] bendé d'or et de noir as quintefeuelles d'argent u noirs a un cokes de geules u quartier devant. Braibanchons.

104. Arangue Briseteste de Cokerel, ses freres, l'escu bendé d'argent et de noir as quintefuelles d'or u noir a un cokes de geules u quartier devant. Braibanchons.

105. Athes de Latinne, l'escu d'or a une faisse de geules a trois cokilles d'argent en le faisse a trois oiselés de geules u kief.

106. Guilliaumes de Baire, l'escu d'or a une faisse de geules fretee d'argent. Braibanchons.

107. Bertrans de Liés, l'escu d'argent a une croix d'azur. Abingnons.

108. Ainris de Guensenille, l'escu blanc a une croix de cokilles de gueulles au lablel vert. Rujers.

109. Li vilains de Glingeham, l'escu d'ermines au kief de geules endenté. Habingnons.

13. *haimades ou haimaides.*
14. The scribe first wrote *bande* then crossed it out and wrote *besande* over it.
15. *lescu bende lescu bende.*
16. *Coquerel de geules u quar lescu.* The second, third, fourth and fifth words were deleted by the scribe.

110. Guires de Clermont, l'escu d'or a une aigle de geules au lablel d'azur besandé d'argent. Habingnons.
111. Jehans de Hostaing, l'escu d'azur au kief blanc a un demy lion de geules. Braibanchons.
112. Gilles de Bergue, l'escu noir a trois fleurs de lis d'or. Braibenchons.
113. Gilles de Quarterebe, l'escu d'azur au kief blanc[17] a trois martiax de geules en beslive. Braibanchons.
114. Jehans de Quarterebe, l'escu d'azur au kief d'or a trois martiax de geules. Braibanchons.
115. Hermans de Vilers, l'escu de geules a le bende d'or billeté d'or. Habingnons.
116. Guilliaumes de Vilers, ses fiex, le porte au lablel d'azur. Habingnons.
117. Alixandre de Vilers, l'escu blanc a le bende de geules a billettes de geules semees. Habingnons.
118. Libous[18] de Merle, l'escu d'or a un lyon d'azur rampant a billettes d'azur semee. Rujers.
119. Guilliaumes de Hornes, l'escu blanc a trois cors de geules. Rujers.
120. Reniers d'Otincort, l'escu blanc a un quevron de geules. Brabainchons.
121. Adans d'Otincort le porte au lablel d'azur. Braibanchons.
122. Gilles d'Otincort, l'escu d'ermine a un kevron de geules. Braibanchons.
123. Glidoup d'Olfendop, l'escu vert au kief estakié d'or et de geules les geules freté d'argent. Brabainchons.

[38 *b*]
124. Lidoup d'Olfendop, li fiex, l'escu vert au kief estakié d'argent et de geules. Braibainchons.
125. Ernox de Rostelers, l'escu d'argent a trois fleurs de lis de geules au lablel d'azur besandé d'or. Braibanchons.
126. Robers de Rostelers, l'escu d'argent a trois fleurs de lis de geules au lablel d'azur. Braibanchons.
127. Guilliaumes de Walehaim, l'escu d'or a un escuchon vert a un baston de geules en beslive. Braibanchons.
128. Jehans d'Ercainne, l'escu blanc a un lion de geules rampant a une fleur de lis en l'espaule du lion a billettes d'azur semees. Brabanchons.
129. Ses freres le porte au lablel d'or. Braibanchons.
130. Hues de Walesus, l'escu de geules a un croissant d'argent croisetté d'argent. Brabanchons.
131. Pierres de Marbais, l'escu d'argent a une faisse d'azur[19] a trois molettes d'or en le faisse a trois oiselés de geules u kief. Braibanchons.
132. Ernox de Landecrone, l'escu d'azur a une coronne d'or. Holandois.
133. Simons de Judoigne, l'escu d'azur a sis lozenges d'or en le crois. Braibanchons.

17. The scribe first wrote *dar* or *daz* then crossed these letters out and added *blanc* over them.
18. *Tibous.* The horizontal stroke of the *T* is crossed out and the letter *L* appears in the left-hand margin.
19. The scribe first wrote *dargent* then crossed it out and added *dazur* over it.

134. Vualirans de Liers, l'escu blanc a trois estriés de geules. Habingnons.
135. Simons de Joudoigne li Joules, l'escu d'azur a dis losenges d'or a un quartier a une molette noire u quartier. Braibanchons.
136. Guilliaumes de Berginnes, l'escu d'or au kief estakié d'argent et de geules a un baston noir endenté en beslive. Braibanchons.
137. Gerars de Sainct Souplais, l'escu eschequeté d'argent et d'azur au lablel de geule. Hannuiers.
138. Jakes de Sainct Souplais, l'escu eschequeté d'argent et d'azur au lablel de geules besandé d'or. Hainmuyers.
139. Vuautiers de Ranecort, l'escu d'hermines a trois hamaides de geules. Hainnuyers.
140. Gerars de Warne, l'escu d'argent a une croix de geules endentee. D'Ostrevans.
141. Othes li Bruns, l'escu bendé d'or et d'azur en beslive a le bordeure de geules endentee a un quartier blanc a une molette noire u quartier. Hainnuyers.
142. Robers Prinekin de Rosin, l'escu de geules a un kevron d'ermine. Hannuyers.
143. Favres de Ferme, l'escu d'ermine a un croissant de geules. Habingnon.
144. Gilles de Ferme, l'escu de geules a un croissant d'or croisetté d'or. Habingnons.
145. Libers de Landriers, l'escu de geules a un lion d'or billetté d'or. Habingnon.
146. Eustasses de Berlos, l'escu blanc a deus bastons de geules au lablel d'azur besandé d'or. Habingnons.

[39 *a*]
147. Fastres de Berlos, l'escu blanc a deus bastons de geules a une molette noire. Habingnons.
148. Phelippes de Velques, l'escu de geules au kief d'or au lablel d'azur. Habingnons.
149. Henris de Tongres, l'escu vairié d'argent et d'azur a une faisse d'or frettee de geules. Habingnons.
150. Jakes de Tongres, l'escu vairié d'argent et d'azur a une faisse de geules. Habingnons.
151. Jehans de Tongres, l'escu vairié d'argent et d'azur a une faisse de geules fretté d'or.
152. Godelon de Waresme, l'escu bendé d'or et d'azur de travers. Habingnons.
153. Ernox de Landebeke, l'escu de geules a un sautoir d'ermine. Braibanchons.
154. Gilles de Vaudripont, l'escu d'or a deus lions de geules adossés au lablel d'azur. Braibanchons.
155. Nicoles de Praele, l'escu d'azur a une faisse d'argent a trois mellettes d'argent u kief. Hanuiers.
156. Gerars de Fornewil, de geules a deus bars d'or sinans. Hannuiers.
157. Gherars de Busingnies, l'escu bendé de geules et de vair a molettes d'or en le geules. Hanuiers.
158. Gerars de Tuin, l'escu d'azur a un lion d'argent rampant coroné d'or au lablel de geule. Hainnuyers.

159. Jehans de Lais, l'escu noir a une faisse d'argent a trois molettes de geules en le faisse a trois oiselés d'argent u kief. Braibanchons.
160. Guilliaumes de Marbaix, l'escu noir a une faisse d'argent a trois cokilles de geules en le faisse a trois oiselés d'argent u kief. Braibanchons.
161. Henris de Setru, l'escu de geules a une faisse d'argent a trois oiselés d'argent u kief. Braibanchons.
162. Henris de Houzainmont,[20] l'escu blanc a un sautoir de geules a trois oiselés de geules. Habingnons.
163. Oliviers de Fontainnel, l'escu d'or a un sautoir de geules a quatre oiselés de geules. Habingnons.
164. Le sire de [Huy],[21] l'escu burelé d'argent et d'azur au kief de geules endenté. Habingnons.

[32 *a*]
165. Vuistasses de Heripont, l'escu blanc a trois lionchiax noirs au lablel de geules. Hennuyers.
166. Vuistasses de Crepilly, l'escu d'argent a trois lionchiax noirs au lablel de geules besandé d'argent. Hennuyer.
167. Gilles de Herlames, l'escu blanc a la bende d'azur. Hennuyer.
168. Gervaisses de Scaxfors, l'escu d'or a trois kevrons de geules au lablel d'azur. Cambresis.
169. Jehans de Warne, l'escu de geules a dis losenges d'hermines.
170. . . . neresole de Batale, l'escu d'or freté de noir. De Cambresis.
171. . . . de Cambray le porte a un quartier noir. De Cambresis.
172. . . . Mancort, l'escu d'or a trois kevrons de geules. Baneres de Tornesis.
173. . . . , l'escu d'or a un escuchon vert a un baston couponné . . . beslive.[22] Baneres et Braibanchons.
174. . . . , d'or et d'azur a le bordure de geules. Alemans.
175. . . . a une mance de geules au lablel d'azur. Rujers.
176. . . . lion d'azur rampant billetté d'azur. Rujers.
177. . . . trois estriers noirs. Habingnons.
177 *bis.* . . . une bende blanque. Habingnons.
178. . . . geules edentee au lablel d'azur. Rujers.
179. . . . ent rampant billetté d'argent au
179 *bis.* . . . ou lablel d'azur. Hennuyer.
179 *ter.* . . . rampant. Hainnuyers.
179 *quater.* . . . au lablel de
179 *quinquies.* . . . aston

[35 *a*]
180. Armans de Montejehan, l'escu d'or freté de gueules. Baneres et Angevins.
181. Guillaume de Sarsael, l'escu vert au lion d'argent coroné d'or. Mansel.
182. Varins de Grantcanp, l'escu blanc a une danche de geule en beslive a sis oisel de geules. Mansel.

20. The scribe first wrote *Bouzainmont* then crossed it out.
21. *Le sire de* (followed by a blank space).
22. *couponne beslive.*

183. Frokes, l'escu parti d'azur et de gueulles a trois kevrons d'argent jumiax. De Toraine.
184. Gervaises de Chavael, l'escu noir a deus jumeles d'or au lablel de geules besandé d'argent. Mansel.
185. Gervaises du Teil, l'escu bendé d'or et d'azur en beslive. Mansel.
186. Robers Pesans, l'escu noir et le crois d'or as oiselés[23] d'or entor. Mansel.
187. Robers de Loudun, l'escu blanc a rosettes de geules semees. Mansel.
188. Jeoffrois de Guirreles de Loudun porte au lablel d'azur. Mansel.
189. Guillaumes li Maires de Cormes, l'escu blanc a trois jumelles noires. Mansel.
190. Jehans de Cormes le porte au lablel de geules. Mansel.
191. Jeoffrois de Rouson, l'escu d'or a un lion de geules. Mansel.
192. Guilliaumes de Loumens, l'escu d'or au lion noir coronné d'argent. Mansel.
193. Guilliaumes de Chelé, l'escu de geules a trois roses d'argent. Mansel.
194. Robers de Juin, l'escu d'argent a une bende de geules a sis oiselés de geules. Mansel.
195. Foukel Revel, l'escu d'azur fretté d'argent au kief d'or. Mansel.
196. Gervaises de Pruillé, l'escu vairié d'argent et d'azur au kief de geules. Mansel.
197. Jehans de la Forest, l'escu blanc au kief noir endenté. Mansel.
198. Payens de Couardon, l'escu blanc a sis aniax noirs au lablel de geules.
199. Payens de Pres, l'escu d'azur a la bende d'argent. Mansel.
200. Payens de Coismes, l'escu d'or au lion d'azur coroné de geules. Mansel.
201. Robers Danguel, l'escu d'or a trois bendes vers de travers. Mansel.
202. Jeoffrois de Danguel, l'escu d'or a trois bendes vers de travers a l'orle de gueules. Mansel.
203. Jeoffrois de Danguel, li mainnés, l'escu d'or a trois bendes vers de travers a un quartier d'ermine. Mansel.
204. Joquerans de Torengny, l'escu lozengié d'or et de geules au lablel d'azur. Mansel.
205. Guilliaume Giré, l'escu blanc au kief de geules a une vuive d'argent de travers el kief. Mansel.
206. Gervaisse de Corterne, l'escu blanc au kief de geules a un baston d'or de travers el kief. Mansel.
207. Raoul de Bazeilles, l'escu d'azur a un lion burelé d'argent et de geule rampant. Mansel.

[35 *b*]
208. Pierre de Bazeilles le porte au lambel d'or. Mansel.
209. Haimeris L'Enfant, l'escu d'or a trois batons de geules de travers u kief. Mansel.
210. Nicolas de la Chieze, l'escu d'argent a sis fausses lozenges noires a la bordeure de geules. Mansel.
211. Hues de Touart, l'escu party d'or et d'azur endenté l'un en l'autre. Mansel.
212. Hues de Buirel, l'escu burelé d'or et d'azur. Mansel.

23. *le crois dor a loiseles.*

213. Jehans de Maule, l'escu parti d'or et de geules endenté l'un en l'autre. Mansel.
214. Joffrois de Couliedre, l'escu de geulles a un lion burelé[24] d'or et de vert coroné d'argent. Mansel.
215. Phelipes de Launoy, l'escu d'azur a deus batons d'or de travers. Mansel.
216. Haymeris de Sugi, l'escu d'azur a trois gemelles d'or. Mansel.
217. Guilliaumes de Tusi, l'escu noir a trois jemelles d'argent au lablel de geules. Mansel.
218. Guis de Garlande, l'escu d'or a trois jumelles noires. Mansel.
219. Renax de Housay, l'escu d'or a trois jumelles noires a un quartier noir. Mansel.
220. Guilliaumes de Cervoise, l'escu d'or a trois jumelles noires au lablel de geule. Mansel.
221. Hues de Soudac, l'escu d'or a une faisse noire. Mansel.
222. Jeoffrois Berard, l'escu bendé d'argent et de noir de travers au lablel de geules. Mansel.
223. Elinans[25] d'Espaigne, l'escu noir a un fer de molin d'argent au lablel de geules. Mansel.
224. Aubris Riboule, l'escu party d'argent et de noir endenté l'un en l'autre. Mansel.
225. Guilliaumes de Radelay le porte au lablel de geules. Mansel.
226. Jeoffrois li seneschax d'Achi le Boine, l'escu parti d'argent et de noir endenté l'un en l'autre a un baton de geules en beslive besandé d'or. Mansel.
227. Li Fou Archiers de Sailli, l'escu noir freté d'or au lablel de geules. Mansel.
228. Levour d'Erni, l'escu d'azur a sis aniax d'argent a la bordure de geules. Mansel.
229. Fouques L'Anfant, l'escu d'ermine a trois batons de geules u kief de travers. Mansel.
230. Tiebaut Trager, l'escu blanc a le bordures d'oiselés de geules. Mansel.
231. Roteline de Puisane, l'escu burelé d'or et de vert[26] au lion de geules au lambel d'argent. Mansel.
232. Joiffrois de Montabon, l'escu d'or a un lion d'azur rampant de geules a florette d'azure semees. Mansel.

[36 a]
233. Herbers de Sainct Aubin, l'escu de geules a fleurs de lis d'or. Mansel.
234. Guis de Vautorte, l'escu blanc a une faisse noire a un baston de geules en beslive. Mansel.
235. Li freres Rotrou de Montfort, l'escu de geules a deus liepars d'or passans au lablel d'azur. Mansel.
236. Li sires de Clincamp, l'escu noir a une bende d'argent a deus listiax d'argent. Mansel.
237. Rotrou de Montfort, l'escu de geules a deus liepars d'or passans. Baneres et Mansel.

24. *buele.*
25. *Elinans (Glinans ou Blinans, Alinans, Olinans).*
26. *dor et de vert.* Several letters were written by the scribe between the third and fourth words then deleted.

238. Le viscuens de Biaumont, l'escu d'azur au lion d'or coroné de geules a fleurs de lis d'or semees. Baneres et Mansel.
239. Gilles de Doucele, l'escu burelé d'or et de vert a un lion de geules coronné d'argent rampant. Baneres et Mansel.
240. Garin de Cortene, l'escu d'or a trois roses de geules. Baneres et Mansel.
241. Guilliaumes de Luerton, l'escu d'azur a un sautoir d'argent a trois estoiles d'or. Baneres et Mansel.
242. Guis de Lanane, l'escu d'or a une croix de geules a cinc cokilles d'argent en le croix a seize aigles d'azur. Baneres et Mansel.
243. Haymeris d'Antenoise, l'escu vairié d'or et de geules. Baneres et Mansel.
244. Bernart de la Freté, l'escu d'or a deus lions noirs passans coroné d'argent. Baneres et Mansel.
245. Payens de Torengny, l'escu losengié d'or et de geules a un lablel d'argent. Baneres et Mansel.
246. Li quens d'Aion, l'escu d'azur a fleurs de lis d'or semees au lablel de geules. Baneres et Angevins.
247. Fouques de Doon, l'escu bendé d'argent et de geules endenté l'un en l'autre. Baneres et Angevins.
248. Pierre de Bausai, l'escu d'or a un fer de molin de geules. Baneres et Angevins.
249. Guilliaumes de Bausai le porte au lablel d'azur. Baneres et Angevins.
250. Hugues de Mailly, l'escu ondé d'argent et de geules. De Torayne.
251. Esteilles de Mauny, l'escu noir a une croix blanque eslaisie a box a un baston de geules en beslive. De Torayne.
252. Harduins de Mailli, l'escu ondé d'or et de geules. Baneres et Torayne.
253. Pierres de la Rajasse, l'escu ecartelé d'or et d'azur au lablel de geules. Baneres et de Touraine.

[36 *b*]
254. Landris de le Tor, d'or a une tor de geules. Baneres et de Toraine.
255. Achienars de Pruilli, l'escu d'or a une manche de geules a le bordure d'aigles d'azur. Baneres et de Toraine.
256. Renax de Pressengny, l'escu contrebendé d'or et d'azur a un escuchon d'argent au kief estakié as cornés geronnés. Baneres et de Toraine.
257. Aubris de Presengny le porte a un baston de geules en beslive. Baneres et de Touraine.
258. Hugues de Taunnrier, l'escu d'or a une aigle de geules a deus testes. Baneres et de Toraine.
259. Bouchars de Mirmande, l'escu d'or a deus bastons noirs de travers. Baneres et de Toraime.
260. Jehans de Mirmande le porte a un baston de geules en beslive. Baneres et de Torainne.
261. Bauduins d'Usé, l'escu eschequeté d'or et d'azur. Baneres et de Torainne.
262. Bertremiex de l'Ille, l'escu de geules a deus liepars d'argent passans. Baneres et de Torainne.
263. Olivier de l'Ille, ses freres, le porte au lambel d'azur. Baneres et de Torainne.

264. Li quens de Vendosme, l'escu blanc au kief de geules a un lion rampant. De Torrainne.
265. Guilliaumes de Saincte More, l'escu blanc a une faisse de geules. Baneres. Il maint en le marche de Poitou et de Torainne.
266. Renaus de l'Ille, l'escu d'or a une croix de geules. Baneres. Cil maint a deus lieustee de Vendosme pres de Veus Casteldun.
267. Nevelon de Fraiteval, l'escu d'or a le bordeure de melletes noires. Baneres et de Dunois.
268. Rochelin de Maimeroles, l'escu estakié d'argent et de noir. Baneres et Dunziens.
269. Pierres de Chaorzel, l'escu burelé d'argent et de geules a une aigle noire a deus testes. Baneres et Dunziens.
270. Favris de Chaorzel, l'escu burelé d'argent et de geules a le bordure de melletes noires. Baneres et Dunziens.
271. Paiens de Chaorse le porte a un quartier noir. Baneres et Mansel.
272. Li quens de Perche, James de Castiau Gontier, l'escu blanc a trois kevrons de geules. Baneres et Percherans.

[37 a]
273. Guis de Lonroy, l'escu d'ermine au kief de geules. Baneres et Percherans.
274. Robert de Viespont, l'escu blanc a dis aniax de geules. Baneres et Percherans.
275. Guilliaumes d'Ilers, l'escu d'or a dis aniax de geules. Baneres et Percherans.
276. Mathius de Biaumont, l'escu de geules freté d'or au kief d'or. Baneres et Angevins.
277. . . . O de Sainct Per, l'escu de geules a trois lions d'or rampant coroné d'azur. Baneres et Angevins.
278. Renax de la Roche Dire, l'escu d'or a un lion de geules coroné d'azur. Baneres et Angevins.
279. Pierre Acars, l'escu bendé d'orr et de noir en beslive. Baneres et Angevins.
280. Payens d'Orliens, l'escu bendé d'argent et de vert a cinc enniax de geules de l'un en l'autre. Baneres et Angevins.
281. Li quens de Bigorre, l'escu d'or a deus lions de geules passans coroné d'argent. De Limoxin.
282. Li visquens de Perrigort, l'escu d'argent a un fer de molin vert a le bordeure de geules besandé d'or.
283. Aymeris de Rochechoart, l'escu ondé d'argent et de geules. Baneres et de Limoxins.
284. Esterlas Tranchelyon de Pierre la Buffiere, l'escu de geules a un lion rampant d'argent coroné d'or a le langhe d'or a une manche vairie en le geule du lyon a une espee d'azur au pong d'or et au heurt d'or quy trenche le lion par my. Baneres et Limozins.
285. Josiaume de Castelnuef, l'escu noir au lion d'or rampant coronné d'argent. De le marche de Limozin et d'Engoulesme. Baneres.
286. Jehans de Sansuerre, l'escu d'azur papellonné d'or a une bande d'argent a deus[27] listiax d'or a une molette de geules en le bende. Baneres et de Berry.

27. *iii.*

287. Henris de Sorli, l'escu d'azur au lion d'or rampant a molette d'or semees. Baneres et de Berry.
288. Renoul de Tulch le porte au lablel de geules. Baneres et de Berry.
289. Pierre de Voizins, l'escu blanc a une faisse de geules endentee. Baneres et de Berry.
290. Guilliaumes de Chauvingny le porte au lablel noir. Baneres et de Berry.
291. Jehans de Chauvingny le porte au lablel noir besandé d'or. Baneres et de Berry.
292. Guilliaumes de Nellac, l'escu d'azur a deus liepars passans d'argent. Baneres et de Berry.

[37 *b*]
293. Hubers de Praele, l'escu d'azur a trois lions d'argent rampant coroné d'or. Baneres et de Berry.
294. Joiffrois du Donjon, l'escu blanc a un lion de geules rampant a le bordure vert. Baneres et de Berry.
295. Jehans de Perie, l'escu de geules a trois tierchesfeuilles d'or. Baneres et de Berry.

Remarks

1. Concordance

Adam-Even: Paul Adam-Even, "Etudes d'héraldique médiévale. Un armorial français du milieu du XIII^e^ siècle. Le rôle d'armes Bigot − 1254," *Archives Héraldiques Suisses* (1949), 15-22, 68-75, 115-121.

BA	Adam-Even
1-64	1-64
65	99
66-99	65-98
100-295	100-295

Item 65 appears at the bottom of fol. 37 *b* and is entered as no. 99 (corresponding to fol. 33 *b*) by Adam-Even. The latter omits 99 *bis*, 99 *ter*, 179 *ter*, 179 *quater*, and 179 *quinquies*. Items 177 and 177 *bis*, and 179 and 179 *bis*, clearly indicated by the scribe as four separate items, are fused together by Adam-Even and entered as no. 177 and no. 179 respectively. The order of items is confused in this copy; we have followed the arrangement proposed by Adam-Even, p. 15, n. 5. The French scholar errs, however, in listing item 69 as the last on fol. 34 b; no. 49 is the item actually involved.

2. Abbreviations

Brab., Braba., for *Brabanchons:* 44-49, 74, 128, 130 (the word *Brabanchons* is spelled out: 68).
Brabai., for *Brabainchons:* 71, 120, 123 (the word *Brabainchoms* is spelled out: 43; cf. *Braibai.,* for *Braibainchons:* 124).
Brai., Braib., Braiban., for *Braibanchons:* 50-53, 69, 70, 72, 73, 99, 101, 103, 104, 106, 111, 113, 114, 121, 122, 125-127, 129, 131, 133, 135, 136, 153, 154, 159-161, 173 (the word *Braibanchons* is spelled out in the caption following item 75; cf. *Braibenchons:* 66, 67, 100, 112).

Ha., Hab., Habing., for *Habingnons:* 35-37, 144-146, 148-150, 152, 162-164, 177, 177 *bis* (the word *Habingnons* is spelled out: 87, 109, 110, 115-117, 134, 147; cf. *Abingnons:* 107; *Habingnon:* 143 and in the caption following item 75; *Hasbinons:* 33; cf. *Hasb.:* 34).

Hai., for *Hainnuyers:* 158, 179 *ter* (the word *Hainnuyers* is spelled out: 139, 141; cf. *Hainmuyers:* 138).

Hen., for *Hennuyer:* 93, 94, 166, 167, 179 *bis* (the word *Hennuyer* is spelled out: 92, 96; cf. *Hennuyers:* 165). Cf. the following variants, spelled out in each case: *Hannuyers:* 142; *Hanuiers:* 155, 157; *Hannuiers:* 137, 156.

Man., for *Mansel:* 184, 314, 241 (the word *Mansel* is spelled out: 181, 182, 185-197, 199-213, 215-240, 242-245, 271).

qus, for *quens:* 5 (the word *quens* is spelled out: 31, 38, 246, 264, 272, 281; cf. the kindred term *viscuens:* 238, *visquens:* 282; the oblique form is also found: *comte:* 6-9, 15, 21, 23, 42; *conte:* 19, 25).

St., for *Sainct:* 137, 138, 233 (the word *Sainct* is spelled out: 277).

Ste., for *Saincte:* 265.

3. Numbers

1, for *un* or *une:* everywhere (these words are frequently spelled out).

2, for *deus:* 7, 28.

ii, for *deus:* 4, 40, 47, 84, 100, 146, 147, 154, 156, 184, 215, 235-237, 244, 258, 259, 262, 269, 281, 292.

3, for *trois:* 1.

iii, for *trois:* 11, 29, 37, 39, 45, 46 (2), 47, 54, 55, 60, 67-69, 77, 88, 90, 105 (2), 112-114, 119, 125, 126, 131 (2), 134, 139, 155, 159 (2), 160-162, 165, 166, 168, 172, 177, 183, 189, 193, 201, 203, 209, 216-220, 229, 240, 241, 272, 277, 286 (error for *ii*), 293, 295 (the word *trois* is spelled out: 66, 202).

iv, for *quatre:* 31 (in a proper name), 163.

v, for *cinc:* 32, 76, 242, 280.

vi, for sis: 92, 93, 95, 133, 182, 194, 198, 210, 228.

x, for *dis:* 33, 135, 169, 274, 275.

xvi, for *seize:* 242.

4. Notes

BA 5 – on this entry, see *Early Blazon,* s.v. *ouisse.* On closer examination, however, the manuscript revealed the spelling *cuisse.* See below, note to *BA* 86.

BA 28 – the scribe occasionally offers two or more readings for words he has trouble deciphering. Cf. *BA* 40, 91, 223.

BA 40 – arms of *Gilles* de Hierges; Adam-Even, p. 68, note.

BA 45 – in his note to this entry, Adam-Even mentions the mascles in the Bautersem arms but does not emend the blazon. However, in his glossary, p. 19, he lists *fausses lozenges* and refers to the item in question. The expression is also found in *BA* 210.

BA 62 – Adam-Even, p. 70, note, correctly identifies these arms as belonging to Jehan Persijn without, however, making the emendation I propose here *(en l'orle] en l'or)* which is clearly indicated by the evidence he cites.

BA 64 – according to Adam-Even, p. 70, this is a conflation of the arms of the Landgrave of Thuringia and those of Henneberg.

BA 86 – in his note to this item (no. 85 in his edition), Adam-Even wonders whether the knight in question might not be Schilling of Bornheim. However, the manuscript reads *cuisse* not, as the late French scholar thought, *ouisse* (see also above, note to *BA* 5), suggesting a connection with no. 712 in the Wijnbergen Roll: "De gueules à la jambe d'argent chaussée de sable" (illustrated p. 55, fig. 1). The latter is captioned *Eurart de Brutehen* but indexed p. 78, s.v. *Buttenheim* by Adam-Even.

BA 164 – for the identification of these arms, see Adam-Even, p. 75, note.

BA 223 – identified as *Alaume* d'Espagne, sire de Villaines, by Adam-Even, p. 117, note.

BA 286 – Adam-Even does not emend but notes, p. 120, that the Sancerre arms feature *two* cotices. Cf. *CP* 8 and see *Aspilogia II,* pp. 164-166.

II Glover's Roll/
St. George's Version

A. Copy a (Ba)

1. Le conte de Chestre, de azure a treys garbes de or.
2. Le conte de Leicestre, de gules a lion de argent a la coue furché.
3. Le conte de Wyncester, de gules a set fauses losenges de or.
4. Le conte de Hereford, de azur a siz lionceus de or o une bende de argent a deus cotrises de or.
5. Le conte de Oxenford, esquartelé de gules e de or un molet de argent.
6. Le conte de l'Ille, de or a une lion rampant de azure.
7. Le conte de Aubemer, de gules a une croyx de vere.
8. Le conte de Fereres, veré de or e de gules.
9. Le conte de Warewyke, eschekeré de or e de azure a un cheverun ermin.
10. Le conte de Kente, de gules a sept losenges de vare.
11. Le conte de Salesbury, de azure a siz lionceus de or.
12. Sire Johan de Plesis, de argent a sis fauses roeles de gules.
13. Willame de Valence, burlé de argent e de azure lez merloz gules.
14. Willam de Munchenesé, de or a treis escuchuns bendez de ver e de gules.
15. Willam de Cantelu, de gules a treis flurettes de or.
16. Johan le FizJohan, esquartelé de or e de gulz od la bordur de vair.
17. Gater de Clifford, eschekeré de or e de azure a une bende de gules.
18. Roger de Clifforde, autel od la fesse de gules.
19. Johan de Vause, eschekeré de argent e de gules.
20. Roger de Someri[1]
21. [William de Mandeville],[1] esquartelé de or e de gules.
22. Warin de Bassingburne, girund de or e de azure.
23. Johan Baylol, de gules od un faus escuchun de argent.
24. Huwe de Bailol, autel a un escuchun de azur a un lion de argent coroné[2] or.
25. Heustace de Turs, au faus eschuchun de argent a lambel de or.
26. Willame de Evereus, de gules a une fese de argent treis turteus de argent.

1. *Roger de Someri esquartele de or e de gules.*
2. *crois* (there is a horizontal line over the last three letters).

27. Baudeuin Dakeni, de azure a la croiz de or a quatre lionceus de or.
28. Willam Marmiun, verré a une fese de gules.
29. Peres de Brus, argent a lioun de azure.
30. Robart de Tateshale, eschekeré de argent e de gules a chefe ermin.
31. Huwe Vak, de or a deus feses de gules a treis turteus in chefe.
32. Robert de Stafford, de argent a cheverun de gules besanté de or.
33. Robert de Nuelle, de argent a deus bastuns de gules besanté or.
34. Willame de Beuchamp de Bedeford, esquartelé de or e de gules un bende gules.
35. James Audedoyle, de gules freté de or.
36. Willame de Bruse, de azure a lion de or a cruseles de or poudré.
37. Patric de Cheures, burlé de argent e de gules od merloz noirs.
38. Roberd Nevile, de gules a sautur de argent.
39. Gilberd Peche, de argent a deus cheveruns de gules a la fesse de gules.
40. Hamund Crevequer, de or une croiz percé.
41. Renaunt de Moun, de gules a la manche de hermin.
42. Robert Auguilun, de gules a un flur de argent.
43. Rauf de Cameis, de or a chefe de gulz treis turteus argent.
44. Willam Maudut,[3] de argent a deus barres de gules.
45. Willam de Ros, de gules treis boous de argent.
46. Robert, son fiz, autel a laubell de or.
47. Willam de Aubini de Bever, de or a deus cheveruns de gules a la bordur de gules.
48. Ricard de Harecurt, de or a deus barres de gules.
49. Willame Barduff, de azure a treys quintefoile de or.
50. Gilbert de Gaunt, barré de or e de azure a un bend de gules.
51. Tomas de Grelei, de gulz a treis bendes de or.
52. Roger de Mubrai, de gules a lion de argent.
53. Gelebert Hausart, de gules a treis esteiles de argent.
54. Willame de Vesci, de gules a une croiz de argent.
55. Renaud FizPerse, de gules a treis lionceus de or.

Remarks

1. Concordance

B: *Ancient Rolls of Arms. Glover's Roll of the Reign of King Henry III*, ed. George J. Armytage (London: John Russell Smith, 1868).
Bl: *Glover's Roll*, ed. Hugh Stanford London in *Aspilogia II*.

Ba	B / Bl	Ba	B / Bl	Ba	B / Bl
1	16	6	12	11	22
2	4	7	13	12	24
3	8	8	15	13	23
4	10	9	20	14	25
5	11	10	21	15	27

3. The word *Martin* is superscribed over this name in a different hand.

Ba	*B / Bl*	*Ba*	*B / Bl*	*Ba*	*B / Bl*
16	28	30	50	45	66
17	30	31	51	46	67
18	31	32	52	47	68
19	33	33	53	48	69
20	19	34	54	49	70
21	19	36	55	50	72
22	35	37	56	51	73
23	36	38	59	52	74
24	37	39	60	53	75
25	38	40	61	54	76
26	45	41	62	55	77
27	46	42	63		
28	47	43	64		
29	48	44	65		

A shield bearing the arms of England and the caption "Henry le tiers roy de Engliter" heads this roll (= *B/Bl* 1). No mention of this is made, however, in the note to *Bl* 1 in *Aspilogia II*. There is no corresponding entry in *Bb*. I have omitted the English blazons which appear under the French in this roll.

Ba 35 is omitted in the base manuscripts followed by Armytage and London and is listed separately by the latter only (p. 159). See also below, note to *Bb* 35.

2. Abbreviations

de arg., for *de argent:* 5, 24.
de gu., for *de gules:* 39.
er., for *ermin:* 9, 30 (cf. 41: *hermin*).
gu., for *gules:* 13, 34.
Joh, John (in both cases there is a horizontal stroke through the stem of the *h*), for *Johan:* 16 (the name *Johan* is spelled out: 12, 19, 23).
Le c., for *Le conte:* 1-11.
Willm (there is a horizontal stroke through the *l*'s), for *Willam:* 14 (the name *Willam* is spelled out with or without a horizontal stroke through the *l*'s and/or above the *a:* 15, 28, 44, 45, 47; cf. *Willarne* spelled out with a horizontal stroke through the *l*'s and/or above the *a:* 13, 26, 34, 36, 49, 54).

3. Numbers

3, for *treis:* 14, 26, 31, 43 (the word *treis* is spelled out: 15, 45, 51, 53, 55; cf. 1, 49: *treys*).
4, for *quatre:* 27.
Also:
for 1: *un* (4, 6, 7, 17, 26, 28, 34 [= *ũ bende*], 40, 50 [= *ũ bend*], 54), *une* (5, 9, 23, 24 [2], 42).
for 2: *deus* (4, 31, 33, 39, 44, 47, 48).
for 6: *siz* (4, 11), *sis* (12).
for 7: *set* (3), *sept* (10).

4. Notes

Aspilogia II, p. 120, note to item 29, erroneously states that the arms of William de Say appear as no. 20 in *Ba* and *Bb* (cf. p. 134, note to item 97). There is a similar error on p. 139, note to item 125 (neither *Ba* nor *Bb* has a no. 121).

Ba 5 – the blazon is *quarterly or and gules* in other versions of this roll; *Aspilogia II*, p. 116, note to item 11.

Ba 20-21 – *Aspilogia II*, p. 159: "This is a conflation of two items. It should read: *Roger de Someri d'or deus leopartz d'azur* (see B I. 97) *Le Comte de Maundevill esquartele d'or e de gules* (see B I. 19)." See also *Bb* 20-21.

Ba 24 – the verbal blazon and the accompanying painted shield place the escutcheon of Galloway within the Balliol orle; for the correct arms, see *Aspilogia II,* p. 122, note to item 37: "Balliol with the shield of Galloway over all in the sinister canton."

Ba 27 – on the name (Dakeny / d'Aubigny), see *Aspilogia II,* p. 124, note to item 46.

Ba 32 – the field is or and the roundels argent in certain later rolls; *Aspilogia II,* p. 125, note to item 52.

Ba 37 – in this version, as in one copy of Cooke's Version, an orle of sable martlets has been added; see *Aspilogia II,* p. 125.

Ba 44 – on the names (Mauduit / Martin), see *Aspilogia II,* p. 127, note to item 65. Cf. *Bb* 44.

Ba 50 – the field is argent and azure in other versions of this roll; *Aspilogia II,* p. 128, note to item 72.

B. *Copy b (Bb)*

[11 *b*]
1. Le conte de Cestre, d'azure treis garbes or.
2. Le conte de Leicestre, de gules a lion d'argent a la coue furché.
3. Le conte de Wyncestre, de gules a set mascles d'or.
4. Le conte d'Hereford, de azure au sis lionceux d'or ou un bend d'argent a deuz cotises d'or.
5. Le conte d'Oxenford, quartelé[1] de gules et or un molet argent.
6. Le conte de l'Isle, or a lion azure.
7. Le conte de Aubemarle, gules a crosse verry.
8. Le conte de Ferrers, verré d'or et de gules.
9. Le conte de Warwik, chequy or and azure a cheveron ermine.
10. Le conte de Kent, gules set mascles varry.
11. Le conte de Salesbury, d'azure a sis lionceux or.
12. Sire Johan de Plesis, d'argent sis fauses roeles gules.
13. William de Valence, barry argent et azure un urle d' merloz gules.
14. William Munchenesi, or treis escocheuns varry ou deux barres gules.
15. William d' Cantelu, gules treis flurettes or.
16. Johan le FizJohan, escartellé or et gules un bordur verry.
17. Gater de Clifford, chequy or et azure a bend gules.
18. Roger de Clifford, autel od la fesse de gules.
19. Johan de Vaus, chequy argent et gules.
20. Roger de Someri[2]
21. [William de Mandeville] ,[2] quarterly or et gules.
22. Warin de Bassingburne, girunné de or et d'azure.
23. Joan de Baylol, de gules od un faus escocheon argent.
24. Huwe de Bayloll, ut in margine.
25. Eustace de Turs, gules a faus escocheon argent a lambel or.
26. William de Evereus, de gules a une fesse d'argent et treis turteus argent in cheif.
27. Baudwin Dakeni, d'azure a crosse et quatre lionceux or.
28. William Marmiun, verry a fesse gules.
29. Peres de Bruse, d'argent a lion azure.
30. Robert de Tateshale, chequy argent et gules a cheife ermine.
31. Hue Wak, or deux barres gules treis turteus gules in cheif.
32. Robert de Stafford, d'argent a cheveron gules besanté d'or.
33. Robert de Nuelle[3], d'argent a deux bastiones de gules besanté d'or.
34. William de Beauchamp de Bedford, quartely or and gules a bend gules.
35. James d'Audley, de gules fretty d'or.
36. William de Bruse, d'azure a lion or a cruseles or semmy.
37. Patric de Cheures, barry argent et gules an urle of merloz sable.
38. Robert de Nevile, gules a saltier argent.
39. Gilberd Peche, argent deux cheverons gules a fesse gules.
40. Hamund Crevecuer, or un crois voydé d' gules.
41. Renaut de Moun, de gules a manche d'ermine.
42. Robert Augiulun, de gules un flur argent.

1. This word is nearly illegible except for the initial letter *q*.
2. *Roger de Someri quarterly or et gules*
3. The scribe initially wrote *Huelle* then made the *H* over into an *N*.

43. Rauf de Cameis, or a cheife gules treis turteus argent.
44. William Martyn, de argent deux barres gules. William Maudet port de mesme.
45. William de Roos, gules treis boous argent deux et une.
46. Robert, son filz, autel a lambel or.
47. William Daubeny de Bever, or deux cheverons gules a border gules.
48. Richard de Harecurt, d'or deux barres gules.
49. William Bardulf, d'azure treis cinquefoyles or.
50. Gilbert de Gaunt, barré or et azure a bend gules.
51. Thomas de Greilei, gules a treis bends or.
52. Roger de Mubrai, gules a lion argent.
53. Gilbert Hansart, gules treis esteiles argent.
54. William de Vescy, gules a crosse argent playne.
55. Renaud FitzPeirs, gules treis lionceux or.

Remarks

1. Concordance

Same as for *Ba*.

2. Abbreviations

A, for *argent*: 5, 25, 26, 42, 43, 45, 52, 53.
Ar, for *argent*: 13, 19, 23, 30, 37, 38, 54 (also *d'Ar*, for *d'argent*: 26; *de Ar*, for *de argent*: 44). The word *d'argent* is spelled out: 2, 4, 12, 29, 33.
B, for *azure*: 6, 9, 13, 29, 50 (the same letter represents *d'azure*: 1, 22, 27, 49). The word *d'azure* is spelled out: 11, 35; the words *de azure* are spelled out: 4.
G, for *gules*: 5, 7, 10, 12-17, 19, 21, 25, 28, 30, 31 (2), 32, 34 (2), 37, 38, 43-45, 47 (2), 48, 50-55 (also *de Gul.*, for *de gules*: 2, 3; *de G*, for *de gules*: 18, 35, 41). The words *de gules* are spelled out: 8, 23, 26, 33, 42; the word *d' gules* is spelled out: 40.
Gilbt (with a horizontal stroke through the last three letters), for *Gilbert*: 50 (the name *Gilbert* is spelled out: 53; cf. 39: *Gilberd*).
Le C:, for *Le conte*: 1-11 (cf. 6: *Le C*: d:).
Robt (with a horizontal stroke through the last two letters), for *Robert*: 30, 32, 33, 38, 42 (the horizontal stroke is omitted: 46).
*Rog*r, for *Roger*: 52 (the name *Roger* is spelled out: 18, 20).
sa, for *sable*: 37.
Tho., for *Thomas*: 51.
Willm (with a horizontal stroke through the *l*'s), for *William*: 34, 44, 45, 49 (the name *William* is spelled out: 13-15, 26, 28, 36, 47, 54; cf. 44: *W*m).
&, for *et*: 13, 16, 17, 19, 21, 22, 26, 27, 29, 37, 50. The word *et* is spelled out: 8 (see also *and*: 9, 34; cf. 37: *an urle of*).

3. Numbers

2, for *deux*: 14, 31, 39, 44, 47, 48 (the word *deux* is spelled out: 33; the word *deuz* is spelled out: 4).
2 & 1, for *deux et une*: 45.
3, for *treis*: 14, 15, 26, 31, 43, 45, 49, 51, 53, 55.
4, for *quatre*: 27.

6, for *sis*: 4, 11.
7, for *set* (the word *set* is spelled out: 3).
Also, for 1: *un* (4, 5, 13, 16, 23, 40, 42), *une:* 26.

4. Tricks

A. The complete coat of arms is drawn in the margin: 22, 24, 33, 50.
B. A single charge is drawn as part of the verbal blazon:
 (1) annulet: 12.
 (2) bend: 17, 34, 50, 51 (the word *bend* / *bends* is spelled out: 4, 51 [also in trick in the latter case]).
 (3) chevron: 9, 32, 47 (the word *cheverons* is spelled out: 39, 47 [in the latter instance, the chevron-like symbol for *er* superscribed over the *v* constitutes a trick]).
 (4) cross or crosslet: 7 (represents a cross paty; see *Aspilogia II*, p. 117, note to item 13), 36 (the words *a crosse* are spelled out: 27, 54; the words *un crois voydé* are spelled out: 40).
 (5) ermine (the fur): 9, 30, 41.
 (6) estoile or mullet (here a five-pointed star): 5, 53.
 (7) fleur de lis: 15, 42.
 (8) label of five points: 25, 46.
 (9) lioncel rampant: 11, 27, 55 (the word *lionceux* is spelled out: 4).
 (10) lion rampant: 6, 29, 36, 52 (the word *lion* is spelled out: 2).
 (11) martlet: 13, 37.
 (12) orle: 25 (the words *faus escocheon* are spelled out: 23; cf. 14: *escocheuns* [spelled out, but here an escutcheon]).
 (13) roundel: 26, 31, 43.
 (14) water-bouget: 45.
Where the charge depicted in trick is not blazoned elsewhere in this copy (viz. annulet, estoile or mullet, fleur de lis, label, martlet, orle, roundel, and water-bouget), the corresponding term found in *Ba* is used.

5. Notes

For the incorrect reference to the arms of William de Say in *Aspilogia II,* see the statement at the beginning of the *Notes* to *Ba.*
 Bb 20-21 – see above, note to *Ba* 20-21.
 Bb 22 – the marginal trick erroneously provides *A* (for *argent*) whereas *or* is correctly found in the verbal blazon (not noted in *Aspilogia II*, p. 121, item 35).
 Bb 24 – the marginal trick shows the shield of Galloway filling the voided escutcheon of Balliol; see above, note to *Ba* 24.
 Bb 35 – see above, *Concordance* to Copy *a*, for note to *Ba* 35.
 Bb 37 – see above, note to *Ba* 37.

\

III Walford's Roll

[12 a]

1. L'empereur de Almaine, d'or ung egle espany ove deux testes sable.
2. L'empereur de Constantinople, gules crusuly d'or un crois passant d'or a quatre rondells d'or in les quatre quarters et in chescun rondell un croisee.
3. Le roy de Almaine, d'or un egle displayé sable.
4. Le roy d'Engleterre, gules a trois leopards d'or.
5. Le roy de France, d'azure semé de florets d'or.
6. Le roy d'Espaigne, escartillé de gules un chasteau or et d'argent un leon rampant purpr.
7. Le roy de Aragon, paly d'or et de gules.
8. Le roy de Sicile, d'azure poudré a florets d'or un labell gules.
9. Le roy de Navarre, gules un carbuncle d'or.
10. Le roy de Boeme, d'argent un lion sable coronné d'or un crois sur l'espall.
11. Le roy d'Escoce, d'or un lion rampant et un borde floretté de gulez.
12. Le roy de Hungrey, d'or un estenzelé a trois leons passans[1] d'azure.
13. Le roy de Cypre, vert besantee un crois passant d'or.
14. Le roy d'Ermeny, d'or un leon rampant gulez un border gulez indentee.
15. Le roy de Denemark, d'or un beauff gulez.
16. Le roy de Norwey, gulez un chivall d'or sellé.
17. Le roy de Man, gulez a trois jambes armés argent.
18. Le roy de Portugall, gulez poudre turells d'or un labell d'azure.
19. Le auntient de Temple, d'argent un cheif sable un crois gulez passant.
20. Le auntient del Hospitall, gules un crois formy d'argent.
21. Llewellin ap Griffith, escartellé d'or et gules quatre leons de l'un et l'autre.
22. Le countee de Poiteres, party d'azure et de gulez l'azure poudré a floretts d'or le gulez poudré a turells d'or.
23. Le contee de Bretaigne, chequy d'or et d'azure un canton d'ermin un border gulez.

1. *estenzele a deux passans.*

24. Le countee de Blois, paly de veir et de gulez un cheif d'or.
25. Le countee de Abrenes, chequy d'or et d'azure un border gulez.
26. Le contee de Seint Paulle, paly de veir[2] et de gules a cheif d'or un labell d'azure.
27. Le contee d'Eu[3] d'azure billeté d'or un leon d'or.
28. Le contee de Flandres, d'or un leon rampant sable.
29. Le contee de Barre, d'azure poudré a florets d'or un labell gulez poudré a circle d'or.
30. Le contee Waldemode, burulé d'argent et de sable.
31. Le contee de Roussy, d'or un leon rampant d'azure.
32. Le countee Wandonie, d'argent un cheif d'azure un leon rampant gules.
33. Le countee Grauntpré, burulee d'or et gulez.
34. Le counte d'Alverne, d'or un ganfanon gulez.
35. Le counte de Forest, gulez un dolphin del mere d'or.
36. Le countee Sessenz,[4] d'or un leon rampant gulez un border entere gules.
37. Le contee de Guisnes, veiré d'or et d'azure.
38. Le countee de Henaud, cheverounnee de or et de sable.
39. Le countee de Tholosa, gules un crois patee percee d'argent un border d'or.
40. Le countee de Champanie, d'azure un bend d'argent cousteces d'or diaprés.
41. Le countee de Restell, gulez troiz rastells d'or.
42. Le county de Joeny,[5] gulez un egle d'argent.
43. Le county de Rige, d'azure un leon rampant barry d'argent et gulez coronne d'or.
44. Le countee de Guerd, gulez un bend d'argent a listes d'or.
45. Le contee de Bologne, d'azure un bend d'or deux leonceux rampanz d'or.
46. Le countee de Rummesvile, d'or trois roses harges ove trois roses vert.
47. Le countee de la Petit Piere, d'or un cheif gulez un cheverone argent sur le cheif.
48. Le conte Monjoye, argent un egle de veyre.
49. Le contee de Leonsteine, argent un leon rampant gules coronné d'or sous un mote d'azure.
50. Le countee de Albemarle, gules un crois patee de veire.
51. Le countee Patrick, gulez un leon rampant d'argent.
52. Le countee de Asceles, paly d'or et de sable.
53. Le countee de Marre, d'azure billetté d'or un bend d'or.
54. Le countee de Cestre, d'azure trois garbes d'or.
55. Le countee de Chalun, gulez un bend d'or.
56. Le countee de la March, burulee de argent et d'azure de un menue burules.[6]

2. *paly de veir.* The word *de* is superscribed between *paly* and *veir* with the aid of a caret.
3. *Le Contee D'en*
4. *Messenz.*
5. The name *Joeny* is underlined. A marginal note reads: *Polony.*
6. *burules de.* The word *de* was crossed out by the scribe.

57. Le counte de Valence, burulle d'argent et d'azure a merloz de gules bordeans.
58. Le countee de Cleve, gules un escocheon d'argent un carbuncle d'or[7] flurte.
59. Le countee de Lucemburg, burulee d'argent et d'azure un leon rampant gulez coronné d'or.
60. Le countee de Musoin, gulez un leopard rampand ove la cowe furché d'or.
61. Le countee de Monte, argent un leon rampant gulez la cowe croisé coronne d'or un laber d'or.
62. Le countee de Kiburc, gules un bend et deux leons rampanz d'or.
63. Le countee de Friburc, d'or un egle gulez un border veiree.
64. Le countee de Wirtenberg, d'or trois perch de daimes sable.
65. Le countee de Trerstein, d'or un bysse gulez.
66. Le counte de Whittingwen, veiré d'or et gulez un escotcheon d'azure un saultoir d'argent.
67. Le countee de Colestein, d'or un cheif sable.
68. Le counte de Vian, gules un egle espany d'or.
69. Signeur de Bilebatia de Try, d'or un bend gobony d'argent et d'azure.
70. Regnald de Try, d'or un bend d'azure un labell gulez.
71. Le countee Danmartin de Beleigne, barry d'argent et de azure un border gulez.
72. Le duk de Burgoine, bendy d'or et d'azure un border gulez.
73. Le duk de Breban, sable un leon rampant d'or.[8]
74. Le duk de Austrich, gules un fesse d'argent.
75. Le duk de Baveire, masculy d'argent et d'azure.
76. Le duk de Pouland, d'or un egle sable un cresçant in le petrine d'argent.
77. Le duk de Loraine, d'or un bend gulez troiz egletts d'argent in le bend.
78. Le duk de Luneburg, d'argent un leon rampant gules la cowe croyzé coronné d'or.
79. Geffry de Nevile, argent un sautour de gules.
80. John le FitzJohn, escartellé d'or et de gulez un border indenté d'argent et d'azur.
81. Guiliam de Breynin, d'or troiz peuz de gulez.[9]
82. William Hansard, d'azure trois mulletts d'argent.
83. William de Roos, d'azure trois bousses d'or.
84. John Commin, gules troiz garbes d'or.
85. Thomas de Clare, d'or trois cheverones gulez un labell d'azure.
86. Roger de Leyburne, d'azure a six leonceux d'argent.
87. William Longspee, d'azure a siz leonceaux d'or.
88. Son frere, autel a un cantell d'ermine.

7. *un carbuncle de flurte.*
8. Walford, p. 383, note *f*: "This name and coat are at the bottom of a column of the MS., and almost worn off. With the aid of [the printed version of Leland's copy] I read the fragments of the letters as above."
9. Walford, p. 384, note *a*: "*Azure* is added after *gulez* as if instead of it, and in the margin *Guy de Bryen*, apparently by a later hand."

89. Hernoll de la Wede, barry d'or et gulez fretty d'argent.
90. Henry de Barnam, lez armes de roy de France al cheif paly d'argent et de gulez.
91. Le sire d'Esegni, d'argent un crois sable a merlos sable bordeans.
92. Gualtier de Gistell, gulez un cheveron d'ermine.
93. Walter de Furnivall, d'argent un bend et siz merloz gulez.
94. Jehan de Gurney, d'argent un crois engrelé de gulez.
95. Peris Pigott, d'azure siz merloz d'or un bend engrelé d'or.
96. Richard FitzNicholl, d'azur un quintefoil d'or quinze escallops bordeants argent.
97. Wauter Estotevile, burellé d'argent et de gules trois leons rampanz sable.
98. Le countee de Hereford, d'azure siz lionceux d'or un bend d'argent les listes d'or.
99. Le countee de Cornewaile, d'argent un leon rampant gulez coronné d'or border sable besantee.
100. Le contee de Wincestre, gules poudré a faux losengez d'or.
101. Le contee de Pembroke, party d'or et vert un leon rampant gulez.
102. Le countee de Warwic, eschekeré d'or et d'azure un cheveron d'ermin.
103. Le counte de le Ille, gules trois barres d'or diasprés.
104. Roger de Mowbraye, gulez un leon rampant d'argent.
105. Robert de Ros, gulez a troiz buzes d'argent.
106. Hugh de Nevile, d'azure un leon rampant d'or.
107. Robert de Nevile, gules un sautour d'argent.
108. Geoffrey de Lucy, gules poudré a croisell d'or et troiz luz d'or.
109. Garin de Bassingburne, geronné d'or et d'azure.
110. Thomas Bardulfe, d'azure poudré a croisel d'or trois quintefoiles d'or.
111. William, son frere, d'azure trois quintefoiles d'or.
112. Fouk de Kerdeston, gulez un sautour engrellé d'argent.
113. Nicholas de Sanford,[10] undee d'argent et de gulez.
114. Richard de la More, escartellé d'argent et d'azure indenté.
115. Eustache de Baliol, gulez a un faux escocheon d'argent.
116. Jehan de Plescy, d'argent a trois mulletts[11] percees gulez.
117. Walter Belechamp, escartellé d'or et gulez und bend gulez.
118. Guy de Rochford, escartellé d'or et gules.
119. John de Berner, escartellé d'or et vert un labell gulez.
120. Raffe de Camois, d'or al cheif gulez trois gastells d'argent.
121. Walter Malduist, d'argent a deux barres de gules.
122. Ernauld de Boyes, d'argent a deux barres et un canton gulez.
123. Ingram de Merke, gulez un leon rampant d'argent.
124. Walter Martell, gules trois martells d'argent.
125. Geoffry de Gaunt, barré d'or et d'azure un bend gulez.
126. Waren de Montchensy, d'or a trois escocheons barry de veire et de gulez.

10. *Manford.*

11. Walford, p. 385, note *b*: "In the margin *anulettes credo*." The word *mulletts* is underlined and the marginal note actually reads: *Anuletts Cre,* part of the second word having disappeared when the edge of the page wore off.

127. Johan de Monemouth, d'or trois cheverones gulez un fesse d'argent.
128. Robert de Mortymer, barry d'or et de vert florettee de l'un et l'autre.
129. Gualtier de Fauconberge, sable un quintefoile d'argent a merloz d'argent bordeans.
130. Hugh Bigot, gules un leon passant d'or.
131. Rauff Bassett, palee d'or et gulez in un cantell d'argent un crois patee sable.
132. Raffe de la Haye, d'argent a ruell de gulez.
133. Alein de la Zouch, sable besantee[12] d'or.
134. Roger de Somery, d'or a deux leons d'azure.
135. Hugh Seingeine, gulez trois rouells d'or ung dansee d'or en cheif.
136. Geffry Tregoz, d'or deux gemells et un leopard in cheif gulez.
137. Geffrey de Segrave, sable a trois garbes d'argent.
138. Raffe Tattishalle, cheky d'or et gulez un cheif d'ermine.
139. Geffrey de Belchamp, escartellé d'argent et de sable.
140. William Boyvile, escartellé d'or et sable un leon passant gulez en le[13]
141. Jehan de Brus, d'or trois cheverones gules un border d'azure indentez.[14]

[12 b]
142. Roger de Mortymer, barry d'or et d'azure al cheif palee al cantel geronné un escocheon d'argent.
143. Marmaduk de Thweng, d'argent un fesse gules trois papegayes vert.
144. John de Burgh, masculee de veire et de gulez.
145. Johan Giffard, gulez troiz leons passantz d'argent.
146. Geffrey Genevile, d'azure al cheif d'ermine un leon recoupé de gulez, en le azure trois bresses d'or.
147. Robert de Clifford, cheky d'or et d'azure un fesse gulez.
148. William Crepin, d'argent trois barres de gulez engrellés.
149. Amary de Miland, sable un leon rampant d'argent a la queue fourché l'escue billeté d'argent.
150. Henry de Cheverouse, d'argent un crois gulez quatre leons rampanz d'azur.
151. Joan de Montmorency, d'or poudré de eglets d'azure un crois de gulez.
152. Baudwin de Frevile, de veire un crois passant gules.
153. William d'Oddingsells, d'argent un fes et deux rouells in cheif de gulez.
154. Robert Angenya, gules un florette d'or.
155. Philip Marmion, de veire un fesse de gulez.
156. Philip le FitzWarine, escartelé d'argent et de gulez indentee.
157. Edward Paveley, d'azure un crois d'or reserscelé.

12. *sable (forse gules) besantee.*
13. *en le.* The edge of the page is worn off but part of a letter (*p*?) and the superscribed sign for *-er* or *-re* are visible. The combination resembles the first part of the word *premier* in the incipit of the Falkirk Roll.
14. Walford, page 386, note *b*: "This name and coat are at the bottom of a column, and nearly worn off; but with the aid of [the printed version of Leland's copy] I read the fragments of the letters as above. In the margin opposite the name are a few words I cannot read, being almost obliterated."

158. Hugh le Hussey, barry d'ermyn et de gules.
159. Jehan de Seint John, d'argent a cheif de gulez deux rouells d'or en cheif.
160. Robert de Vaux, chequy d'argent et de gulez.
161. Baudewin Peche, veiré d'or et gules.
162. Peres de Meuclerk, d'azure trois quintefoyles d'argent.
163. Walter de Sein John, d'azure trois fermaulx d'or.
164. Walter de Burg, escartilé d'argent et gules un crois passant gulez.
165. Richard de Heselington, d'argent trois cressants sable.
166. Morice le FitzGerald, d'argent un sautour de gulez.
167. Richard Talbott, d'or un leon gules collered d'or un border vert besanté d'or.
168. Johan de Harecourt, gulez a deux barres d'or.
169. Hugh le Archevesque, burulé de un menue burlure d'argent et d'azure und bend gulez.
170. Geffry de Sergines,[15] gules un fesse d'or et un danse d'or en cheife.
171. Robert de Cresiques, d'azure al cheif d'or et trois gemells d'or.
172. Hugo de Bauçoy, d'or[16] un crois gules resercelé un labell sable.
173. Lancelot Sein Mark, d'argent un bend engrelé gulez un labell d'azure.
174. Eschelard de Monsyrolle, d'argent un bend gulez engrelé six escallops d'azure.
175. Thomas de Coucy, barry de veire et de gules un bend d'or.
176. Robert de Basseger, paly de verry et de gulez al cheif d'or un florete de sable.
177. William de Chavegn, d'argent un fesse engrelé gulez un labell sable.
178. Phillip de Montfort, gulez un leon rampant d'argent la cowe furché un labell d'azure.
179. Henry de Baunstersein, vert a trois faux losenges d'argent al cheif paly d'or et de gulez.
180. Gauter Bertram, palé d'or et de gules a un cantell d'azure un rouell d'argent.

Remarks

1. Concordance

Same as for *Cl*.

2. Abbreviations

Arg., for *argent:* 47-49, 61, 79, 96 (the word *argent* is spelled out: 17).
d'ar., for *d'argent: 39.*
d'arg., for *d'argent:* 6, 51, 58, 59, 66, 69, 71 76-78, 80, 90, 91, 93, 94, 98, 99, 104, 112, 114-116, 121-123, 129 (2), 131, 132, 145, 148-150, 153, 156, 169, 178, 179 (everywhere else, the word is spelled out: *d'argent* except 56: *de argent*).
ramp. (there is a horizontal stroke over the *p*), for *rampant:* 11, 14.

15. *Mergines.*
16. *Baucoy le Labyn vert* &. These words are underlined. A marginal note reads: *Inghams Cote.*

ramp., for *rampant:* 6, 28, 31, 36, 49, 51, 59, 61, 78, 99, 101, 104, 106, 123, 149, 178; for *rampanz* : 45, 62, 97, 150 (the word *rampant* is spelled out: 43; cf. 60: *rampand*; the plural form is nowhere spelled out; cf., however, 12: *passans;* 91, 129: *bordeans;* 96: *bordeants;* 145: *passantz;* 165: *cressants*).

Robt, for *Robert:* 176.

Robt (there is a horizontal stroke through the shafts of the last two letters), for *Robert:* 105, 107, 128, 154, 160, 171 (the name *Robert* is spelled out: 147).

sab., for *sable:* 91, 99 (the word *sable* is everywhere else spelled out).

S^t, for *Seint:* 26, 159 (cf. 164, 173: *Sein;* cf. also 135: *Seingeine*).

Walt, for *Walter:* 163, 164 (the name *Walter* is spelled out: 93, 117, 121, 124; cf. 97: *Wauter;* 92, 129: *Gualtier;* 180: *Gauter*).

Will (there is a horizontal stroke through the *l*'s), for *William:* 83, 177.

Willm, for *William:* 153 (the name *William* is spelled out: 82, 87, 111, 140, 148; cf. 81: *Guiliam*).

3. Numbers

3, for *trois:* 46, 64, 97, 110, 135, [141] (the word *trois* is spelled out: 4, 17, 46, 54, 82, 83, 85, 103, 111, 116, 120, 124, 126, 127, 137, 143, 146, 148, 162, 164, 165, 171, 179; cf. *troiz:* 41, 77, 81, 84, 105, 108, 145).

4, for *quatre:* 2 (2), 21, 150.

6, for *siz:* 98 (the word *siz* is spelled out: 87, 93, 95; cf. *six:* 86, 174).

15, for *quinze:* 96.

Also:

for 1: *un* (everywhere except 1, 135: *ung;* 117, 169: *und*).

for 2: *deux* (everywhere).

4. Tricks

A. Individual words in trick:

florets: 5 (the word *florets* is spelled out: 8, 29; cf. 22: *floretts;* 154: *florette;* 176: *florete*).

gastells: 120.

labell: 8 (in the latter two cases, the trick is added to the end of the verbal blazon which includes the word itself).

B. Marginal tricks of the entire shield: 167, 179.

5. Notes

C 12 – see the note to *Cl* 11.

C 14 – London errs in *Aspilogia II*, p. 171, when he states that this copy "omits the field tincture". It was inadvertently left out by Walford in his edition of this roll, but it is found in the manuscript.

C 29 – as pointed out by London in *Aspilogia II*, p. 174, this item is a conflation of two blazons; cf. *Cl* 30 and 31 (arms of Bar and Artois).

C 36 – for the emendation *Messens*] *Sessens*, see the note to *Cl* 38. Walford and London both read this word as *Messons*, but made the correction.

C 39 – the Toulouse cross should properly be *or*, not *argent* (*Aspilogia II*, p. 176).

C 42 – Charles's marginal note is in error; see *Aspilogia II*, p. 177.

C 46 – on this "incomprehensible" blazon, see *Aspilogia II*, p. 179.

C 48 – the tincture of the field should read *or*, not *argent* (*Aspilogia II*, p. 180).

C 58 – for the emendation *de*] *d'or*, see *Aspilogia II*, p. 190.

C 61 – the label should be *azure*, not *or* (*Aspilogia II*, p. 190).

C 81 – *Aspilogia II*, p. 181, apropos of the additions cited above in footnote 9: "It is not clear whether this emendation was due to Glover [sic, for Charles] or to an earlier scribe."

C 113 – see the note to *Cl* 38.

C 116 – *Aspilogia II*, p. 196: "this is evidently a copyist's gloss."

C 133 – *Aspilogia II*, p. 186: "The addition *forse gules* after *sable* in [this copy] must be Charles's emendation; it is supported by Glover's and other rolls."

C 138 – the name *Raffe*, instead of *Robert*, in this copy "may be a mistake" (*Aspilogia II*, p. 187).

C 140 – Walford, p. 386, note *a:* "When complete the conclusion was probably *premier cantell*."

C 170 – see the note to *Cl* 38.

C 171 – Walford and London (*Aspilogia II*, p. 201) both read this name as *Cresignes*, but the letters may also be read as *Cresiques*, a form which corresponds more closely to Old French *Creseques*.

C 172 – on the words *le Labyn vert* and Charles's marginal note, see the note to *Cl* 177 and *Aspilogia II*, pp. 201-202.

B. Leland's Version

1. Copy a (Cl)

[p. 897]

1. L'empereur de Alemaine, de or a un egle neyr a deus testes.[1]
2. Le rey de Fraunce, de asur poudré a flurette de or.[2]
3. Le roy d'Engleter, de goules a treys leparde de or.
4. Le roy d'Espaine, esquartilé de argent e de goule a deus chastelle de or en les quarter de goules, a deus liunceus d'azur en les quarters de argent.
5. Le roy de Cecyle, d'azur poudré a florettes de or a un lambeu de goules.
6. Le roy de Navar, de goules a un charbucle de or besancé.[3]
7. Le roy de Chastelle, de goules a un chastel de or.
8. Le roy d'Almayne, de or a un egle de sable.
9. Le roy d'Arrogon, palé de or e de goule.
10. Le roy de Boesme, de argent a un lion de sable coroné de or a un croyz d'or sur l'espaule.
11. Le roy de Hongerye, de or estenzelé a treis leuns passanz[4] d'azur.
12. L'emperour de Constantinople, de goule poudré a crosyle d'or a un croyz d'or passaunt a quatre roundeles d'or en quatre quarteres e en chekun roundelle un croysille.
13. Llewelin ab Griffin, esquartilé d'or e de goules a leparz de l'un e l'autre.
14. Le roy d'Acre, d'argent poudré a croysille d'or a une croyz d'or bylletté.
15. Le roy d'Eschosce, d'or a un lion de goule a un bordure d'or fluretté de goules.
16. Le roy de Chipre, de vert besanté de goule a un croyz d'or passant.[5]
17. Le roy de Norwey, de goule a un chevald d'or sellé.
18. Le roy de Denemark, d'or a un beuf de goule.
19. Le roy de Man, de goule a treys gambes armés o tutte le quisses et en chekun[6] cornere seyt une pee.

[p. 898]

20. Le roy d'Ermenye, d'or a un liun rampant de goule a un bordure de goule endenté.
21. Le baucent del Temple, d'argent al chef de sable a un croyz de goule passant.
22. Le baucent del Hospitale, de goule a un croyz d'argent fourmé.
23. Le counte de Poyters, party d'azur e de goule, per le goule poudré a turelles d'or, l'azur poudré a flurettes d'or.
24. Le counte de Bretaine, eschekeré d'or e d'azur a une kantelle d'ermine a un bordure de goule.

1. *a un egl* [corner of manuscript torn off] *deus testes.*
2. *a flurette de* [corner of manuscript torn off].
3. *lesance.*
4. *estenzele a deus passanz.* The lower part of the long s of *estenzele* has disappeared as a result of a small hole in the manuscript.
5. *passante.* The last letter was deleted by the scribe with a vertical stroke.
6. *et chekun.*

25. Le counte de Blaes, palé de veyr e de goule al chef d'or.
26. Le counte de Brenes,[7] eschekeré d'or e d'azur a une bordeur des goule.
27. Le counte de[8] Sein Paule, palé de veyr et de goule al chef d'or a une labeu d'azur.
28. Le counte d'Eu, d'azur billetté d'or a un liun d'or.
29. Le counte de Flaundres, d'or a une liun de sable raumpant.
30. Le counte de Bar, d'azur pudré a croisile d'or a deus bars de mere.
31. Le counte d'Artoys, d'azur pudré a florette d'or a une labeu de goule pudré a circle d'or.
32. Le counte Waldemond, burlé de une grose burlure d'argent et de sable.
33. Le counte de Russye, d'or a un liun rampant d'azur.
34. Le counte de Wandome, d'argent al chef d'azur a une lion raumpant de goule.
35. Le counte de Grantpré, a une menue burlure d'or e de goule.
36. Le counte d'Alverne, d'or a un gunfanun de gule.
37. Le counte de Forest, de goule a un dauffin de mer d'or.
38. Le counte Sessons,[9] d'or a une liun raumpant de goule a une bordure entere de goule.

[p. 899]
39. Le counte de Gynes, veyré d'or et d'azur.[10]
40. Le counte de Henaud, cheveroné d'or e de sable.
41. Le counte de Tolosa, de goule a un croyz d'or paté et persé a une bordure d'or.
42. Le counte Chaumpaine, d'azur a une bende d'argent a custeses[11] d'or diasprez.
43. Le counte de Restelle, de goule a treis rastelle d'or.
44. Le counte de Joeny, de gule a une egle d'argent.
45. Le counte de Rige,[12] d'azur a un liun raumpant barre d'argent et de goule coronee d'or.
46. Le duke de Breban, de sable a un lion rampant d'or.
47. Le duk d'Ostriche, de goule a un fesse d'argent.
48. Le duk de Bavaire, maclé de argent e d'azur.
49. Le duk de Poulane, d'or a un egle de sable a une cressant en la petryne d'argent.
50. Le duk de Loreyne, d'or a une bende de goule a treis egles d'argent en la bende.
51. Le duk de Luneburg, d'argent a un lion de goule rampant a la cowe[13] croyzé[14] e coronee d'or.

7. *brenes.* An *.A.* is superscribed over the *b*.
8. The word *de* is superscribed between *counte* and the abbreviation for *Sein*.
9. *Messons.* An *.S.* is superscribed over the *M*.
10. *et daz* [corner of manuscript torn off].
11. *custeres.*
12. *Rige.* An *.l.* is superscribed over the *R*.
13. *bowe.*
14. The third and fourth letters of *croyze* have disappeared as a result of a small vertical tear in the manuscript.

52. Le counte de Guerd, de gule a un bende d'argent a litte d'or fluretés.
53. Le counte de Belingne, d'azur a un bende d'or a deus liuncels d'or raumpante.
54. Le counte de Rampsvile, d'or a treis rosers sur chekune roser une rose chekune roser verte.
55. Le counte de la Petite Pierre, d'or al chef de gule a une chefrune d'argent en le chef.
56. Le counte de Munjoye, d'or a une[15] egle de veyr.
57. Le counte de Leonsteine, d'argent a une lion de goule coroné d'or estant sus une mote d'azur.
58. Geffrey de Neville, d'argent a une sautour de goule.
59. John le FizJohn, esquarteré d'or e de gule a un bordure endenté d'argent e de azur.
60. Le counte de Albemarle, de gule a une croyz de veyr.
61. Le counte Patriz, de gule a une liun rampant d'argent.

[p. 900]
62. Le counte de l'Ascele, palé d'or e de sable.
63. Le counte de Marre, d'azur byleté d'or a une bende d'or.
64. William de[16] Brequyn, d'or a treys peuz de goule.
65. Le counte de Cestre, d'azure a treys garbes d'or.
66. Alein Lasser, d'argent a chef de goule.
67. William Hansard, d'azur a treys molette d'argent.
68. William de Ros, d'azur a treys buz d'or.
69. Le counte Chaloun, de gule a un bende d'or.
70. John Comyn, de goule a treys garbes d'or.
71. Le counte de la Marche, burlé de une menue burlure d'argent e d'azur.
72. Le counte de Valence, burlé d'argente et d'azur a merloz de[17] goule bordeand.
73. Thomas de Clare, d'or a treys cheverouns de gule a une labeu d'azur.[18]
74. Roger[19] de Leyburne, d'azur a sis liuncels[20] d'argent.
75. Guillame Longespé, d'azur a sis liuncels d'or.
76. Soun[21] frer, autel a une cauntel d'ermin.
77. Hernol de la Wede, barré d'or e de gule fretté d'argent.
78. Henry de Bernam, les armes le roy de Fraunce al chef palé d'argent e de gule.
79. Le seyre d'Esegney,[22] d'argent a un croiz de sable a merlos[23] de sable bordeanz.

15. *Munjoye a une.*
16. The word *de* is superscribed between *William* and *Brequyn.*
17. *le.*
18. The scribe started the word *darg* (evidently for *d'argent*) then crossed it out and wrote *dazur.*
19. The fourth letter of *Roger* has partially disappeared as a result of a small hole in the manuscript.
20. *liunceuls.* The second last letter was deleted by the scribe with a vertical stroke.
21. *Moun.*
22. *Le Meyre de Segney.*
23. *merlor.*

80. Gaultier de Gistelle, a gule a un cheffron d'ermine.
81. Walter de Furnivalle, d'argent a un bende de gule a sis merlos[24] de gule.
82. John de Gurney, d'argent a une croyz de goule engarlé.
83. Perys Pigot, d'azur a sis merlos[25] d'or a une bende d'or engralé.
84. Richard FizNicol, d'azur a un quinfefoyl d'or as escalopes d'argent bordeauntz.[26]

[p. 901]
85. Walter de Stotevile, burlé d'argent e de goule a[27] treis cos de sable.
86. Geffrey de Gaunt, barré d'or e d'azur a un bende de gule.
87. Warin de Montchesy, d'or a treis escochons[28] barry de veyr et de gule.
88. John de Monemuth, d'or a treis cheverons de gule a une fesse d'argent.
89. Robertus de Mortimer, barrey d'or e de vert flureté de l'une e de aultre.
90. Gualter de Falconberge, de sable a une quintefoil d'argent a merlos[29] de argent bordiauz.
91. Hugh Bigot, de gule a un leun d'or passant.
92. Rafe Basset, palé d'or e de goulle a une cantel d'argent a une croys de sable patee en le cantelle.
93. Rauf de la Haye, d'argent a ruell de goule.
94. Aleyn de la Zouch, de sable[30] bezantie d'or.
95. Roger de Somery, d'or a deus leons d'azure.
96. Hugh Sengayne, de goule a treis rouelle[31] d'or a une dans d'or en le chefe.
97. Geffrey Tregoz, d'or a un leparde de gule en le chef a deus gymele de goule.[32]
98. Geffrey de Segrave, de sable a treys garbes[33] d'argent.
99. Robert de Tatishale, eschekeré d'or e de gule al chef armine.
100. William de Boyvile, esquartilé d'or e de sable a une leun passant de goule en le cantel d'or.
101. John de Brusse, d'or a treys cheverons de gule a une bod d'azur endenté.

24. *merlor.* The scribe first wrote *merlos de* then crossed these words out.
25. *merlor.*
26. *estapes dargent bordeauntz.* The letters *.c.* and *lo* were added by the scribe over the *t* and *ap* respectively of *estapes,* the *lo* with the aid of a caret. A letter before the *tz* of *bordeauntz* has been crossed out and is no longer legible.
27. *dargent e de g* [corner of manuscript torn off] *.iij. cos.*
28. *eschochons.* The fourth letter was deleted by the scribe with a vertical stroke.
29. *merlor.*
30. *gable.*
31. *ronelle.*
32. *mele de goule.* The scribe first wrote *mele* then added *gy* above the line before these letters. A five-or six-letter word beginning with *g* and ending with *ne* precedes *goule* but has been deleted by the scribe with a horizontal stroke.
33. Two additional letters at the end of this word have been scratched out by the scribe.

102. Roger de Mortymer, barré d'or et d'asur al chef palé al chantel geroné a un escochon[34] d'argent.
103. Marmaduke de Twenge, d'argent e une fesse[35] de gule a treys papagays.
104. John de Burgh, maclé de veyr et de goule.[36]
105. John Giffard, de goule a treis lions d'argent passantz.[37]

[p. 902]
106. Geffrey de Genevile, d'azur al chef d'ermine a un leun recoupé de goule, en l'azur treis bresses[38] d'or.
107. Robert de Clifford, eschekeré d'or e d'azur a une fesse de goule.
108. William Crepyn, d'argent a treys barres de goule engrellé.
109. Amary de Miland, de sable a un liun d'argent raumpant a la cowe furché l'escue byleté d'argent.
110. Henry de Chevrouse, d'argent a un croyz de gule a quatre liuns rampant d'azur.
111. John de Mountmorency, d'or poudré d'egle d'azur[39] a une croyz de goule.
112. Le duk de Burgoyn, bendé d'or e d'azur a une bordure de gule.
113. Le counte de Cleve, de goule a un eschochon[40] d'argent a une charbocle d'or flurté.
114. Le counte de Lucenburg, burlé d'argent e d'azur a une leun de gule rampant coroné d'or.
115. Le counte[41] de Musein, de goule au lapard d'or raumpant a la cowe furché.
116. Le counte del Monte, d'argent a un leon rampant de goule a la cowe croysé coroné d'or a une labeu d'azur.
117. Le counte de Kyburc,[42] de gule a un bend d'or a deus liuns rampant d'or.
118. Le counte de Friburc, d'or a un egle de gule a un bordure de veyr.
119. Le counte de Wircenberg, d'or a treis perche de deym de sable.
120. Le counte de Trersteyn, d'or a un byse de gule.
121. Le counte de Whitingwen, veiré d'or e de gule a une escuchon d'azur a un sautour d'argent.
122. Le counte de Colesteyn, d'or a un cherf de sable.
123. Le counte de Herford, d'azur a sis liuncels d'or a un bende d'argent lyte d'or.

34. *esbochon.*
35. *fes* [corner of manuscript torn off].
36. Only the first letter of this word remains, the corner of the manuscript being torn away.
37. *lions dargent* [corner of manuscript torn off]
38. *bresser.*
39. *degle e dazur.*
40. *eschoschon.* The sixth letter, a long s, has been deleted by the scribe with horizontal hatching.
41. The first letter of this word has disappeared as a result of a small hole.
42. The scribe first wrote *Ch* then crossed out these letters.

[p. 903]

124. Le counte de Cornwale, d'argent a un lion[43] raumpant de goule coroné d'or a une bordure de sable besanté d'or.
125. Le counte de Winchestre, de goule poudré a fause losenge d'or.
126. Le roy de Portugal, de goule poudré a turelle d'or a une labeu d'azur.[44]
127. Counte de Danmartyn de Boleyngne, barré d'argent et d'azur a une bordre de goule.
128. Misir Bilebaud[45] de Trie, d'or a une bende goboné d'argent et d'azure.
129. Reynalde de Trie, d'or a un bende d'azur a un label de gule.
130. Le counte de Vian, de gule a une egle d'or.
131. Roger de Moubrey, de gule a un leun raumpant d'argent.
132. Robert de Ross, de goule a treis buz d'argent.
133. Hugo de Nevile, d'azur a un leon raumpant d'or.
134. Geffrey de Luscy, de goule poudré a croisil d'or a treis luz d'or.
135. Robert de Nevile, de goule a une sautor d'argent.
136. Garin de Bassingburn, geroun d'or et d'azur.
137. Thomas Bardulf, d'azur poudré a croisil d'or e treis quintefoile d'or.
138. Guillame, sun frer, d'azur a treys quintefoile d'or.
139. Fouke de Karketon, de gule et un sautor d'argent engrallé.
140. Nicolaus de Sanfort,[46] undé d'argent e de goule.
141. Richard de la Moore, esquartilé d'argent et d'azure endenté.
142. Eustache de Bailiol, de goule a un faus eskochin[47] d'argent.
143. Le counte de Pennebrok, party d'or e de vert a un lion raumpant party de or e de gule en lunge.
144. Le counte de Warwik, eschekeré d'or e d'azure[48] a un cheveron d'ermine.
145. John de Plescy, d'argent a treis molette de goule percés.[49]

[p. 904]

146. Le counte de l'Ille, de goule a treis barres d'or diasprez.
147. Walter Belchaump, esquartilé d'or e de goule a un bende de gule.
148. Guy de Rocheforte, esquartilé d'or et de gule.
149. Jon de Berner, esquartilé d'or et de verte a une labeu de gule.
150. Geffrey de Belchaump, esquartilé d'argent e de sable.
151. Rafe de Camoys, d'or al chef de goule a treis gastelle d'argent en le chef.
152. Walter Maldust, d'argent a deus barres de gule.

43. The words *a un lion* are nearly completely effaced.

44. *labeu lazur.* The word *bende* precedes *labeu* but was deleted by the scribe with two horizontal strokes.

45. *Mi Mir Bilebatid.*

46. *Manford.* A *.t.* is superscribed above the letter *d* which is expunged.

47. *faus eskochin.* Two letters between the *fa* and *us* of the first word have been deleted with horizontal strokes by the scribe and are now illegible. The last letter of the second word has now disappeared, the edge of the page having worn away.

48. The scribe started the words *et dar* (evidently for *et d'argent*) then crossed them out and wrote *e dazure.*

49. *molette d* [corner of manuscript torn off] *perces.*

153. Arnald del Boyis, d'argent a deus barres de goule a une kantel de goule.
154. Ingram del Merk, de gule a une lion raumpant d'argent.
155. Walter Martel, de goule a treis martelle d'argent.
156. Baudewin de Friville, de veyr a une croyz passant[50] de goule.
157. Wiliam d'Odingcele, d'argent a une fesse de gule a deus rouele de gule en le chef.
158. Robert Angevyn, de gule a une florette d'or.
159. Philip Marmion,[51] de veyr a une fesse de gule.
160. Edwarde de Paveley, d'azure a un croys d'or rescerselé.
161. Hugh le Huse, barré d'ermine e de gule.
162. Philip le FizMarmion, ecartilé[52] d'argent e de goule endenté.
163. John de Sein John, d'argent a chef de goules a deus roueles d'or en le chef.
164. Robert de Vausse, eschekeré[53] d'argent et de gule.
165. Bawdewin Peche, veyré d'or e de gule.
166. Bawdewin de Creyke, d'azur a une manche d'ermine.
167. Peres de Meuclerk, d'azur a treys quintefoile d'argent.

[p. 905]
168. Walter de Sein John, d'azur a treis fermas d'or.[54]
169. Walter de Burg, eskartilé d'argent et de goule a une croyz[55] de gule passant.
170. Richarde de Haselington, d'argent a treis cresçantz[56] de sable.
171. Morice le FizGerald, d'argent a un sautour de goule.
172. Richard Talbot, d'or a un leon de goule a une color d'or a une bordure de vert besanté d'or.
173. John de Harcourte, de gule a deus barres d'or.
174. Hugh l'Archevesk, burlé de une menue burlure d'argent et d'azure a une bende de gule.
175. Geffrey de Sergynes, de gule a une fesse d'or et une danse d'or[57] en le chef.
176. Robert de Creseques, d'azur al chef d'or a treis gemelle d'or.
177. Hugh de Bauçoy, d'or[58] a une croyz de goule recerselé a une labeu de sable.

50. The sixth letter of *passant* is missing as a result of a small hole in the manuscript.
51. *Marmionn.* The seventh letter was deleted by the scribe with a vertical stroke.
52. *ebartile.*
53. *eskere.* The letters *che* are superscribed over the *sk* of this word.
54. *Walter de Meiniohn dazur a treis ferma* [corner of manuscript torn off]. One stroke of another letter following the *a* of *ferma* may also be seen.
55. *dargent et de* [corner of manuscript torn off] *a une croyz.*
56. *dargent e de goule* [the last three words were deleted by the scribe with a horizontal stroke; a corner of the manuscript is torn away after these words] *crescantz.*
57. *Geffrey de Mergynes de gule a une fesse dor et une dazur dor a.* The last word was deleted by the scribe with horizontal strokes and the preceding word is superscribed above it with the aid of a caret.
58. *le labiau verte dor.*

178. Launcelot de Sein Mark, d'argent[59] a un bende de gule engrallé a une labeu d'azur.
179. Eschalard de Monttyrelle, d'argent a une bende de gule engrallé a sis escalopes d'azur.
180. Thomas de Coscy, barré de veyr e de gule et une bende d'or.
181. Robert de Basseches,[60] palé de veyr et de gule al chef d'or a une flurette de sable recoupé.
182. William de Chavegn, d'argent a une fesse de goule engrallé a une labeau de sable.
183. Philip de Mountfort, de goule a un leon[61] d'argent a la cowe furché a une labeu d'azure.
184. Henry de Bausterseyn, de vert a treis fause losenges d'argent al chef palé d'or e de goules.
185. Gauter Bertaut, palé d'or et de gule a une cauntel d'azur a une rouel[62] d'argent.

Remarks

1. Concordance

C: Weston Styleman Walford, "A Roll of Arms of the Thirteenth Century," *Archaeologia,* 39 (1864), 373-388.

Cl	Cd	C	Cl	Cd	C	Cl	Cd	C
1	1	1	21	38	19	41	19	39
2	2	5	22	39	20	42	20	40
3	3	4	23	40	22	43	21	41
4	4	6	24	41	23	44	22	42
5	5	8	25	42	24	45	23	43
6	6	9	26	43	25	46	24	73
7	7	–	27	44	26	47	25	74
8	8	3	28	45	27	48	26	75
9	9	7	29	46	28	49	27	76
10	10	10	30	47	29	50	28	77
11	11	12	31	48	29	51	138	78
12	29	2	32	49	30	52	139	44
13	30	21	33	50	31	53	140	45
14	31	–	34	12	32	54	141	46
15	32	11	35	13	33	55	142	47
16	33	13	36	14	34	56	143	48
17	34	16	37	15	35	57	144	49
18	35	15	38	16	36	58	145	79
19	36	17	39	17	37	59	146	80
20	37	14	40	18	38	60	147	50

59. *de Meinmark dargent.* A part of the letter *a* of the last word has disappeared as a result of a small hole.
60. *Basseges.* The letters *ch* are superscribed above the *g.*
61. *a une bende.*
62. *ronel.*

Cl	Cd	C		Cl	Cd	C		Cl	Cd	C
61	148	51		105	115	145		149	82	119
62	149	52		106	116	146		150	83	139
63	150	53		107	117	147		151	84	120
64	151	81		108	118	148		152	85	121
65	152	54		109	119	149		153	85	122
66	153	–		110	120-1	150		154	86	123
67	154	82		111	122	151		155	87	124
68	155	83		112	123	72		156	88	152
69	156	55		113	124	58		157	89	153
70	157	84		114	125	59		158	90	154
71	158	56		115	126	60		159	91	155
72	159	57		116	127	61		160	92	157
73	160	85		117	128	62		161	93	158
74	161	86		118	129	63		162	94	156
75	162	87		119	130	64		163	95	159
76	163	88		120	131	65		164	96	160
77	164	89		121	132	66		165	97	161
78	165	90		122	133	67		166	98	–
79	166	91		123	134	98		167	99	162
80	167	92		124	135	99		168	100	163
81	168	93		125	136	100		169	66	164
82	169	94		126	137	18		170	67	165
83	170	95		127	51	71		171	68	166
84	171	96		128	52	69		172	69	167
85	172	97		129	53	70		173	70	168
86	173	125		130	54	68		174	71	169
87	174	126		131	55	104		175	72	170
88	175	127		132	56	105		176	73	171
89	176	128		133	57	106		177	74	172
90	177	129		134	58	108		178	–	173
91	101	130		135	59	107		179	–	174
92	102	131		136	60	109		180	–	175
93	103	132		137	61	110		181	–	176
94	104	133		138	62	111		182	–	177
95	105	134		139	63	112		183	–	178
96	106	135		140	64	113		184	–	179
97	107	136		141	65	114		185	–	180
98	108	137		142	75	115				
99	109	138		143	76	101				
100	110	140		144	77	102				
101	111	141		145	78	116				
102	112	142		146	79	103				
103	113	143		147	80	117				
104	114	144		148	81	118				

2. Abbreviations

Gul., for *Guillame:* 75, 138.
S., for *Sein:* 27 (the name *Sein* is spelled out: 163, 168; cf. 178: *Meinmark* [i.e. *Sein Mark*]).
6., for *en le:* 55, 92, 96, 97, 100, 151, 157, 163, 175.

3. Numbers

ii, for *deus*: 97, 117 (the word *deus* is spelled out: 1, 4 [2], 30, 53, 95, 152, 153, 157, 163, 193).

iii, for *treis*: 85, 87, 88, 96, 106, 119, 184 (the word *treis* is spelled out: 43, 50, 54, 132, 134, 137, 145, 146, 151, 155, 168, 176 [cf. 11 and 170]; the word *treys* is spelled out: 3, 19, 64, 65, 67, 68, 70, 73, 98, 101, 103, 108, 138, 167; cf. *3*: 105).

4. Notes

Cl 1 – the printed version of Leland's copy reads: *Lempereur de Alemaine de or a un egle peyr a deus testes.* Max Prinet, "Armoiries françaises et allemandes décrites dans un ancien rôle d'armes anglais," *Le Moyen Age,* 2ᵉ série, 25 (1923), 225, proposes the emendation *peyr] neyr* (for *neir* 'sable'), pointing out, however, that the scribe everywhere else uses the form *sable* for this tincture. We have accepted this emendation although it does not offer an entirely satisfactory solution. London in *Aspilogia II,* p. 167 substitutes the corresponding blazon in *C* but reads *a* instead of *ove* for prepositional consistency.

Cl 2 – the tincture of the fleurs-de-lis is taken from the printed version of Leland's copy.

Cl 6 – Prinet, p. 226, first recognized *lesance* as a scribal error for *besanté;* we have preferred to keep changes to a minimum by emending to *besancé.* *Aspilogia II,* p. 167, adds a superfluous *d'or* at the end of this blazon.

Cl 11 – *Aspilogia II,* p. 169, proposes the following emended blazon: *Le Roy de Hongerye de or estenzele a deus [leons] passans d'azur,* the only change being the addition of the word *leons.* London accepts the brilliant deduction by Dr. Paul Adam-Even that the arms are in reality those of Denmark (*or, semy of hearts gules, three lions passant azure*). I am proposing a further refinement by suggesting that the missing word is *treis* and that *deus* should be read as *leuns* (representing an original *leūs* 'lions'). Even so, the blazon may still be incomplete unless we are to assume that the tincture of the sparks (see *Early Blazon,* s.v. *estencelé*) is the same as that of the lions passant, that is *azure.*

Cl 13 – London adds the superfluous word *quatre* between the words *a leparz* in this blazon (*Aspilogia II,* p. 169).

Cl 31 – Prinet, p. 30: "*Circle* est-il pour *turelles* ou pour *chastels?* Je ne sais." *Aspilogia II,* p. 174: "it should be *chasteles.*" Cf. *Cd* 48: *cerele.*

Cl 38 – *Aspilogia II,* p. 175: "This is one of several cases where the capitals *S* and *M* have been confused." See also Prinet, pp. 232, 245, n. 1. Other errors made by this scribe include reading *b* for *c, n* for *u,* and *r* for *s.*

Cl 39 – the word *d'azur* has been completed with the aid of the printed version of Leland's copy.

Cl 42 – for the emendation *custeres] custeses,* see above, note to *Cl* 38; Prinet, p. 234. *Aspilogia II,* p. 176, emends to *custeces.*

Cl 51 – for the emendation *bowe] cowe,* see above, note to *Cl* 38; Prinet, p. 236.

Cl 56 – for the addition of the tincture of the field (*d'or*), see Prinet, p. 239; *Aspilogia II,* p. 180.

Cl 76 – for the emendation *Moun] Soun,* see above, note to *Cl* 38.

Cl 79 – for the emendations *Meyre] seyre* and *merlor] merlos,* see above, note to *Cl* 38. On the title, cf. *Cl* 128.

Cl 81 – for the emendation *merlor] merlos,* see above, note to *Cl* 38.

Cl 85 – the word *goule* has been completed with the aid of the printed version of Leland's copy which reads *goules.*

Cl 90 – for the emendation *merlor] merlos,* see above, note to *Cl* 38.

Cl 96 – for the emendation *ronelle] rouelle,* see above note to *Cl* 38. *Aspilogia II,* p. 186: "The blazon in all three copies [i.e. *Cl, Cd,* and *C*] appears to mean

three pierced molets with a dance in chief, but such a coat is otherwise unknown. All three copies write the surname with a capital *S*, but the name must be d'Engaine." Cf., however, *Cl* 175 (*Sergines*) where the surname and blazon are strikingly similar.

Cl 102 – for the emendation *esbochon*] *escochon*, see above, note to *Cl* 38.

Cl 103 – the word *fesse* has been completed with the aid of the printed version of Leland's copy.

Cl 104 – same as note to *Cl* 85.

Cl 105 – the word *passantz* is taken from the printed version of Leland's copy.

Cl 106 – for the emendation *bresser*] *bresses*, see above, note to *Cl* 38.

Cl 111 – the conjunction *e* which follows *d'egle* in Leland's copy is indicated as superfluous by Prinet, p. 243, and *Aspilogia II*, p. 189.

Cl 115 – Prinet, pp. 244-245: "Le nom est tellement défiguré que, si nous n'avions pas une bonne description des armes, nous ne saurions le reconnaître. C'est celui du comte de Sayn; il devait être othographié primitivement 'su Sein' (zu Sayn) puis écrit par erreur 'Susein'. On sait que la maison de Sayn tire son nom d'une localité voisine de Coblence." Cf. *Aspilogia II*, p. 190.

Cl 122 – *Aspilogia II*, p. 192, emends *cherf* to read *chief*, but the identification of these arms is uncertain; cf. Prinet, p. 248.

Cl 124 – the words *a un lion* were read with the aid of the printed version of Leland's copy.

Cl 126 – for the emendation *lazur*] *d'azur*, see *Aspilogia II*, p. 193.

Cl 128 – London in *Aspilogia II*, p. 194, reads the name as *Mi Mir Bilebatind* and emends to *Signeur de Bilebatia*, borrowing the orthography found in *C* 69. I see no reason, however, for rejecting the suggestion made by Prinet, p. 249: "Il faut lire: 'Mi sir Bilebaud de Trie'," *misir* or *misire, messire* being a common title used when referring to high-ranking individuals. See Lucien Foulet, "Sire, Messire." *Romania*, 71 (1950), 1-48, 180-221; 72 (1951), 31-77, 324-367, 479-528. The title is used repeatedly in the Camden Roll and in the Chifflet-Prinet Roll. Cf. also *Cl* 79 (*Le seyre d'Esegney*).

Cl 140 – same as note to *Cl* 38.

Cl 142 – the word *eskochin* has been completed with the aid of the printed version of Leland's copy.

Cl 145 – same as note to *Cl* 85.

Cl 162 – for the emendation *ebartile*] *ecartilé*, see above note to *Cl* 38.

Cl 168 – the words *fermas d'or* were taken from the printed version of Leland's copy which reads, however: *a treis fermar dor*. On the emendation *fermar*] *fermas* (for *fermaus*, the oblique plural of Old French *fermail* 'buckle'), see above, note to *Cl* 38. *Aspilogia II*, p. 200, emends as follows: *a treis fermaulx d'or*, evidently relying on *C* 163 (*fermaulx*). For the emendation *Meiniohn*] *Sein John*, see again note to *Cl* 38.

Cl 169 – same as note to *Cl* 85.

Cl 170 – the words *a treis* were taken from the printed version of Leland's copy.

Cl 175 – for the emendation *Mergynes*] *Sergynes*, see above, note to *Cl* 38. Prinet, p. 251: "*Dazur* est pour *dance*, nom de la fasce vivrée, ou vivre." *Aspilogia II*, p. 201, proposes the orthography *danse* which we have retained here (cf. *Cl* 96: *a une dans*).

Cl 177 – Prinet, p. 252, n. 5, referring to the words *le labiau verte*: "Note corrective qui se rapporte aux derniers mots de la description et que le copiste n'a pas comprise." See also *Aspilogia II*, p. 202.

Cl 178 – for the emendation *Meinmark*] *Sein Mark*, see above, note to *Cl* 38.

Cl 183 – Prinet, p. 255: "Au lieu de 'une bende', c'est 'un lion' qu'il faut lire." See also *Aspilogia II*, p. 203: *a un leon* (we have retained the latter orthography).

Cl 185 – for the emendation *ronel*] *rouel*, see above, note to *Cl* 38.

2. Copy b (Cd)

[9 a]
1. L'empereur d'Alemaigne, or a un egle a une teste sable.
2. Le roy de France, azur semé flour de lis or.
3. Le roy d'Angletere, de gules treys leopards or.
4. Le roy d'Espayne, de gules un chasteaus d'or, pour Lion[1] d'argent un lion de pourple.
5. Le roy de Sicille, azur semé flor de lis or a labeal gules.
6. Le roy de Navare, de gules a un scharbucle or bezancé.[2]
7. Le roy de Castile, gules a chastel or.
8. Le roy d'Alemaine, or a un egle sable.[3]
9. Le roy d'Aragon,[4] palé d'or e de gules uit pieces.
10. Le roy de Bowheme, d'argent a ung lion de sable corone or a une crosse or sur l'esspaule.[5]
11. Le roy de Hugarie, de or estenzelé de gules a treys lions passanz coronés.[6]
12. Le conte de Wandom, argent cheif[7] azur une lion rampant gules.
13. Le conte de Granpré, a une menue[8] burlure or e de gules.
14. Le conte d'Alwerne, or a une gunfanun[9] gules.
15. Le conte de Forest, gules a dolfin or.
16. Le conte de Sessons,[10] or a lion rampant gules a bordoure entere gules.
17. Le conte de Guissnes, veiré d'or e azur.
18. Le conte de Henaut, cheveroné or e sable.
19. Le conte de Tolose, gules a crosse patté e percee une[11] bordoure d'or.
20. Le conte de Champayne, azur a une bende d'argent a custices or diasprés.[12]
21. Le conte Restel, gules a treys rastels d'or.
22. Le conte de Joeny, gules a n'egle argent.
23. Le conte de Rige, azur a lion rampant barré argent e gules crounnet or.
24. Le ducke de Brabannt, sable a lion or.
25. Le duck de Ostrich,[13] gules a fese argent.

1. This word is underlined in the manuscript.
2. *lozence.*
3. After *egle,* the scribe wrote a word, then crossed it out and superscribed the letter s (for *sable*) before it with the aid of a caret.
4. The word *daragon* is written below a first attempt to write this name which was corrected in a number of places then crossed out by the scribe.
5. The last letter of this word is a blot.
6. *a ij passanz roron'.*
7. *ar cheif.* One or two letters between these two words have been crossed out.
8. After *menue,* the scribe wrote *bordure* then crossed it out.
9. The scribe first wrote *gunffanun* then drew two vertical strokes through the second *f* to delete it.
10. *Dessone.*
11. *percee une.* Before the second of these two terms, the scribe started a different word then drew two vertical strokes through the single letter he wrote.
12. *clistires or erasrer.*
13. *ostrib.*

26. Le ducke de Baviere, masclé azur e argent.[14]
27. Le ducke de Poulanne, d'or a une aigle de sable a cressannt in la peitrine[15] argent.
28. Le duck de Lorangne, or une bende gules a treys eigles argent sur[16] le bende.
29. L'empereur de Constantinoble, de gules[17] poudré a crosyle d'or a ung croyz or passant a quatre bessannts in quatre quarteres in cheschun bessannt ung croshylle gules.
30. Lewelyn ab Griffyn,[18] esquartlé d'or et de gules a liepard de l'ung in l'authre.
31. Le roy de Acre,[19] d'argent poudré a croysile d'or a une croys d'or billeté.
32. Le roy d'Eschosce, d'or a un lion de gules a une bordur d'or floretté gules.
33. Le roy de Scypre, de verte bessannté de gules une croyz d'or passant.
34. Le roy de Norvey, de gules a un shaivall d'or sellé.
35. Le roy de Dennemarche, d'or a une beuff de gules.
36. Le roi de Man, de gules a treys gambes armés o tute les quisses chekune quysse joynte a autre et en[20] schekune cornere seyt un pee.
37. Le roy d'Armynye,[21] d'or a une lion rampant[22] de gules a une bourdoure de gules endentit.
38. Le baron del Temple, d'argent le cheif de sable a une croiss de gules passannt.
39. Le baucent[23] del Hospital, de gules a une croiss d'argent formé.
40. Le conte de Peisters,[24] party azur e de gules,[25] par le gules poudré a turelles[26] d'or, l'autre poudré a flouretes[27] d'or.

14. *caltele az ar.*

15. *first* or *firse.*

16. *3 eigles sur.* After *3,* the scribe started a new word then crossed it out before writing *eigles sur.* He then superscribed the letters *ar* (for *argent*) between the latter two words with the aid of a caret.

17. After *g* (for *gules*), the scribe wrote two words (*semé de?*) then crossed them out.

18. The scribe first wrote *Lonnevyn,* then expunged the letters *o, nn,* and *v,* superscribing these with *e, w,* and *l,* respectively. Above *ab Griffyn,* two other words are written which may be *de Gales* although this is not certain.

19. *bcre.* The *b* is expunged and superscribed with the letter *A*

20. *ben.* This word doubtless represents & *en.*

21. The scribe first wrote *dermynye* then expunged the second letter of this word and added an *a* above it.

22. The last letter of this word has disappeared as the edge of the page is worn off.

23. The letter *b* which begins this word appears to be expunged.

24. *Poisters.* An *e* is superscribed above the *o* which is expunged.

25. & *g.* The word *de* is superscribed between the two letters with the aid of a caret.

26. *tupelles.*

27. The scribe first wrote *flour de lis* then crossed out the last letter of *flour* and the two words which follow it. The letters *retes* are superscribed above the cancelled words.

41. Le conte de Bretayne,[28] eschaker d'or et azur a une canton d'ermyn a une bourdour gules.
42. Le conte de Blaes, palé de veyr e de gules al chef d'or.
43. Le conte de Brenes, eschaker d'or e azur a bourdure de gules.
44. Le conte de Seynt Poul, palé de veire e de gules al chef or a label argent.
45. Le conte d'Eu, azur belletté a une lion d'or.
46. Le conte de Flandres, or a lion rampannt sable.
47. Le conte de Bar, azur pudré a croysile d'or a deus bars de mer.
48. Le conte d'Artois, pudré a florette d'or a un label[29] de gules pudré cerele d'or.
49. Le conte de Waldemond, burlé de un grosse burlure argent e sable.
50. Le conte de Russye, or[30]

[*9 b*]
51. Le conte[31] Dammartyn de Bouloingne, barré d'argent et d'azur a bourdour gules.
52. Myssire Bibeald[32] de Trie, d'or a une bende goboné[33] d'argent e d'azur.
53. Reynald de Trie, d'or a une bende d'azur a une labbele de gules.
54. Le conte de Vyan,[34] de gules a un egle or.
55. Roger de Mowbrey,[35] de gules a lion argent ranpant.
56. Robert de Rosse, de gules a treys buges argent.
57. Huge de Newille, d'azur a une leon or rampant.
58. Geffrey[36] de Lascy, de gules poudré a crosyl d'or a treys luz d'or.
59. Robert de Newille, gules a saulter argent.
60. Garyn de Bassyngburne, geroné or e azur.[37]
61. Thomas[38] Bardolf, azur semé crossill or[39] a treys cynquefoles d'or.
62. Wilam, his brother, azur treys cynquefoyeles or.
63. Fouke de Karquetone,[40] de gules a saulter engreled argent.
64. Nycholl de Sanfford, undé argent e gules.[41]
65. Richard de la More, eschartelé argent e azur endentit.

28. *Briayne.*
29. *la.* The last part of this word is missing as the edge of the page is torn off.
30. Parts of these words, which are nearly illegible as the bottom of the page has worn off, were restored with the aid of the corresponding blazon in *Cl.*
31. The last letter of this word is rubbed.
32. *Bibeard.* An *l* (or *e*) is superscribed above the *r.*
33. *bende gobone.* The scribe first wrote *de* after *bende* then crossed it out. The first two letters of *gobone* are a blot.
34. *byanb.* There is a horizontal stroke over the *a* and the last letter is crossed out.
35. *Roger de Mowbrey.* Before this name, the scribe wrote *Robert* then crossed it out. Between *de* and *Mowbrey* another false start was crossed out.
36. *Greffrey.*
37. *Wassyngburne gerone or az.*
38. A *t* is superscribed above the *m.*
39. This word is superscribed above another word or letter which is crossed out.
40. *barquerone.*
41. *Manfford unde ar g.* The conjunction *e* is superscribed between the last two words with the aid of a caret.

66. Walter de Burghe, esquarterlé d'argent e de gules a une croise de gules parssannt.
67. Richard de Haschlyngton, argent a treys[42] cresannts sable.
68. Moris le FizGerard, d'argent a une[43] saulter de gules.
69. Richard Tabot, d'or a un leon de gules a un colier or a un bourdur de ver bessannté.
70. Jon de Harcourte, de gules a deus barres or.
71. Huge l'Archewecke, burlé de une menue burlure d'argent e de azur a une bende de gules.
72. Geffre de Sergines,[44] de gules a une fees d'or a une dance[45] d'or en le cheif.
73. Robart de Creseques, d'azur a chief d'or a treys gemes d'or.
74. Huge de Bauçoy, a une crosse gules[46]
75. Eustasche[47] de Baylyoll, gules a une faus eskochun[48] argent.
76. Le conte de Pennebrok, party d'or e de vert a lyon rampant party de or e de gules en lung.[49]
77. Le conte de Warwik, eschekeré d'or e azur a une cheveron d'ermyne.
78. Jon de Plescy, argent treys mouletts gules perceys.
79. Le conte de Ylle, de gules a treys barres d'or diasprés.
80. Walter de Beuchampe, esquarterlye d'or e gules a une bende de gules.
81. Guy de Rocheforte,[50] esquarteley d'or e[51] de gules.
82. Jon de Berner, esquarterlé d'or et vert a une labeau de gules.
83. Geffrey de Belchamp,[52] esquarterlé argent e sable.
84. Rauff de Camoys,[53] or a cheif de gules a treis gasteles[54] argent en le chief.
85. Walter Maldust,[55] argent a deus barres gules.[56]
85. *bis.* [Ernald de Boys] a un cantell de gules.[56]
86. Yngram del Merk, de gules a un lion rampant argent.
87. Walter Martell,[57] de gules a treys martels[58] d'argent.
88. Baudewyn de Fruyll, de veyr a une croyes passant de gules.

42. *ar 3.* The letter *a* is superscribed between these two words with the aid of a caret. See below, note to *Cd* 66-69.
43. The tail of the *n*, which extends a little below the line, is crossed out.
44. *Mergines.*
45. *dame.*
46. *ge de baucoy d le labiau a une crosse g.* The entire blazon is nearly illegible as the bottom of the page is badly damaged from wear. There are words crossed out after *labiau, une,* and *crosse.*
47. Before this name, the scribe first wrote *Es* then crossed it out.
48. *esbochun.*
49. *lug.*
50. *Rocheforte.* Two letters between *for* and *te* in this name were crossed out by the scribe.
51. *esquarteley e.*
52. *de belchamp.* A le.. er has been crossed out between these two words.
53. *camoyles.* The sixth and seventh letters have been crossed out.
54. *casteles.*
55. *malaust.*
56. *Walter malaust ar a ij barres g a un cantell de g.*
57. *martell.* The *t* in this name is partially erased.
58. *marels.*

89. Willam d'Odyngeles, d'argent a une fees de gules a deus[59] rowels de gules en le cheif.
90. Robart Angevyn,[60] de gules a une florete d'or.
91. Philipe Marmyon, de weyr[61] a une fees de gules.
92. Edouard de Pavely, argent a une crois d'or[62] recrosselé.
93. Hue le Heuse,[63] barré d'ermyn et gules.
94. Phylip le FizWaryne, ekarquelé[64] d'argent e de gules endenté.
95. Jon de Seyn[65] Jon, d'argent au cheif de gules a deus ruelles d'or en le cheif.
96. Robart de Wausse, escheker de argent e gules.
97. Bawdewyn Peche, wer d'or e de gules.
98. Bawdewyn de Creyke, d'azur a une mawnche[66] d'argent.
99. Piers de Meucler, d'azur a treys cynquefoles d'argent.
100. Waltier de Seyn[67] Jon, d'azur a treys fermailes d'or.

[10 *a*]
101. Hue Bigot, de gules a lion passant or.
102. Rawff Basset, pallé d'or e de gules a canton argent en les canton a crosse paté sable.
103. Rauff de la Haie,[68] argent a une ruel de gules.
104. Elayn de la Surche, de sable bessanté.
105. Roger de Somery,[69] d'or a deus lions azur.
106. Hue Sengsygne, de gules treys roueles d'or[70] a une danz d'or en le cheif.
107. Geffrey Tregoz, d'or a un lepard de gules en le cheif a deus gemeles de gules.
108. Geffrey de Segrave,[71] de sable a treys garbes argent.
109. Robert de Tatishale, eschekeré d'or e gules a cheif ermyne.
110. Willam de Boyvyle, esquartelé d'or e de sable a un lion passant de gules en le cantel d'or.
111. Jon de Breusse, d'or a treys cheverons de gules a bourdour argent indentit.
112. Roger de Mortimer, barré d'or e azur al cheif palé al[72] cantel geroné a n'yneschochon d'argent.

59. *une.*
60. *Angevyn.* This word is underlined in the manuscript and *Launcelyn (Aspilogia II*, p. 198), or *Lanncelqu,* is superscribed above it.
61. *de weyr.* Two letters between these words have been crossed out.
62. This word is smudged.
63. The scribe first wrote *Hiuse,* or *House,* then superscribed an *e* above the second letter.
64. *le fiz marmyon ebaqle* (there are horizontal strokes over the first *e* and the *q* of the last word).
65. *meyn.* An *S* is superscribed above the *m.*
66. *une mawnche.* Several letters between these two words have been crossed out.
67. *meyn.*
68. *Hare.*
69. *gomery.*
70. *roueles dor.* A word approximately nine letters long between these two words has been crossed out.
71. The scribe first wrote *gegrave* then superscribed an *S* above the first letter.
72. *cheif al.*

113. Marmaduc de Twenge, d'argent a une fesse gules a treys popayngais.
114. John de Burge, masclé de vaier e de gules.
115. Jon Giffard, de gules a treys lions passant argent.
116. Geffrey de Genvylle, d'azur al cheif d'ermyne a un lion recoupé[73] de gules, in l'azur breser d'or.
117. Robart de Clifford, escaker d'or et d'azur a fesse gules.
118. Willam Crepyn, argent treys barres ingrelé[74] gules.
119. Imary de Miland, sable a lion rampant a la quewe forché l'eschuchon semé billetts argent.
120. Henry de Cheverouse, argent a une crosse de gules a quatre egles d'azur.
121. N. de Cheverouse, argent a crosse gules quatre lions rampant on the quarters of the feld.
122. Jon de Montmorency,[75] d'or une crosse de gules inter seize aiglets azur.
123. Le duck de Burgoine, bendé d'or e d'azur a bourdour gules.
124. Le conte de Clewe, de gules a un eschouçon argent a un[76] escharbucle d'or floretté.
125. Le[77] conte de Lucenburge, burlé d'argent e azur a un lion de gules rampant coroné d'or.
126. Le[78] conte de Guseyne, de gules a liopar rampant d'or la quewe forché.[79]
127. Le conte del Monte, d'argent a un lion gules a la cowe crossé coroné d'or a un label d'azur.[80]
128. Le conte de Kyeburc, de gules a bend or a deus lions[81] rampant d'or.
129. Le conte de Friburc, d'or a un eigle gules a une bourdure de veyr.[82]
130. Le conte de Wirtemberc, d'or a treys perches de deym de sable.
131. Le conte de Trersteyn, d'or a une byse de gules.
132. Le conte de Fieyagnen, veiré d'or e de gules a un eschouchon d'azur a un saiccour argent.
133. Le conte de Colesteyn, d'or a un cherf de sable.
134. Le conte de Herford, azur a sis lioncs d'or a une bende argent lyte d'or.

73. *recope.* A *u* is superscribed above the *o*.
74. *barres ingrele.* A single letter between these two words has been crossed out.
75. The scribe first wrote *morency* then superscribed the rest of the name (*mont)*.
76. These words are nearly completely erased.
77. This word is erased.
78. This word is erased.
79. *fforche.* The double *f* normally indicates a capital *f* in this copy (e.g. *ffriburc* in item 129; cf. *llasscele* in item 149).
80. The corner of the page is covered by a large ink stain. This much of the first part of the blazon is clear: *Le conte del monte dar a u;* the rest of the line is illegible. Above the line in question, the following words are superscribed: *l lion ar.* The word *ar* (for *argent*) is incorrect, however, and should read *gules.* Part of the word *label,* which ends this blazon, and the tincture which follows are covered by the same ink stain. The tincture of the label is supported by *Cl* 116 only, but according to *Aspilogia II,* p. 190: "*C* 61 misblazons the label *d'or.*"
81. Before *lions,* the scribe wrote *bends* followed by a shorter word (*de?*) both of which he then crossed out.
82. *de veyr.* A *g* between these two words has been crossed out.

135. Le conte de Cornewale, argent a un lion rampant de gules coroné d'or a une bourdure sable bessannté.
136. Le conte de[83] Wyncestre, de gules[84] poudré a fause lozengs d'or.
137. Le roy de Portigal, de gules poudré a turetes d'or a une labeu azur.

[10 *b*]

138. Le duck de Lemborge, argent a lion gules rampant a la quwe[85] croysé e coroné d'or.
139. Le conte de Guerde, gules a une bende argent a lytte d'or floretés.
140. Le conte de Belyngne, azur a bend or a deus lionceus rampant or.
141. Le conte Rampsshroyke, or a treys rosers sur chekune rosser ver[86] une rose checkune rosere verte.[87]
142. Le conte de la Petite Pierre, d'or al cheif de gules a un cheveron argent sur le chef.
143. Le conte de Myreffiye, d'or a n'eigle de vere.
144. Le conte de Lowsteyn,[88] argent a une lyon de gules coroné d'or estant sus une mote d'azur.
145. Geffrey de Nevile, argent a une saltoier gules.
146. Jon le FyzJon, esquarteré d'or e de gules a une bordoure endentit argent e azur.
147. Le conte d'Albemarle, gules a crosse veyr.
148. Le conte Patriz Dae, gules a lion rampant argent a bourdur argent semé rossetets gules.
149. Le conte[89] del l'Asscele, palé d'or e de sable.
150. Le conte de Marre, azur bileté d'or a une bende[90] or.
151. Willam de Breyquyn, d'or a treys peuz[91] de gules.[92]
152. Le conte de Cestre, d'azur a troys garbes or.
153. Aleyn Lusser, argent a cheif de gulers.
154. Willam Hannsard, d'azur a treys moulets[93] d'argent.
155. Willam de Ros, d'azur a treys buz d'or.
156. Le conte de Chalon,[94] de gules a bend or.
157. John Comyn,[95] de gules a treys gaerbes d'or.
158. Le conte de la Marche, burlé de une menue burlure d'argent e d'azur.
159. Le conte Walence,[96] burlé d'argent e d'azur a merloz de gules bordeand.

83. *conte de.* Several letters between these two words have been crossed out.
84. After this word, two or three letters beginning with *p* were crossed out by the scribe.
85. After this word, two letters were crossed out by the scribe.
86. *ber.*
87. *berte.*
88. *rowsteyn.*
89. The last letter of this word is a blot.
90. *ben.* The end of this word has disappeared as the edge of the page has worn off.
91. *peur.*
92. *gul.* The end of this word has disappeared as the edge of the page has worn off.
93. This word is partially erased.
94. *Thalon.*
95. The scribe first wrote *bomyn* then expunged the first letter and superscribed it with a *C*.
96. The scribe first wrote *Walenze* then superscribed a *c* above the *z*.

160. Thomas de Clare, d'or a treys scheverons de gules a une labeaus azur.
161. Roger de Leyburne, d'azur a sis lioncieus d'argent.
162. Willam de Lonngeespé, azur a sis lionsceus[97] d'or.
163. Son frere, le meme a canton d'ermyn.
164. Hernold de la Wede,[98] barré d'or e de gules a goules fretté argent.
165. Henry de Bernam, les armes du roy de France al cheif pallé argent e gules.
166. Le syre[99] d'Esegney, argent a une crosse sable a merlon sable bordeanz.
167. Gawltier de Gystelle, de gules a une scheweron d'ermyne.
168. Walter de Fornywalle, d'argent a bend gules e sis merlets[100] de gules.
169. Jon de Gurney, argent a crosse de gules engrelé.
170. Piers Pigot, azur sis merloz d'or a une bende ingrelé[101] or.
171. Richard FizNichol, azur a une cynquefole d'or as escalopes[102] argent bourdanz.
172. Walter de Stotevyl, burelé[103] argent e gules a treys cos sable.
173. Geffrey de Gant, barré d'or e azur a bende[104] gules.
174. Waryn de Montcheysi, or treys schoçons barré[105] de veyr e gules.
175. Jon de Monemeuwe, or treys cheverons a fece argent.[106]
176. Robart de Mortimer, barré d'or[107] e de ver floretté del l'un e del l'autre.
177. Walter de Falkenberge, sable a une cynquefoele argent a merloz d'argent bourdanz.[108]

Remarks

1. Concordance

See *Cl.*

2. Abbreviations

ar, dar, for *argent, d'argent*: everywhere.
az, daz, for *azur, d'azur*: everywhere except in 144 where *d'azur* is spelled out.
Fra (there is a horizontal stroke above the *a*), for *France:* 2 (the word *France* is spelled out: 165).

97. *lionscembl.*
98. The *W* is superscribed above another letter which is illegible.
99. *myre.*
100. The *t* in this word is a blot.
101. *ingre.* The end of this word has disappeared as the edge of the page has worn off.
102. *escalop.* A small letter (*b*?) is superscribed above the *p*.
103. *buele.* An *r* is superscribed above the first *e*.
104. *a bordor* (there is a horizontal stroke above the last letter).
105. *bar.* The end of this word has disappeared as the edge of the page has worn off.
106. This word has disappeared entirely as a result of a hole in the manuscript.
107. This word is nearly erased.
108. *bourdaur.*

g, for *gules:* everywhere (the word *gules* is spelled out: 35, 79 [see also 151]; cf. 153: *gulers;* 164: *goules*).

p., for *pieces:* 9.

rapt, for *rampant:* 76, 121, 135, 138 (the word *rampant* is spelled out: 37; cf. 46: *rampannt;* 55: *ranpant*).

rapt (there is a horizontal stroke over *ap*), for *rampant:* 16, 57, 125, 129.

Rich, for *Richard:* 65, 67, 69 (cf. *Ric* [the tail of the *c* curves over to a point above this letter]: 171).

Rog (the tail of the *g* curves over to a point above this letter), for *Roger:* 112.

s, for *sable:* 1, 8, 10, 18, 24, 27, 46, 49, 83, 102, 104, 108, 110, 119, 130, 133, 135, 149, 166 (2), 172, 177 (the word *sable* is spelled out: 38, 68.)

S^t, for *Seynt:* 44 (cf. 95: *Seyn;* 100: *Meyn* [i.e., *Seyn*]).

Walt', for *Walter:* 168, 172, 177 (the name *Walter* is spelled out: 66 80, 85; cf. 100: *Waltier;* 167: *Gawlt',* for *Gawltier*).

W^am for *Willam:* 110, 118, 154, 155, 162 (the name *Willam* is spelled out: 151; cf. 63: *Wilam*).

W^iam, for *Willam:* 89.

The conjunction for 'and' is everywhere written *e* except in 30, 41, 51, 93, and 117, where it is spelled *et*. I have, consequently, rendered & in 9, 40, 52, and 146, as *e* (see also above, note 20).

Finally, the sign resembling a *v* with an elongated left leg is for *en le* in 72, 84, 89, 95, 106, 107, and 110.

3. Numbers

i, for *un* or *une:* everywhere except in item 127 where this number is written as an *l* (see above, note 80).

ij, for *deus:* 12 (but here an error), 47, 70, 85, 105, 107, 128, 140 (the word *deus* is spelled out: 95).

3, for *treys:* 3, 21, 28, 56, 58, 61, 67, 73, 78, 79, 84, 99, 100, 106, 108, 111, 113, 115, 118, 130, 141, 154, 155, 157, 160, 172, 174, 175 (the word *treys* is spelled out: 36, 151; cf. 152: *troys*).

iiij, for *quatre:* 29 (2), 120, 121.

5, for *cynque:* 61, 99 (*5 foles*); 62 (*5 foyeles*); 177 (*5 foele*) (the word *cynquefole* is spelled out: 171).

6, for *sis:* 134, 161, 162, 168.

8, for *uit:* 9.

16, for *seize:* 122.

Whenever the scribe spells out the word for 'one', he uses *un* or *une,* often without any concern for the gender of the following noun. In four cases, however, he uses the form *ung:* 10, 29 (2), 30.

Finally, mention needs to be made of the agglutinated form for *un* or *une* in items 22 (*a n'egle*), 112 (*a n'yneschochon*), and 143 (*a n'eigle*).

4. Tricks

The word *saulter* is tricked in item 59 (it is spelled out in 68; see also 63: *sault';* cf. 132: *saiccour* [a scribal error for *sautour?*] ; 145: *saltoier*).

London, in *Aspilogia II*, p. 189, was confused by the locution *on the + of the feld* in item 121: "121 *de Cheverouse ar a crosse g iiij lions rapt on the cross of the feld*. The latter coat, with the lions on instead of beside the cross, is otherwise unknown." However, the difficulty disappears when one reads the + as *quarters*.

For the Stafford crest, see below, note to *Cd* 66-69.

5. Notes

Cd 4 – on this defective blazon, see *Aspilogia II*, p. 167, note to item 4. In *Early Blazon*, p. 263, s.v. *pour Lion*, I inadvertently solved the abbreviation for

d'argent (*dar*) here as *d'azur* (abbreviation: *daz*). While he generally distinguishes his final *r* from his final *z*, the copyist at times uses the former where the latter is plainly called for and I have read the words accordingly (106: *danz*; 107: *Tregoz*; 151: *peuz*; 159, 170, 177: *merloz*; cf. above, note to *Cl* 38, and below, note to *Cd* 92).

Cd 11 – see the note to *Cl* 11. London, in *Aspilogia II*, p. 169, reads the last word in the blazon as *rormy*. He also states, p. 98: "The substitution of *rormy* (sic) for *d'azur* in the Hungary entry, no. 11, may be another attempt to emend an incomplete text."

Cd 16 – London, *Aspilogia II*, p. 175: "In *Cd* the initial appears to be a *D* but it may be meant for *S*."

Cd 26 – London, *Aspilogia II*, p. 178: "[*Cd*] blazons this 'catele az. ar.', a term which is still to be explained." The manuscript actually reads *caltele*.

Cd 27 – London, *Aspilogia II*, p. 178: "[*Cd*] has 'first' instead of 'petrine' (*poitrine*). This looks like a mis-hearing of *breast* or the German *Brust*." See also *Aspilogia II*, p. 98: "A detailed comparison of the text with [*Cl*] suggests that it was written at dictation by someone unused to that exercise."

Cd 28 – erroneously entered s.v. *eglet en la bende* in *Early Blazon*.

Cd 44 – the label should be azure; see *Aspilogia II*, p. 173.

Cd 48 – on the form *cerele*, see note to *Cl* 31.

Cd 50 – on the Pierrepont-Roucy arms (*or, a lion rampant azure*), see *Aspilogia II*, p. 174.

Cd 66-69 – a drawing which may be blazoned: *issuing out of a crest-coronet or, a boar's head gules* extends from items 66 through 69 about two-thirds down the left column of this page. Spaces left in items 66, 68 and 69 indicate that the drawing was made before the blazons were copied. The device is a trick in that the letter *g* (for *gules*) is written immediately before the caret in item 67 (see above) and connected to the sinister side of the boar's neck with a stroke, and the word *or* is written to the right of the sinister tip of the crown. In the space between items 67 and 68 and to the right of the boar, the name *Stafford* has been written in what appears to be the same scribe's hand.

Cd 74 – on this blazon and its error (*le labiau*), see the note to *Cl* 177.

Cd 81 – the emendation *esquarteley e de gules*] *esquarteley d'or e de gules* is supported by *Cl* 148 and *C* 118.

Cd 85-85 *bis* – the conflation of these two items is noted in *Aspilogia II*, pp. 98 and 197.

Cd 89 – the error in the number of rowels is noted in *Aspilogia II*, p. 198.

Cd 92 – the field, which should be *azure* (cf. *C* 157, *Cl* 160), is *argent* in this blazon. This error, stemming no doubt from the resemblance between the abbreviations *ar* and *az*, is not noted in *Aspilogia II*, p. 198. See also above, note to *Cd* 4.

Cd 94 – for the emendation *le fiz marmyon*] *le Fiz Waryne*, see *Aspilogia II*, pp. 98 and 199.

Cd 98 – in *Cl* 166, the maunch is ermine. *Aspilogia II*, p. 199, does not note this variant but states: "No Baldwin de Creke has been found."

Cd 105 – there is a similar confusion of *g* and *S* in *Cd* 108.

Cd 112 – the emendation *cheif al*] *cheif palé al* is supported by *Cl* 102 and *C* 142.

Cd 120-121 – the splitting of this blazon into two items is discussed in detail by London in *Aspilogia II*, pp. 98 and 188-189. London concludes that this emendation was made by the scribe of *Cd* and does not represent the original version.

Cd 127 – the emendation *argent*] *gules* is supported by *Cl* 116 and *C* 61. The variant in *Cd* is not noted in *Aspilogia II*, p 190.

Cd 133 – on the reading *cherf* vs. *cheif*, see the note to *Cl* 122.

Cd 148 – the border is mentioned in this copy only; on this variant, see *Aspilogia II*, pp. 98 and 181. London, however, does not mention the word which follows *Patriz* (*Dae*, for *Dunbar?*) in this copy.

Cd 173 – the emendation *bordor*] *bende* is supported by *Cl* 86 and *C* 125. This variant is not noted in *Aspilogia II*, p. 185.

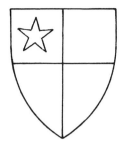

IV The Camden Roll D

1. Le rey de Jerusalem porte le escu de argent a une croiz de or cruselé de or.[1]
2. Emperur de Rome porte l'escu d'or a un egle de deus testes[2] de sable.
3. Le rey de Espayne porte argent et gules . . . rampans en l'argent et deus toreles . . . en le goules.[3]
4. Emperur de Alamaine . . . a un egle
5. Le rey de France . . . l'escu de azur floretté de or.[4]
6. Le rey de Aragon[5] . . . l'escu palé d'or et de goules.
7. Le rey de Engletere, l'escu de goules od treis leopars d'or.
8. Le rey de Cezile, l'escu de azur floretté d'or a un label de gules.[6]
9. Le rey de Navare, l'escu parté de azur et de goules od demy charbocle d'or a une bende d'argent od deus cotices d'or.
10. Le rey de Cypre, l'escu de azur od treis targes d'or.
11. Le rey de Bealme, l'escu de azur od treis barges d'argent.
12. Le rey de Griffonie, l'escu de azur od un griffun d'or.
13. Le rey de Norwey, l'escu de goules a un leun rampant de or od une hache d'argent.
14. Le rey de Ermenie, l'escu de ermine a une croiz de goules od une corone d'or.
15. Le rey de Denemarche, l'escu de goules od treis haches d'or.

1. The first six blazons are badly rubbed. I can do no better than to reproduce Greenstreet's partial readings, adding, however, the names found on the face of the manuscript which everywhere correspond closely to those on the dorse. Greenstreet begins item 1 with the letters *rlm,* part of the standard abbreviation for *Jerusalem.* On the face, the corresponding name reads: *Le Rey de Ier'l'm.* Weston reads *l'escu* instead of *le escu* and *crusile* instead of *crusele.*

2. Greenstreet: *[a une e]gle*; Weston: *od deus testes.*

3. Greenstreet reads item 3 as follows: *. . . [p]orte argent et gules . . . rampans en l'argent et deus toreles (?) . . . en le goules.*

4. Greenstreet reads item 5 as follows: *. . . l'escu de azur [florette] de [or].* The corresponding name on the face reads: *Rey de France.*

5. Greenstreet begins this item as follows: *. . . de . . .* The corresponding name on the face reads: *Rey de Aragon.* Weston reads: *Aragoen.*

6. The space following this item was left blank by the scribe. The corresponding name on the face reads: *Rey de Escoce.*

16. Seynt Edward le Rey, l'escu de azur od une croiz d'or a quatre merloz d'or.
17. Le rey de Man, l'escu de gules a treis jambes armez.
18. Duc de Breban, l'escu de sable a un leun d'or.
19. Duc de Loreyne, l'escu d'or od une bende de gules a treis egles d'argent.
20. Duc de Venise, l'escu de gules od un chastel d'argent.
21. Duc de Brusewic, l'escu d'or od deus leuns passans de gules.
22. Duc de Lamburg, l'escu d'argent a un leun rampant de goules od la couwe furché.
23. Duc de Beyvere, l'escu burelee de azur et de argent a une bende de goules.
24. Cunte de Nichole, l'escu esquartelé d'or et de goules od une bende de sable a un label d'argent.
25. Sire Aunfour porte les armes le rey de Engletere a un label de azur.
26. Cunte de Glocestre, l'escu d'or od treis cheveruns de gules.
27. Prince de Gales, l'escu esquartelé d'or et de gules a quatre lepars de l'un en l'autre.
28. Le cunte de Hereford, l'escu de azur od sis leuncels d'or a une bende d'argent od deus cotices d'or.
29. Cunte de Oxeneford, l'escu esquartelé d'or et de gules a une molette d'or.
30. Cunte de Blois, l'escu palé de veir et de gules od le chef d'or.
31. Cunte de Puntif, l'escu bendé d'or et de azur od la bordure de gules.
32. Cunte de Seynt Pol, l'escu palé de veir et de gules od le chef de or a un label de azur.
33. Cunte de Cornwaile, l'escu d'argent od la bordure de sable besanté d'or a un leun rampant de goules coroné d'or.
34. Cunte de Flandres, l'escu d'or a un leun rampant de sable.
35. Cunte de Richemund, l'escu escheckeré d'or et de azur od le quarter d'ermine od la bordure de gules.
36. Cunte de Wareyne, l'escu escheckeré d'or et de azur.
37. Munsire William de Sey, l'escu esquartelé d'or et de gules.
38. Munsire Thomas de Clare, l'escu d'or od treis cheveruns de gules a un label de azur.
39. Munsire Johan de Vescy, l'escu d'or od une croiz de sable.
40. Munsire Otes de Cransun, l'escu pale de azur et de argent[7] od une bende de gules a les escalops d'or.
41. Munsire William de Vescy, l'escu d'or od une croiz de sable[8] a un label de gules.
42. Munsire Gerard de l'Ildle, l'escu de gules od un leopard de argent coroné d'or.
43. Sire de Botresham, l'escu d'or od treis losenges percé de azur od le chef palé de argent et de gules.
44. Sire de Waudripun, l'escu d'or a deus leuns rampans de gules dos a dos.
45. Sire de Hundescote, l'escu de ermine od la bordure de gules.

7. *pale de & de argent.* The word *azur* is superscribed between *de* and & with the aid of a caret.

8. *de de sable.*

46. Sire de Viane, l'escu de or a un leun rampant de gules bilettee de gules.
47. Cunte de Gelre, l'escu de azur a un leun rampant d'or bilettee d'or.
48. Munsire Aunsel de Guyse, l'escu palé de veir et de goules od le quarter d'or.
49. Sire de Lovayne, l'escu de sable a un leun rampant de argent coroné d'or.
50. Munsire William Peynferer, l'escu d'argent od treis flurs de glagel de sable.
51. Munsire William de Betune, l'escu d'argent od une fesse de gules a un leun passant de sable.
52. Sire de Ramerne, l'escu d'argent a un leun rampant de sable od une bende de gules.
53. Henri de Penebrugge, l'escu barré d'or et de azur.
54. Prince de la Morree, l'escu d'or od un fer de molyn de sable.
55. Sire de Oudenarde, l'escu barré d'or et de gules.
56. Sire de Asche, l'escu de argent od une fesse de azur a un sautur de gules.
57. Munsire Louwis Bertout, l'escu palé d'argent et de gules.
58. Sire de Beyvere, l'escu burelé de azur et de argent od un sautur de gules.
59. Sire de Gavre, l'escu de gules a treis leuns rampans d'argent coroné d'or.
60. Munsire Tebaud[9] de Verdun, l'escu d'or fretté de gules.
61. Munsire William Marmiun, l'escu verré de azur et d'argent a une fesse de gules.
62. Munsire Peres Corbet, l'escu d'or a deus corbyns de sable.
63. Munsire Johan Giffard, l'escu de gules a treis leuns passans de argent.
64. Munsire Johan de Cantelo, l'escu de azur od treis flurs de glagel d'or.
65. Munsire Robert de Munteny, l'escu de azur a une bende d'argent od sis esmerloz d'or.
66. Munsire Robert de Quency, l'escu de gules od une quintefoille d'argent.
67. Munsire Johan de Eyvile, l'escu d'or od une fesse de gules od le flurs de glagel de l'un en l'autre.[10]
68. Munsire Robert Typotot, l'escu d'argent a un sautour engraslé de gules.
69. Cunte de Guynes, l'escu verré d'or et de azur.
70. Sire de Antoyne, l'escu de gules od leun rampant d'or biletté d'or.
71. Munsire Johan le Strange, l'escu d'argent od deus leuns passans de gules.
72. Munsire Ernaud de Guynes, l'escu verré d'or et de azur od la bordure de gules.
73. Munsire Henri de Basores, l'escu paslé de veir et de gules od le chef d'or od demy flur de glagel[11] de sable.
74. Munsire William de Rodes, l'escu de azur od un leun rampant d'or a une bende de gules.

9. These two words are partially rubbed.
10. The last letter of this word is rubbed.
11. *glag*. The remaining part of this word is rubbed.

75. Munsire Johan le Bretun, l'escu esquartelé d'or et de gules od la bordure de azur.
76. Munsire Henri de Percy, l'escu de azur od une fesse d'or endentee.
77. Munsire Johan de Gavre, l'escu d'or a un leun rampant de gules coroné de vert od la bordure de sable endentee.
78. Munsire Johan de la Haye, l'escu d'argent od un ray de solail de gules.
79. Munsire Almari de Lucy, l'escu de azur od treis luz d'or crusilé d'or.
80. Sire de Dist, l'escu d'or a deus barres de sable.
81. Munsire Roger de Clifford, le pere, l'escu escheckeré d'or et de azur a une fesse de gules.
82. Munsire Gefrey de Picheford, l'escu escheckeré d'or et de azur a une fesse de gules a treis leunceus d'argent rampant.
83. Cunte de Chalun, l'escu d'or a une bende de gules.
84. Munsire Robert le FizRoger, l'escu esquartelé d'or et de gules a une bende de sable.
85. Munsire Robert de Offord, l'escu de sable a une croiz engraslé d'or.
86. Munsire Roger de Clifford,[12] le fiz, l'escu escheckeré d'or et de azur a une fesse de gules od treis roses d'argent.
87. Rey de Hungrie, l'escu de gules a un leun rampant d'or.
88. Munsire Robert le FizWalter, l'escu d'or od une fesse de gules a deus cheveruns de gules.
89. Munsire Hue Turbervile, l'escu d'argent a un leun rampant de gules.
90. Munsire William la Zouche, l'escu de azur besanté d'or.
91. Cunte de Cessun, l'escu de gules a un escuchun d'or od un leun passant de gules.
92. Munsire Aleyn la Zouche, l'escu de gules besanté d'or.
93. Munsire Johan Tregoz, l'escu d'or od deus listes de gules a un leopard de gules.
94. Munsire Jorge de Kantelo, l'escu de gules a treis flurs de glagel d'or.
95. Munsire Baudewyn Wake, l'escu d'or a deus barres de gules od treis pelotes de gules.
96. Munsire William de Audelee, l'escu de gules fretté d'or.
97. Munsire Roger de Mortimer, l'escu palé, barré et gerouné d'or et de azur od un escuchun d'argent.
98. Munsire Robert de l'Ildle, l'escu d'or a une fesse de sable od deus cheveruns de gules.
99. Munsire Gefrey de Lucy, l'escu de gules od treis luz d'or crusilé d'or.
100. Munsire Nicholas de Seygrave, l'escu de sable od treis garbes de aveyne d'argent.
101. Cunte de Warewic, l'escu de gules od une fesse d'or crusilé d'or.
102. Munsire Roger le Leyburne, l'escu d'or od sis leuncels rampans de sable.
103. Cunte de Anegoz, l'escu de gules od une quintefoile d'or crusilé d'or.
104. Peres de Munfort, l'escu bendé d'or et de azur.
105. Munsire Johan de Seynt Johan, l'escu d'argent od le chef de gules od deus molettes d'or.
106. Munsire Roger de Trumpyntoun, l'escu de azur od deus trumpes d'or crusilé d'or.

12. An oil stain partially obscures this name as well as the words *l'escu* in item 87 and *le Fiz* in item 88.

107. Munsire William de Leyburne, l'escu de azur od sis leuncels rampans d'argent.
108. Munsire Robert Agilun, l'escu de gules a une[13] flur de glagel d'argent.
109. Munsire Johan de Armenters, l'escu escheckeré d'or et de azur od un leun rampant de gules.
110. Munsire Estevene de Penecestre, l'escu de gules[14] a une croiz d'argent.
111. Munsire Phelip Marmiun, l'escu de sable od une espee d'argent.
112. Munsire Johan de Cameys, l'escu de gules od treis gastels d'argent.
113. Munsire Johan de Vals, l'escu escheckeré de argent et de gules.
114. Munsire Aleyn de Plokenet, l'escu de ermine a une bende engraslé de gules.
115. Munsire Rauf Basset de Draytoun, l'escu palé d'or et de gules od le quarter d'ermine.
116. Munsire Hue le FizOtes, l'escu bendé d'or et de azur od le quarter d'ermine.
117. Munsire William de Munchensy, l'escu d'or od treis escuchuns verrez de azur et de argent.
118. Munsire Reynaud de Grey, l'escu barré de azur et de argent a un label de gules.
119. Cunte de Wyncestre, l'escu de gules od les losenges d'or[15] percés.
120. Cunte de l'Ildle, l'escu d'or a un leun rampant de azur.
121. Munsire Reynaud le FizPeres, l'escu de gules od treis leuns rampans d'or.
122. Munsire Warin de Bassingeburne, l'escu gerouné d'or et de azur.
123. Munsire Symun de Munford, l'escu de gules a un leun rampant d'argent od la cue furché.
124. Munsire Phelipe Basset, l'escu undee d'or et de gules.
125. Munsire Henri de Hastinge, l'escu d'or od une manche de gules.
126. Munsire Johan de Burg, l'escu masclé de veir et de gules.
127. Munsire Robert de Crevequer, l'escu d'or od une croiz percé de gules.
128. Cunte de Aubemarle, l'escu de gules od une croiz patee verré de azur et d'argent.
129. Munsire Robert de Brus, l'escu d'or od le chef de gules a un sautur de gules od une molette d'argent.
130. Munsire Alisander de Bailol, l'escu de gules a un escuchun d'argent percé.
131. Munsire Hue le Despenser, l'escu esquartelé d'argent et de gules fretté d'or a une bende de sable.
132. Munsire William de Valence, l'escu burelé de azur et de argent od les merloz de gules.
133. Munsire Johan del Boys, l'escu d'argent, od deu barres de gules od le quarter de gules.
134. Munsire William de Breouse, l'escu de azur od un leun rampant de or crusilé d'or.

13. *a un.* A small letter *e* is superscribed above the *n* with the aid of a caret.
14. A small oil stain partially obscures the last letter of this word.
15. A small oil stain partially obscures this word.

135. Munsire Patrik de Chawurthe, l'escu burelé d'argent et de gules od les merloz de sable.
136. Munsire Richart le FizJohan, l'escu esquartelé d'or et de gules od la bordure verré d'azur et d'argent.
137. Munsire Adam de Cretinge, l'escu de argent a un cheverun de gules od treis molettes de gules.
138. Cunte de Ferers, l'escu verré d'or et de gules.
139. Munsire Hue Sanz Aveir, l'escu de azur od treis cressantes d'or crusilé d'or.
140. Munsire Giles de Argentun, l'escu de gules a treis cupes d'argent.
141. Munsire William de Echingham, l'escu de azur fretté d'argent.
142. Munsire Gilbert Pecche, l'escu d'argent a une fesse de gules od deus cheveruns de gules.
143. Munsire Guy de Rocheford, l'escu esquartelé d'or et de gules a un label d'azur.
144. Munsire Bartholemeu de Sulee, l'escu d'or a deus barres de gules.
145. Munsire Robert de Mortimer, l'escu de gules a deus barres verrés d'azur et d'argent.
146. Munsire Davy de Jerkanvile, l'escu esquartelé d'or et d'azur a un leuncel rampant de gules.
147. Munsire William de Ferers, l'escu verré d'or et de gules od la bordure de sable od les fers d'argent.
148. Munsire Nichol Malemeyns, l'escu de gules a treis meyns d'argent.
149. Munsire Robert de Munford, l'escu bendé d'or et d'azur a un label de gules.
150. Munsire William Bardouf, l'escu d'azur a treis quintefoiles d'or.
151. Munsire Johan de Sandwis, l'escu d'or od le chef endenté[16] d'azur.
152. Munsire de Langelé, l'escu d'argent od une fesse de sable a treis escalops de sable.
153. Munsire William de Orlanstoun, l'escu d'or a deus cheveruns de gules od le quarter de gules a un leuncel rampant d'argent.
154. Munsire Robert de la Warde, l'escu verré d'argent et de sable.
155. Munsire Nichol de Hanlo, l'escu d'or a deus cheveruns de gules od le quarter de gules a une cressante d'argent.
156. Munsire Gefrey de Genevile, l'escu de azur od treis brayes[17] d'or od le chef de ermine a un leun recoupé de gules.
157. Munsire Richart Syuward, l'escu de sable od une croiz d'argent floretté.
158. Munsire Roger de Leukenore, l'escu de azur od treis cheveruns d'argent a un label d'or.
159. Munsire de Grey, l'escu barré d'azur et d'argent.
160. Munsire Walran de Muncels, l'escu d'argent od une bende de sable.
161. Munsire William Grandyn, l'escu d'azur od treis molettes d'or.
162. Cunte de Assele, l'escu palé d'or et de sable.
163. Cunte de Karrik, l'escu de sable od treis quintefoiles d'or.
164. Munsire Walter le FizHunfrey, l'escu esquartelé d'argent et de sable.
165. Cunte de Jungi, l'escu de gules a un egle d'argent coroné d'or.
166. Munsire William le Chamberleng, l'escu de azur od treis clefs d'or.

16. *od les endente.*
17. *bayes.*

167. Munsire Johan Comyn, l'escu de gules a treis garbes d'or.
168. Sire de Brussele, l'escu d'or a un sautur de gules.
169. Munsire Nichol de Kuggeho, l'escu de gules a une fesse d'argent od treis losenges d'argent.
170. Munsire Robert de Muscegros, l'escu d'or a un leun rampant de gules.
171. Munsire Moris de Berkelé, l'escu de gules a un cheverun d'argent.
172. Munsire Guncelyn de Batelesmere, l'escu d'argent od une fesse de gules a deus listes de gules.
173. Munsire Rauf de Seynt Leger, l'escu d'azur fretté d'argent od le chef d'or.
174. Munsire Johan Lovel, l'escu undee d'or et de gules a un label de azur.
175. Munsire Rauf de Normanvile, l'escu de gules a une fesse d'argent od deus listes d'argent.
176. Munsire Godefrey de Breban, l'escu de sable a un leun rampant d'or od une bende de gules.
177. Munsire William de Flandres, l'escu d'or a un leun rampant de sable od une bende de gules.
178. Munsire James de Trumpyntoun, l'escu de gules a deus trumpes d'or crusilé d'or.
179. Munsire Moris le FizGeroud, l'escu de argent a un sautur de gules.
180. Munsire Robert de Ros, l'escu de gules a treis bussels d'argent.
181. Munsire Henri Tregoz, l'escu d'azur od deus lystes d'or a un leun passant d'or.
182. Munsire Robert de Cokefeud, l'escu de gules[18] a une flur de glagel d'ermine.
183. Munsire William Heringaud, l'escu de azur od sis harangs d'or crusilé d'or.
184. Munsire[19] William de Hevere, l'escu de gules od une croiz d'argent a un label d'azur.
185. Munsire William de Valoynes, l'escu undee de lung d'argent et de gules.

Remarks

1. Concordance

The numeration of the verbal blazons here corresponds exactly to that found in James Greenstreet, "The Original Camden Roll of Arms," *Journal of the British Archaeological Association,* 38 (1882), 309-328; see also Walter J. Weston, "The Camden Roll," *Notes and Queries,* 6th ser., 8 (1883), 21-23, 41-43, 83-85. Scholars, however, frequently refer to the list of painted shields which follows a slightly different order.

2. Abbreviations

Barthol', for *Bartholemeu:* 144.
Gilbt (the conventional sign for *er* is superscribed between the *b* and the *t*), for *Gilbert:* 142.

18. This word is partially rubbed.
19. This word is partially rubbed.

Henr (the letter *i* is superscribed above the *r*), for *Henri:* 53, 73, 76, 125, 181.

John (the conventional sign for *a* is superscribed above the *n*) for *Johan:* 39, 63, 64, 67, 71, 75, 77, 78, 93, 105 (2), 109, 112, 113, 126, 133, 136, 151, 167, 174).

Nich', for *Nichol:* 148, 155 (the name *Nichol* is spelled out: 169).

Robt (the conventional sign for *er* is superscribed between the *b* and the *t*), for *Robert:* 65-68, 84, 85, 88, 98, 108, 127, 129, 145, 149, 154, 170, 180, 182.

Rog (the conventional sign for *er* is superscribed above the *g*), for *Roger:* 86, 97, 102 (the name *Roger* is spelled out: 106, 158).

Thom (a horizontal stroke is superscribed above the letter *m*), for *Thomas:* 38.

Will', for *William:* 37, 41, 50-52, 61, 74, 90, 96, 107, 117, 132, 134, 141, 147, 150, 153, 161, 166, 177, 183-185.

3. Numbers

No numerals are utilized in this copy. Also, the forms *un* and *une* are used regularly throughout for number 1. The other numbers are:

for 2, *deus:* 2, 9, 21, 28, 44, 62, 71, 80, 88, 93, 95, 98, 105, 106, 142, 144, 145, 153, 155, 172, 175, 178, 181 (cf. 133: *deu*).

for 3, *treis:* 7, 10, 11, 15, 19, 26, 38, 43, 50, 59, 63, 64, 79, 82, 86, 94, 95, 99, 100, 112, 117, 121, 137, 139, 140, 148, 150, 152, 156, 158, 161, 163, 166, 167, 169, 180.

for 4, *quatre:* 16, 27.

for 6, *sis:* 28, 65, 102, 107, 183.

4. Notes

For further observations on the Camden Roll, especially its relationship to the Heralds' Roll and the Dering Roll, see my forthcoming article.

D 8 – Greenstreet, p. 310: "where the name of the King of Scotland, with the description of his arms, should be set down a blank space is left. This indicates the date of the explanatory French blazon to be a period subsequent to the assertion of Edward's claim to suzerainty over Scotland, namely close upon A.D. 1286." On the background of this development and its significance for Girart d'Amiens' Arthurian romance *Escanor,* commissioned by Queen Eleanor of Castile, see my article entitled "Arthurian Heraldry and the Date of *Escanor,*" *Bulletin Bibliographique de la Société Internationale Arthurienne,* 11 (1959), 81-88.

D 10 – fictitious arms; for the correct arms of Cyprus, see *Aspilogia II,* p. 170.

D 11 – see *Early Blazon,* pp. 115-116.

D 14 – fictitious arms; for the correct arms of Armenia, see *Aspilogia II,* pp. 171-172.

D 15 – another fictitious coat; see *Aspilogia II,* p. 171.

D 23 – Greenstreet, p. 325, ascribes this coat to the Duke of Bavaria. The distinctive arms of Bavaria, however, are *bendy lozengy argent and azure* (see Max Prinet, "Armoiries françaises et allemandes dans an ancien rôle d'armes anglais," *Le Moyen Age,* 2e ser., 25 [1923], 236; *Aspilogia II,* p. 178; and the fourteenth-century Dean Tract: ' Le Duc de Beyvre porte l'escu masclee d'argent et d'azeure, et si est la masclure en belif" [Ruth J. Dean "An Early Treatise on Heraldry in Anglo-Norman," *Romance Studies in Memory of Edward Billings Ham,* ed. Urban Tigner Holmes (Hayward, Cal., 1967) (*California State College Publications,* No. 2), p. 27]). The coat in question is doubtless a back-formation based on *D* 58. Knowing Bavaria to be a duchy, the Camden copyist ascribed it the same arms as *D* 58 without, however, the saltire which he assumed had been added in differencing for cadency.

D 25 – Denholm-Young, *History and Heraldry*, p. 62: "[*D*] was drawn up about 1280 and is the only one to contain 'Sire Aunfons' or Alfonso, eldest son of Edward I (no. 26) (born 24 November 1273, died August 1284), who had a household of his own of which fragmentary accounts remain. A point of interest is that Alfonso had a coat of arms assigned to him as a child, though he did not live to be knighted."

D 31 – Greenstreet, p. 325, ascribes these arms to the "Earl of Poictou". For the correct identification (Simon de Dammartin, Count of Ponthieu), see *Aspilogia II*, p. 193. The arms should be barry, however, not bendy as they appear here in both the painted shield and the verbal blazon.

D 52 – corresponds perhaps to "Sir de Arderne" in the Heralds' Roll (no. 394) and in the Dering Roll (no. 320), where the lion, however, is azure.

D 54 – *la Moree* or *Mouree* was the medieval name for the Peloponnesus. On this principality, consult Robert Lee Wolff and Harry W. Hazard, *The Later Crusades, 1189-1311*, in Kenneth M. Setton, *A History of the Crusades*, II (Madison, Milwaukee, and London, 1969), Chapter VII, "The Frankish States in Greece, 1204-1311," pages 235-274. The verbal blazon here does not agree with the painted shield which, according to Greenstreet (shield no. 56) bears "Traces of three chevrons".

D 58 – Thierry V, Sire de Beveren and Dixmude in Flanders. In the Heralds' Roll (no. 375), the tinctures of the barruly field are correctly given as *or and azure* (see G.W. Watson, "Notes on the Foreign Coats in Planché's Roll," *The Genealogist* NS 6 [1889], 224). The Camden copyist plainly mistook *Bevre* for Bavaria. This explains *D* 23.

D 70 – identical arms are ascribed to *S^r de Antonye* in the Heralds' Roll (item 398).

D 87 – a variant of the arms of Hungary (the lion should be argent, not or); see *Aspilogia II*, p. 168.

D 146 – identical arms are ascribed to *Ralph de Jerpanville* (var.: *Jairponvill, Jairkonvill, Marconvile*) in the Dering Roll (no. 247) and to *Davy de Gercomvile* in the Heralds' Roll (no. 199).

D 156 – for the emendation *bayes*] *brayes*, see Greenstreet, p. 321.

V The Chifflet-Prinet Roll CP

[p. 145]

1. N . . . de Hu, d'azur au lion billeté d'or.
2. Li contes de Bouloinge porte les armes d'or a un fanuns de gueulles.
3. Messire Godefroit de Bouloinge porte celles mesmes[1] a un baston d'asur.
4. Li contes d'Abbeville porte les armes d'asur a trois bandes d'or et a une bordure de gueulles.
5. Li contes de la Marche porte les armes burelé d'argent et d'asur.
6. Li contes d'Auchoire porte les armes de gheulles a une bande d'or et a un escuchon des armes du duc de Bourgoigne en la bande.[2]
7. Li contes de Forés porte les armes de gheules a un daufin d'or.
8. Li contes de Sansoire porte les armes d'asur a une bande d'or et a deux[3] cotices d'argent.
9. Li contes de Venise porte les armes pallé d'argent et d'asur[4] et a une fese d'or.
10. Li sires de Monmoranchi porte les armes d'or a une crois de gheules et a seize egles d'asur es quatre cartiers.
11. Li vicontes de Meleun porte les armes d'asur a sept tourtiaus d'or et au chief d'or.

[p. 146]

12. Mesire Symon de Meleun porte les armes celles mesmes a trois oiselés de gheules au chief.
13. Mesire Bouchart de Marli porte les armes d'or a une crois de gheules a quatre egles d'asur es quatre quartiers.
14. Mesire Amouri de Mullant porte les armes noir a un lion d'argent a la ceue fourcie.
15. Mesire Willame Crespin porte les armes fascé d'argent et de gheules endenté de l'un a l'autre.
16. Mesire Guillames, ses fieus, porte celles armes au lambiaus d'asur.
17. Mesire[5] Jehan Crespin porte les armes de son pere a un quartier d'or.

1. The word *armes* which precedes *mesmes* has been crossed out by the scribe.
2. *bordure.*
3. The scribe first wrote *trois* then crossed it out and substituted the Roman numeral for *deux.* Cf. *BA* 286.
4. *asur franchois.*
5. *Mesires.* The last letter was deleted by the scribe with a vertical stroke.

18. Mesire Ansels de l'Ile porte les armes d'argent a une fesse de gheules et a une bordure d'oiselés de gheules.
19. Mesire Jehan de l'Ile porte celles mesmes au lambiaus d'asur.
20. Mesire Ansel de Chevreuses porte les armes d'argent a une crois de gheules a quatre lions d'asur es quatre cartiers.
21. Mesire Gui le Boutillier porte les armes escartelé d'or et de gheules.
22. Mesire Ansiaus le Boutillier porte celles mesmes au lambiaus.
23. Mesire Jehans de Schoisel porte les armes d'asur billeté d'or et a une crois d'or.
24. Mesire Ansel de Schoisel porte les armes noir[6] au fleurs de lis d'or semees et une bande d'argent.
25. Mesire Mahiu de Trie porte les armes d'asur a une bande d'or.

[p. 147]
26. Mesire Renaut de Trie porte les armes d'or a une bande tronçonnée d'argent et d'asur.
27. Mesire Piere de Chambeli porte les armes de gheules a trois coquilles d'or.
28. Mesire Piere, son fiex, porte celes memes au lambiaus noirs.
29. Mesire Oudart de Chabeli porte ces mesmes armes au lambiaus vers.
30. Mesire Piere de Machau porte les armes d'asur a trois coquilles d'or.
31. Mesire Raous de Soisons porte les armes d'or a un lion noirs passant et a une bordure noire.
32. Mesire Gui de la Roche porte les armes d'or a cinq cotices d'asur et a une bordure de gueulles.
33. Mesire Renaut de Dammartin porte les armes fessié d'argent et d'asur a sis pieces a une bordure de gheules et a un oiselet noir.
34. Mesire Symon de Lalain porte les armes de gheules a dix losanges[7] d'argent au lambiaus d'asur besanté d'or.
35. Mesire Guillame d'Iveri porte les armes d'or a trois chevrons de gheules.
36. Mesire Gui de Laval porte les armes d'or a une crois de gheules a cinq coquilles d'argent en la crois et a seize egles d'asur es quatre cartiers.
37. Mesire Hardoin de Mailli porte les armes ondoié d'or et de gheules.
38. Mesire Renaut de Prechenig porte les armes fessié d'or et d'asur et contrefescié et bande contrebandé, au coigniet gironné et a un escuchon d'argent ou milieu.
39. Mesire Raoul de Soisson porte les armes d'or a un lion noir passant et a une bordure noire.

[p. 148]
40. Mesire Jehan de Genville porte les armes d'asur au chief d'ermine a un demi lion de gheules et couronné d'or au chief, et a trois broies d'or sor l'asur.[8]
41. Li conestables porte les armes de gheules a deux bars d'or treflé d'or.

6. The word *d'or* precedes *noir* but was crossed out by the scribe.
7. The scribe started to write *sosan* then crossed out this word.
8. The scribe started a word beginning with a long *s* then deleted it with a vertical stroke.

42. Mesire Gui de Nele porte les armes d'or a deux bars[9] de gheules treflé de gueules.
43. Le vidame de Pingquingny porte les armes fessié d'argent et d'asur a une bordure de gheules.
44. Mesire Renaut, son fiex, porte celles mesmes a la bordure besantee d'or.
45. Mesire Angoran de Bailleul porte les armes de gheulles a un faus escucon d'ermine.
46. Mesire Piere de Bailleul porte les armes de gheulles a une fesse d'or.
47. Mesire Gerart de Boubert porte les armes d'argent a trois escussons de gheules.
48. Mesire Hue de Caumont porte les armes de gheules semé de croisettes d'or a trois molettes[10] d'or.
49. Mesire Aubert de Hangiet porte les armes d'argent a une crois de gheules a cinq coquilles d'or en la croix.
50. Mesire Adam du Cardonnoy porte les armes d'or a une crois de gueulles a cinq coquilles d'argent en la crois.
51. Mesire Jehan de Remeval porte les armes d'or a une crois noire a cinq coquilles d'argent en la crois.
52. Flammans de Cauni[11] porte les armes d'or a dix losenges de gueulles au lambiaus d'asur.
53. Mesire Bernard de Moreul porte les armes de France a un demi lyon d'argent.

[p. 149]
54. Li vicontes de Pont de Remi[12] porte les armes d'argent au chief de gheules.
55. Mesire Gui de Brianst porte les armes d'ermine a un lion de gheules couronné d'or.
56. Li conestables de Boulonnois porte les armes d'argent a un lyon noir couronné d'or.
57. Mesire Dreus de Milli porte les armes noir au chef d'argent.
58. Mesire de Biauval porte les armes d'argent a une dante de gheules.
59. Mesire Jehan de Maignelers porte les armes de gheules a une bande d'or.
60. Mesire Jehan de Heilli porte les armes de gheules[13] a une bande d'or engrelee.
61. Mesire Gauchier d'Austreste porte les armes de Blois a un lyon de gheules passant.
62. Mesire Simon de Mailli porte les armes d'or a trois maillés de gheules.[14]
63. [Mesire de Pruillé porte les armes d'or] a une bordure d'aiglettes de gheules.[14]

9. *bars picars*
10. *merlettes.*
11. *Caunyi.* The *y* was deleted by the scribe with a vertical stroke.
12. *vioces de pont remyi.* The *y* of the last word was deleted by the scribe with a vertical stroke.
13. *d'or et de gheules.*
14. *Mesire Simon de Mailli porte les armes d'or a trois mailles de gheules prime les de gheulles a une bordure dantelee de gheules.*

64. Mesire de Poi porte les armes de gheules a une bande d'argent semé de croisettes d'argent.
65. Mesire de Nonvillier porte les armes d'argent a un fer de molin de gheules a testes d'or de serpens au fer de molin.
66. Mesire Angoran de Couchi porte les armes fessié de vair et de gheules.
67. Mesire Robert de Pingnons porte celles mesmes a un quartier d'or.
68. Mesire Dreus de Melon porte les armes d'or a deux fesses de gheules et a une bordure d'oiselés de gheules.
69. Mesire Robert de Bellens porte les armes vert a une fesse d'argent.

[p. 150]
70. Sauset[15] de Bursay porte les armes d'asur a un fer de molin d'argent.
71. Mesire . . . de Saint Venant porte les armes d'asur a un escusson d'argent au lambiaus de gheules.
72. Li castelains de Bergues porte les armes d'or a un lion de gheules.
73. Mesire Jehan de Haveskerke porte les armes[16] d'or a une fesse de gheules.
74. Mesire Gille de Haveskerke porte[17] celles mesmes au lambiaus d'asur.
75. Mesire Godefroit de Brebant porte les armes d'or a un lion noir au lambiau de gheules.[18]
76. Mesire de Ferriere porte les armes d'argent a un escusson de gheules et a une bordure de fers a ceval de gheules.
77. Mesire Joffroi de Vendome porte les armes d'argent au chef de gheules a un lion d'asur et a une fleur de lis d'or en l'espaule du lion.
78. Li camberlains de Tancarvile porte les armes de . . . a un escusson d'argent par mi, agegnies d'or en l'escu.
79. Mesire Nicole de Serbonne porte les armes gironné d'or et d'asur a un escusson d'argent et au sautoir d'ermine.
80. Mesire Gobiert de Monsablon porte les armes de gheules a trois peus vairés d'argent et de vert au chief d'or.
81. Mesire Robert Bertran porte les armes d'or a un lion vert.
82. Mesire de Tibourvile porte les armes d'ermine a une fesse de gheules.
83. Mesire Jehan Mallet porte les armes de gheules a trois fermaus d'or.

[p. 151]
84. Mesire Guillame Marteel porte les armes d'or a trois marteaus de gheules.
85. Mesire Gui d'Anevaul porte les armes pallé d'or et d'asur au chief de gheules.
86. Mesire Guillame d'Iveri porte les armes d'or a trois chevrons de gheules.
87. Mesire Piere de Ricebourg porte les armes chevronné d'or et de gheules.

15. *Fauset.*
16. *les armes querque.* The third word is superscribed with the aid of a caret.
17. *Gilles de Haveskerke porte querque.* The *s* of *Gilles* was deleted by the scribe with a vertical stroke.
18. *gheules Norman.*

88. Mesire Guillame d'Iveri[19] porte les armes d'or a trois chevrons de gheules.
89. Mesire Jehan de Harecourt porte les armes de gheules a deux fesses d'or.
90. Mesire Guillame de Harecourt porte celes mesmes au lambiaus d'asur.
91. Mesire Raou Patri porte les armes de gheules semé de grains d'or a trois roies d'argent.
92. Mesire Foucaut de Merle porte les armes de gheules a trois roies d'argent.
93. Mesire Jaques de Beiaune porte les armes d'argent a une bande de[20] gheules a trois egles d'or en la bande au lambiaus d'asur.
94. Mesire de Triechastel porte les armes d'or a la clef[21] de gheules.
95. Mesire Jehan de Courtenay porte les armes d'or a trois tortiaus de gheulles.
96. Mesire Mahiu de Ville porte les armes d'or a trois jumelles d'asur et a une bordure de gheules.
97. Mesire Hue de Bauville porte les armes d'argent a une fesse de gheules a trois annelets d'or en la fesse.
98. Mesire Hervi de Lion porte les armes d'or a un lion noir.

[p. 152]
99. Son fiex, celles mesmes a un baston de gheules.
100. Mesire Richart de la Roche porte celles mesmes au lambiaus de gheules.
101. Mesire Jehan de Clere porte les armes d'argent a une fesse d'asur diapree d'or.
102. Mesire Jehan de Saint Martin porte les armes d'or billeté de gheules.
103. Mesire Ernoul de Wesemael porte les armes de gueules a trois fleurs de lis d'argent en lonc.
104. Mesire Gautier de Ligne porte les armes d'or a une bande de gheules.
105. Mesire de Denisi porte les armes d'or a trois cotices noires.
106. Mesire de Chastelier porte les armes noir a sept tourteaus d'or et au chef pallé d'or et de gheules.
107. Mesire Tibaut de Mathefelon porte les armes d'or a trois escussons de gheules.
108. Mesire Jehan de Biaumont porte les armes de France a un demi lyon d'argent.
109. Mesire Hardoin de le Haye porte les armes de gheules a une crois d'ermine eslargie par les bous.
110. Mesire de Toukes porte les armes burelé d'argent et de gheules a une bordure de merles noires.
111. Le vidame de Chaalons porte les armes de gheules a trois peus vairés au chief d'or a deux lionceaux de gheules passans l'un contre l'autre en chief.
112. Mesire Gerard de Los porte les armes fessié d'or et de gheules au lambiaus d'asur besanté d'argent.
113. Mesire Piere de Praiaus porte les armes de gheules a une egle d'or.

19. This name is superscribed with the aid of a caret.
20. The scribe started a *g* then crossed it out and wrote *de*.
21. *au chef.*

[p. 153]
114. Mesire Jehan de Bailleur porte les armes d'or a une fesse de gheules.
115. Mesire Piere de Corneul porte les armes d'or a une fesse de gheules et a trois tourteaux de gheules.
116. Mesire Jehan de Rouveray porte les armes burelé d'or et d'asur[22] a un lion de gheules et a un collier d'argent.
117. Mesire Piere d'Emboise porte les armes pallé d'or et de gheules.
118. Mesire de Monbason porte les armes de gheules a un lion d'or.
119. Mesire Guillame de Saincte More porte les armes d'argent a une fesse de gheules.
120. Mesire Hion de Gaurenchieres porte les armes de gheules a trois chevrons d'or.
121. Mesire Adam de Bruieres[23] porte les armes d'or a un lion noir a la queue fourchue billeté d'or.
122. Mesire Hardoin de Mailli porte les armes ondoié d'or et de gheules.
123. Li Bruns de Vernoil porte les armes escartelé de gheules et de vair.
124. Mesire Gui de Chemilli porte les armes d'or a une bordure d'oiselets de gheules et a un canton[24] de gheules.
125. Mesire Guillame li Vidame porte les armes d'or a deux fesses noires et a une bordure d'oiselets noirs.
126. Mesire Guillame de Mortemer porte les armes fascé d'or et de vert au fleur de lis[25] de l'une a l'autre et a un baston de gheules.
127. Mesire Vincent de Hotot porte les armes d'asur semé de tencelles d'or a un lion d'argent.

[p. 154]
128. Messire Hue de Bauchei porte les armes d'or a un fer de molin de gheules.
129. Mesire Joffroy d'Averton porte les armes d'asur a un sautoir d'argent et a quatre estancelles d'or.
130. Mesire Itier de Merdoine porte les armes d'asur semé de trefles d'or a un lion d'or.
131. Mesire Jehan de Charni porte les armes de gheules a trois escussons d'argent.
132. Mesire de Saint Lignaen porte les armes de gheules a une rose d'argent.
133. Li vicontes de Burniquet porte les armes mi party d'argent et de gheules a une fausse crois partie d'or et de gheules pommelé, de gheules[26] sur l'argent et d'or sur le gheules.
134. Mesire Morachi de Bellevile porte les armes gironné de vair et de gheules.
135. Mesire Bruiant de Monjehan porte les armes d'or freté de gheules.
136. Li vicontes de Touart porte les armes d'or au fleur de lis d'asur semees et a un cartier de gheules.

22. *burele dor a un.*
23. *Būmeres.* There is a horizontal stroke over the *u*.
24. *de gheules et a un bordon.* The scribe first wrote *mesme* then crossed it out and substituted *gheules.*
25. *d'azur.*
26. *d'or et de gheules.*

137. Mesire Hue de Touart porte celles armes[27] a une espee d'argent au cartier.
138. Mesire Joffroi le Bornie porte les armes noires a crois d'argent.
139. Mesire Raoul de Montfort porte les armes d'argent a un fer de molin de gheules a testes d'or de serpens au fer de molin.
140. Mesire Piere de Rotelen porte les armes fessé d'hermine et de gheules.

[p. 155]
141. Mesire Jehan de Beaumanoir porte les armes d'asur billeté d'argent.
142. Mesire Thiebaut de Rochefort porte les armes vairé d'or et d'asur.
143. Mesire de Doucheille porte les armes burelé d'or et de vert et a un lion de gheules.
144. Mesire de Rouchi porte les armes de gheules a une crois d'argent eslargie.
145. Mesire Joffroit d'Ancenis porte les armes de gheules a trois quintesfueilles d'ermines.
146. Mesire Jehan de Macheclou porte les armes d'argent a trois chevrons de gueules.
147. Mesire Tiebaut de Cabric porte les armes fessié d'argent et de gheules a un baston d'asur.

Remarks

1. Concordance

Prinet: Max Prinet, "Armorial de France composé à la fin du XIIIe siècle ou au commencement du XIVe," *Le Moyen Age*, 31 (1934), 1-49.

CP	Prinet	CP	Prinet	CP	Prinet
1-61	1-61	80	79	99	98
62	62	81	80	100	99
63	–	82	81	101	100
64	63	83	82	102	101
65	64	84	83	103	102
66	65	85	84	104	103
67	66	86	85	105	104
68	67	87	86	106	105
69	68	88	87	107	–
70	69	89	88	108	106
71	70	90	89	109	107
72	71	91	90	110	108
73	72	92	91	111	109
74	73	93	92	112	110
75	74	94	93	113	111
76	75	95	94	114	112
77	76	96	95	115	113
78	77	97	96	116	114
79	78	98	97	117	115

27. After this word the scribe wrote *d'or au fleurs de lys d'asur* which he then crossed out.

CP	Prinet	CP	Prinet	CP	Prinet
118	116	128	126	138	136
119	117	129	127	139	137
120	118	130	128	140	138
121	119	131	129	141	139
122	120	132	130	142	140
123	121	133	131	143	141
124	122	134	132	144	142
125	123	135	133	145	143
126	124	136	134	146	144
127	125	137	135	147	145

Prinet did not detect the conflation of *CP* 62-63 and overlooked *CP* 107 (see *Notes*).

2. Abbreviations

Guill (with a horizontal stroke through the *l*'s), for *Guillame:* 84, 86, 88, 90, 119, 125, 126 (the name *Guillame* is spelled out: 35).
Guills (with a horizontal stroke through the *l*'s), for *Guillames:* 16).
pics(with the symbol for -*ar* superscribed between the *c* and the *s*), for *Picars:* 42 (see note).
S, for *Saint:* 102, 132 (the name *Saint* is spelled out: 71; cf. *Saincte:* 119).
Will (with a horizontal stroke through the *l*'s), for *Willame:* 15.

3. Numbers

1, for *un:* 2 (the word *un* or *une* is spelled out everywhere else).
ii, for *deux:* 8 (the word *deux* is spelled out: 41, 42, 68, 89, 125).
3, for *trois:* 4, 97 (the word *trois* is spelled out everywhere else).
6, for *sis:* 33.
xvi, for *seize:* 36 (the word *seize* is spelled out: 10).
Also:
for 4: *quatre* (10, 13 [2], 20 [2], 36, 129).
for 5: *cinq* (32, 36, 49-51).
for 7: *sept* (11, 106).
for 10: *dix* (34, 52).

4. Notes

CP 6 – for the emendation *bordure*] *bande,* see Prinet, p. 6, n. 2.
CP 9 – Prinet, p. 7, n. 3: "Après *asur,* Chifflet a écrit *franchois.* Ce mot se trouvait, sans doute, en marge dans le manuscrit original. C'est une sorte de titre qui s'applique aux mentions suivantes. L'auteur a énuméré d'abord les comtes: il va décrire ensuite les armes des seigneurs de l'Ile de France (nos 10-42), de la Picardie et des pays du Nord Est (nos 43-74 [i.e. 75]); de la Normandie (nos 75-91 [i.e. 76-92]). Plus loin, il confondra les provinces, constituant cependant çà et là quelques petits groupes régionaux." See below, notes to *CP* 42, 75.
CP 31 – repeated in item 39 below.
CP 35 – repeated in items 86 and 88 below.
CP 37 – repeated in item 122 below.
CP 38 – *bandé contrebandé* appears to be an error here as the other thirteenth-century rolls of arms blazon a chief bearing pallets between corners divided diagonally into gyrons. Medieval treatise writers frequently cite these arms or the kindred Mortimer coat as being difficult to blazon and often fail to provide the correct verbal description.
CP 39 – repeats item 31 above.
CP 42 – Prinet, p. 16, n. 2: "Ici, on lit le mot 'Picars' qui devait se trouver en marge, dans l'original. C'est un titre indiquant à quelle région appartenaient les

seigneurs dont les noms suivent." See above, note to *CP* 9, and below, note to *CP* 75.

CP 48 – for the emendation *merlettes*] *molettes,* see Prinet, p. 18, n. 2; Paul Adam-Even, "Rôle d'armes de l'ost de Flandres (juin 1297)," *Archivum Heraldicum,* 73 (1959), 3.

CP 54 – for the emendation *vioces*] *vicontes,* see Prinet, p. 20, n. 1.

CP 58 – according to Prinet, p. 21, n. 1: 'Le mot *dante* doit être lu *dance.*" While I agree that a daunce, i.e. a fess dancetty, is plainly involved here, the copyist may have been influenced by OFr. *dent* 'tooth' in his orthography. Prinet further notes that the daunce should properly be placed on a fess in these arms.

CP 60 – the words *d'or et* have been omitted in this blazon following Prinet, p. 21, n. 3; cf. below, note to *CP* 133.

CP 62-63 – on the conflation of these two items in this copy, see Adam-Even, pp. 3, 5 (and notes).

CP 73 – Prinet, p. 25, n. 1: "Après le mot *armes,* on lit *querque.* Ces deux syllabes représentent une variante de la fin du nom. Elles se trouvaient, sans doute, en interligne, dans l'original." See note to *CP* 74.

CP 74 – Prinet, p. 25, n. 3: "Après le mot *porte,* Chifflet a écrit *querque,* variante des dernières syllabes du nom de famille." See note to *CP* 73.

CP 75 – Prinet, p. 25, n. 4: "A la fin de cet article, Chifflet a écrit le mot *Normans* [sic, for *Norman*]; c'est un titre qui s'applique aux articles suivants et qui devait se trouver, dans l'original, en marge ou en interligne." See above, notes to *CP* 9, 42.

CP 86 – repeats items 35 above and 88 below.

CP 88 – repeats items 35 and 86 above.

CP 94 – for the emendation *au chef*] *a la clef,* see Prinet, p. 31, n. 1.

CP 98 – Prinet erroneously reads *Henri,* for *Hervi* although he correctly identifies the person in question as Hervé de Léon (p. 32, n. 3).

CP 107 – this entire entry was inadvertently omitted by Prinet in his edition. On the knight in question, see Adam-Even, p. 5, note to item 147 (includes additional references). Louis-Fernand Flutre, *Table des noms propres avec toutes leurs variantes figurant dans les romans du moyen âge* (Poitiers, 1962) [*Publications du Centre d'Etudes Supérieures de Civilisation Médiévale,* II], p. 178, cites a "Tiebaut de Mathefalon" in the fifteenth-century prose romance *Pontus et Sidoine.*

CP 108 – the demi-lion is an error for a lion; see Adam-Even, p. 3.

CP 116 – the tinctures for the barruly field have been completed with information provided by Prinet, p. 38, n. 1.

CP 121 – the billets should be sable, not or; see Prinet, p. 39, n. 3; Adam-Even, p. 3.

CP 122 – repeats item 37 above.

CP 124 – for the emendation *bordon*] *canton,* see Prinet, p. 40, n. 2; Adam-Even, p. 3.

CP 126 – for the emendation *d'azur*] *de lis,* see Prinet, p. 41, n. 1 (the latter, however, erroneously transcribes the word in question as *d'asur*).

CP 127 – Prinet, p. 41, n. 3: "Il s'agit probablement de Nicolas de Hotot qui vivait en 1295 et 1302."

CP 132 – on this knight (Enlart de Sinninghem), not identified by Prinet, see Adam-Even, p. 5, note to item 130.

CP 133 – the words *d'or et* have been omitted in this blazon following Prinet, p. 43, item 133; cf. above, note to *CP* 60.

CP 138 – according to Prinet, p. 44, n. 3, the cross should be charged with five gules escallops.

VI The Falkirk Roll/
Thevet's Version H

[9 a]

Anno Domini Millesimo CCLXXXXVIII.
Ceux sount lez grauntz seignours a banniere quelx le roy Edward le premier
puis le Conquest avoit par devers Escoce l'an de son reigne vint et sisiem a
la bataille de Fawkyrke a jour de sainct Marie Magdalen.

La vaunt garde.

1. Henry de Lacy, counte de Nichole, chevetaigne de la premier bataille, porte d'or ou ung leoun rampaund de purpure.
2. Humfray de Boun, counte de Herford, conestable de Engleterre, porte d'azur ou ung bende d'argent ou sis leonceux d'or ou deux cotises d'or.
3. Roger Bigot, counte mareshall d'Engleterre, port party d'or et de vert ou ung leon rampaunt de gulez.
4. Henry de Bown, porte lez armez son pere ou ung labell de gulez.
5. Sir Robert FitzRoger port quartellé d'or et de gulez ou ung baston de sable.
6. Sir Roger le FitzWauter port d'or ou deux cheverouns de gulez ou ung fez de gules.
7. Sir Robert Tatershall port eschequeré d'or et de gulez od le chief de hermyn.
8. Sir Johnn Segrave port de sable ou ung leon rampaunt d'argent coronné d'or.
9. Sir Alain de Souche port de gulez besanté d'or.
10. Sir Hugh Bardolf port d'azure ou trois quintfoils d'or.
11. Sir Nicol de Segrave port de sable ou ung leon d'argent coronné d'or ou ung labell de gulez.
12. Sir Wauter de Mouncy port eschekerré d'argent et de gulez.
13. Sir John Lovell, undé or et de gulez.
14. Sir Robert Tatraesall, le fitz, port eschekeré d'or et de gulez od le chief d'armin ou ung lambel de azure.
15. Sir Robert Mohaut port d'azure o ung leon d'argent.
16. Sir Henry le Gray port barré d'argent et d'azure.

17. Sir John Claveryng porte quartillé d'or et de gulez fretté [a un baston de sable od le lambel d'asur] .[1]
18. Sir William Vavassour port d'or ou ung daunse de sable.
19. Sir John de Hodilstoun port de gulez fretté d'argent.
20. Sir Henry Tyes port d'argent ou ung cheveron de gulez.
21. Sir Nicol d'Aundeley port de gulez fretté d'or.

Summa en la premier bataile: vint et ung baniers.

La secund bataille.

C'est la bataille l'evesk de Duresme, la secund.

22. Antoyn Beke porte de gulez ou ung fer de molyn d'ermin.
23. Le counte Patrik porte de gulez ou ung leon d'argent ou le bordure d'argent de roses.
24. Le counte d'Anegos port de gulez ou ung quintfoyl d'or croisilé d'or.
25. Sir John de Wake porte d'or ou deux fesses de gulez ou trois tourtous de gulez[2] en le chief.
26. Sir Peres de Mauley porte d'or ou ung bende de sable.
27. Sir Peres Corbett porte d'or ou deux corbins de sable.
28. Sir Alexandre de Bayloylfs porte d'argent ou ung faus eschue de gulez.
29. Sir Rauffs Basset port pallé d'or et de gulez ou le cantell d'ermynn.
30. Sir Bryan le FitzAlayn porte barré d'or et de gulez.
31. Sir William de Breuse[3]
32. [Sir William de Ros] porte de gulez ou trois bousses d'argent.[3]
33. Sir William Sampson[4] porte de sable ou ung ferr de moulyn d'or.
34. Sir Waultier Huntyrcoump porte d'ermyne[5] ou deux gemeus de gulez.
35. Sir Edemund de Hastynges porte d'or ou la maunche[6] de gulez ou le lambell d'azure.
36. Sir John FitzMarmeduk Thwenge porte d'argent ou ung fesse de gulez et troys papejoyes de vert.
37. Sir John Gray porte barré d'argent et d'azure ou le baston de gules.
38. Sir John Cantelu port d'azure ou trois[7] floures de lyz d'or cressauntz hors de la test du lepard d'or.
39. Sir Philippe de Arcy porte d'argent ou trois cruselettez de gulez.
40. Sir Rauffe le FitzWilliam porte borel d'argent et d'azure ou trois chapeus de gulez.
41. Sir Robert de Hylton port d'argent ou deux barrez d'azure.
42. Sir John Paynell porte de vert ou la maunche d'or.
43. Sir William Martyn porte d'argent ou deux barrez de gulez.
44. Sir Theobald de Verdounn port d'or fretté de gulez ou lambel d'azure.

1. *Sir John Claveryng porte quartille dor et de gulez frette de argent.*
2. *do.*
3. *Sir William de Bryane porte de gulez ou iiij bousses d'argent.*
4. *William Dafs Sampson.*
5. *porte d'argent d'ermyne.*
6. *ou iij maunches.*
7. *deux.* The word is underlined and the number *iij* is superscribed above it.

45. Sir Thomas de Moltoun port barré d'argent et de gules.
46. Sir Edmund Dancourte porte d'azure ou ung daunce d'or byletté d'or.
47. Sir Andrew de Esteley porte d'argent ou ung leoun raumpantt de gulez et en les espaules du lyon ung quintfoil d'argent.
48. Sir Alexandre de Lyndsey porte de gulez ou ung feez eschekeré d'or et d'azure.

Summa en la secund bataille: vint et sis baniers.

La tierce bataille.

C'est la bataille le roy, la tierce.[8]

49. Le roy porte de gulez ou trois leopardes passauntz d'or.
50. Sir Thomas, le counte de Loncastre, porte mesmes lez armez ou le label d'azure en checun lable trois floures de lyz d'or.
51. Sir Henry de Loncastre porte lez armez le roy ovec ung baston d'azure.
52. Sir Johnn de Bretaigne porte eschekeré[9] d'or et d'azure ou le cantell d'ermyne ou la bordure de gulez poudré ou leopars[10] d'or.
53. Sir John de Bare porte d'azure ou deux barbes d'or croiselé d'or ou la bordure endenté de gules.
54. Sir Guy de Beauchaump, counte de Warrewyk, porte de gulez ou ung fez d'or croiselé d'or.
55. Sir Hugh Despenser porte quartillé d'argent et de gulez[11] o quarter de gulez fretté d'or ou le baston de sable.
56. Sir Robert de Clyfford porte chekeré d'or et d'azure ou le fes de gules.
57. Sir Eumenious de la Brett porte tout de gulez.
58. Sir de Castilton port de gules ou ung chastel d'or.

[9 b]
59. Sir William de Ferres port gules ou set losenges d'or.
60. Sir captan de Bucher port palé d'or[12] et de gules ou le cantel d'ermyne ou le bordoure de sable besaunté d'or.
61. Sir Raignald de Gray port sis peces d'argent et d'azur ou[13] le lable de gulez.
62. Sir John de Moyles port d'argent ou deux barrez de gules ou trois turteus de gulez en le chef.

8. *tierce*. This word is followed by the abbreviation for *que* (the letter *q* partially encircled by a stroke resembling a capital letter *C* going from the tail to a point above and slightly to the right of the *q*).

9. *escheke*. The remainder of this word has disappeared as the edge of the page has worn away.

10. *leopar*. The remainder of this word has disappeared as the edge of the page has worn away.

11. *d'argent de gulez*.

12. *port d'or*.

13. *d'argent ou*. The words & *d'azur* are superscribed between *d'argent* and *ou* with the aid of a caret.

63. Sir William le Latymer port de gules ou la croys paté d'or croyselé.[14]
64. Sir Robert Tonney port d'argent ou le maunche de gulez.
65. Sir Robert[15] le FitzPayn port de gules ou trois leons passauntz d'argent o ung baston d'azure.
66. Sir Adam de Velles port d'or ou ung leon rampaunt de sable e la cowe fourché.
67. Sir Roger de Mortymer port barré d'or et d'azure ou le chef palee et les corners geruné ou ung eschuchun d'ermyne.
68. Sir Thomas Fournivall port d'argent ou la bende de gulez ou sis marletez de gulez.
69. Sir Henry Pynkeney port d'or ou la feez engrelee de gules.
70. Sir John de la Mare port de gules ou la maunche d'argent.
71. Sir William de Cantelou port de gulez ou la feez de veire ou trois flours d'or cresçauns hors de la test du leopard.
72. Sir John Badeham port d'argent ou la croys de gulez ou cinc molets d'or en la croys.
73. Sir John Botetourte port d'or ou le sautre de sable engrelee.
74. Sir Eustace de Hache port d'or ou la crois engrelee de gulez.
75. Sir John Tregoz port d'or ou deux gemeus de gules en le chef ung leopard passaunt de gulez.
76. Sir Hugh de Mortymer port de gulez ou deux barrez de verre.
77. Sir Nichol de Meynill port d'azure ou trois gemeus d'or ou le chef d'or.
78. Sir Richard de Syward port de sable ou ung croys florettez d'argent.
79. Sir Symond Frysell port de sable ou sis rosez d'argent.
80. Sir William le FitzWilliam port d'or ou ung feez de gulez.
81. Sir Robert Peche port d'argent ou deux[16] cheverons de gulez.
82. Sir Robert de Scales port de gulez ou sis scaloppez d'argent.
83. Sir Walter de Beuchamp port de gulez ou la[17] feez d'or ou sis merlots d'or.
84. Sir Peres de Chavent port palee d'argent et d'azure[18] ou ung feez de gulez.
85. Sir William de Rye port d'azure ou lez cressaunts d'or.
86. Sir John Drochefford port quartillé d'or et d'azure ou lez roses en ung en l'autre.
87. Sir John de Benestede port la croys percé et patee et botonee d'argent.
88. Sir John de Haverinng, port d'argent o le leon[19] ramphaunt de gulez od ung collour d'or.
89. Sir William Grantson port palee d'argent et d'azure ou la bende de gulez et en la bende trois eglettez d'or.
90. Sir Perez Burdeux porte d'or ou ung leverer de gulez ou la collere de sable ou le bordour de sable besaunté d'or.

14. This blazon is repeated twice in its entirety.
15. *Sr le Fitz Payn.*
16. *d'argent ij.* The word *ou* is superscribed between *d'argent* and *ij* with the aid of a caret.
17. *lez.*
18. *Chanent port palee d'argent d'azure*
19. *port o le leon.*

91. Sir Hotes de Sassenau[20] port d'or ou lez pies de sable.
92. Sir Simond de Monteacu port quartilé d'argent et d'azure en lez quarters d'azure deux griffouns d'or, en lez quarters d'argent deux feez engrelés de gulez.
93. Sir John de Ryver port masclé d'or et de gulez.

Summa en le tierce bataile: quarante et sis baniers.

Le quarte bataille.

C'est la quarte bataile.

94. Sir John, counte de Garein, chevetainn del quarte bataile, porte eschekeré d'or et d'azure.
95. Sir Rauff de Monthermer port d'or ou ung egle de vert.
96. Sir Robert de Vere, count de Oxinford, porte quartilé d'or et de gulez et en le cantel de gulez ou ung moleit d'argent.
97. Sir Richard FitzAlain, counte de Arundell, porte de gules ou ung leon d'or.
98. Sir Henry de Percy porte d'or ou ung leon d'azure.[21]
99. Sir Thomas de Barkeley porte de gules ou ung cheveron d'argent ou lez croiselettes d'argent.
100. Sir John de Ewill porte d'or ou ung feez de gules[22] florré de l'une et de l'autre.
101. Sir Robert de la Ward port verré d'argent et de sable.
102. Sir John de Sainct John, le fitz, porte d'argent ou le chef de gules ou deux moletties d'or en le chef.
103. Sir William le Latymer, le fitz, port de gulez ou ung crois patee d'or ou le lambel d'argent.
104. Sir William de Morley, d'argent ou leon de sable et le cowe fourché.
105. John de Beauchamp porte de veere.
106. Sir Rauff Pipart porte d'argent ou ung feez et demy feez et le cantell d'azure et en le cantell quintfoyl d'or.
107. Sir Hugh Poyns port barré d'or et de gules.
108. Sir Rauff Grendon port d'argent ou deux cheverons de gulez.
109. Sir Thomas de Barkeley, le fitz, porte de gulez[23] ou ung cheveron d'argent croyselee de argent ou le labell d'azure.
110. Sir Hugh de Courteney porte d'or ou trois tourtaus[24] de gules ou ung labell d'azure.
111. Sir John Moun port d'or ou ung croys engrelé[25] de sable.

Summa en le quarte bataile: dis et uit banniers.

Summa de toutz baniers en lez quatre bataillez: cent onze banniers.

20. *Sassenan.*
21. *daz.* The remainder of this word has disappeared as the edge of the page has worn away.
22. *gul.* The remainder of this word has disappeared as the edge of the page has worn away.
23. *gule.* The remainder of this word has disappeared as the edge of the page has worn away.
24. *tourta.* The remainder of this word has disappeared as the edge of the page has worn away.
25. The letter *e* (or *ee*) which concludes this word is a blot .

Remarks

1. Concordance

Greenstreet: James Greenstreet. "The 'Falkirk' Roll of Arms " *Jewitt's Reliquary*, 15 (1875), 27-32, 68-74.

H	Greenstreet	H	Greenstreet
1-31	1-31	48	47
32	31	49	48
33	32	50	49
34	33	51	50
35	34	52	51
36	35	53	52
37	36	54	53
38	37	55	54
39	38	56	55
40	39	57	56
41	40	58	57
42	41	59	58
43	42	60	59
44	43	61	60
45	44	62	61
46	45	63	62-63
47	46	64-111	64-111

Greenstreet inadvertently repeats number 66 twice in his numeration, omitting 65 in the process. His items 62 and 63 are identical, following the manuscript in this particular.

The edition of *H* in Henry Gough, *Scotland in 1298* (Edinburgh, 1888), pp. 129-159, follows the order of the Wrest Park manuscript but provides numerals in parentheses corresponding to the British Museum copy and, consequently, Greenstreet's numeration except that our items 31 and 32 are entered as 31 and 31 *b* respectively by him (Greenstreet was unaware of the conflation here). In his notes, p. 72, Greenstreet erroneously conjectured that the second blazon for William le Latimer was for the latter's brother, Thomas, who he thought might have borne the same arms undifferenced. Comparison with the Wrest Park manuscript by Gough, however, revealed that the repetition was the result of a scribal error resulting in the omission of the blazon for John d'Engaine.

2. Abbreviations

Robrt (there is a horizontal stroke through the shaft of the *b*), for *Robert* (the name *Robert* is spelled out: 64, 96, 101).

Robt (there is a horizontal stroke through the shaft of the last two letters), for *Robert*: 5.

Sr, for *Sir:* 5-21, 25-48, 50-57, 59-63, 66-93, 95-104, 106-111 (the word *Sir* is spelled out: 58, 65, 94).

St, for *Sainct:* 102 (the word *sainct* is spelled out in the incipit).

3. Numbers

ii, for *deux:* 25, 34, 41, 43, 62, 75, 76, 81, 92 (2), 102, 108 (the word *deux* is spelled out: 2, 6, 27, 38 [an error]).

iii, for *trois:* 10, 25, 35 (an error), 38-40, 62, 65, 71, 77, 89, 110 (the word *trois* is spelled out: 49; cf. 36: *troys*).

3, for *trois:* 50.

iiii, for *quatre:* 32 (an error) (the word *quatre* is spelled out in the final summa).

v, for *cinc:* 72.

vi, for *sis:* 2, 61, 68, 79, 82.
vii, for *set:* 59.
xviii, for *dis et uit:* fourth summa.
xxi, for *vint et ung:* first summa.
xxvi, for *vint et sis:* second summa.
xlvi, for *quarante et sis:* third summa.
cxi, for *cent onze:* final summa.
The word for 'one' never appears as a figure and is always spelled out *ung* whether the following noun is masculine or feminine.
Ordinal numbers appear as follows:
iio, for *secund:* second caption (the word *secund* is spelled out in the same caption and in the second summa).
iiio, for *tierce:* third caption and third summa (the word *tierce* is spelled out in the third caption).
iiiio, for *quarte:* fourth caption and fourth summa (the word *quarte* is spelled out in the fourth caption and in 94).
xxviem, for *vint et sisiem:* incipit.

4. Tricks

Marginal tricks of the entire shield: 38, 71, 80, 81 92, 100, 104.

5. Notes

As a result of editorial emendation, the total indicated by the scribe in the second summa is one short of the correct figure (27 bannerets are listed, not 26) but this is compensated by the fact that one entry (the second blazon for William le Latimer) has been omitted in our edition, producing an incorrect total in the third summa (there are 45 bannerets, not 46). However, the remaining totals including the grand total are correct.

Incipit – on the use of *quel, queux,* or, as we find it in this instance, *quelx* as a relative pronoun in Anglo-Norman, see Pope, *From Latin to Modern French,* para. 1262.

First caption – on Anglo-Norman word division, see Pope, para. 1137.

H 4 – Gough, p. 130: " 'Henry', in [*H*] is an error [for Humphrey] ."
H 6 – Gough, p. 132: " 'Roger', in [*H*] is an error [for Robert] ."
H 17 – Gough, p. 132: "[*H*] is corrupt here, some words being copied from No. 19." The correction in brackets is from the Wrest Park MS.
H 25 – for the emendation *do*] *de gulez,* see Gough, p. 134.
H 27 – Gough, p. 134: "The coat *Or, 3 ravens sable* [in the Wrest Park manuscript] belonged to other Corbets."
H 31-32 – Gough, p. 136: " 'Bryane', in [*H*], is a mistake for 'Breuse'. The MS., omitting the arms of this commander, erroneously proceeds with the arms of Roos." The correct arms for William de Braose or Brewes (*azure, crusily a lion rampant queue fourchee or*) are found in the Wrest Park copy. On these arms, see *Aspilogia II,* p. 125.
H 32 – for the emendation *iiij*] *iij* [i.e. *trois*] , see Gough, p. 136.
H 33 – Gough, p. 136: " 'Daf' is inserted in [*H*] by mistake."
H 34 – Gough, p. 136: "The words 'd'argent' in [*H*] should, no doubt, have been erased."
H 35 – for the emendation *iij maunches*] *la maunche,* see Gough, p. 136.
H 36 – according to Gough, p. 138, John FitzMarmaduke, who bore *gules a fess between 3 popinjays argent,* is confused here with Marmaduke de Thweng, whose arms and a part of whose name are given in this blazon.
H 39 – Gough, p. 138: "The word 'cruselettez' in [*H*] is an error." Philip Darcy's arms, correctly identified by Gough, feature three cinquefoils, or heraldic roses. See also *Aspilogia II,* p. 137.

H 48 – Gough, p. 140: "[*H*] has *or and azure,* which seems to be incorrect." The Wrest Park copy reads *argent and azure.*

H 52 – both Greenstreet and Gough read the words *eschekeré* and *leopars* as I have written them here.

H 55 – the emendation *d'argent de gulez*] *d'argent et de gulez* is made by both Greenstreet and Gough.

H 59 – Gough, p. 143, emends this blazon to read *losenges persees,* a form found in the Wrest Park copy. The arms of William de Ferrers do, as a matter of fact, feature mascles conjoined. In early blazon, however, voiding of the lozenges is not always specified.

H 60 – Gough, p. 142: "The Captal de Buch was the hereditary holder of a fort situated on a small promontory 14 leagues from Bordeaux, now called La Tête de Buch. (Beltz. *Memorials of the Garter,* p. 28.) The captal at this period is not identified: the arms seem to be those of Foix – *Or, 3 pallets gules* – with the addition of *a border sable, bezanty, and a canton ermine* – perhaps referring to Poitou and Britanny." I have emended *port d'or et de gules* to read *port palé d'or et de gules* on the basis of the Wrest Park copy.

H 61 – Greenstreet emends *port vj peces* to read *port barré de vj peces* but neither the British Museum copy nor the Wrest Park manuscript provide a textual basis for this correction. The Grey arms are known to be barry, however; see Gough, p. 144.

H 63 – Gough, p. 144: "The addition 'croysele' in [*H*] is erroneous. In that copy the entry is repeated, and Engaine is omitted." The Wrest Park manuscript blazons the arms of John d'Engaine as *gules, crusily a fess dancetty or.* The semy of crosslets found in the blazon of the Latimer arms in *H* may derive from the latter item.

H 65 – I have followed Gough in emending this blazon to include the baron's Christian name which is found in the Wrest Park copy. The knight in question had earlier been identified in a note by Greenstreet, p. 70.

H 80 – Gough, p. 146: "not identified."

H 81 – Gough, p. 146: "[*H*] seems to be erroneous as to both Christian name and arms." The Wrest Park MS. gives the name Gilbert and indicates a fess between the two chevrons.

H 83 – I have emended *lez* in this blazon to read *la* on the basis of the Wrest Park copy. On the Beauchamp arms, see Gough, p. 148.

H 84 – for the emendations *Chanent*] *Chavent* and *d'argent d'azure*] *d'argent et d'azure,* see Greenstreet; Gough makes only the latter change in spite of the fact that the Wrest Park copy provides the reading *Chauvent.* On the name Champvent or Chavent, see Gough, p. 148.

H 87 – the tincture of the field is omitted in both copies of this roll.

H 88 – I have followed Gough for the emendation *port o le leon*] *port d'argent o le leon,* the reading found in the Wrest Park copy.

H 91 – Gough, p. 150: " 'Casenau' and 'Sassenau' (for so the words should be written [in the Wrest Park copy and the British Museum manuscript, respectively]) are forms of Casenave, or, as the place is now called, Cazeneuve. The arms are not intelligibly blazoned."

H 98 – both Greenstreet and Gough read the word *d'azure* as I have written it here.

H 100 – both Greenstreet and Gough read the word *gules* as I have written it here.

H 102 – the Wrest Park copy adds a label azure.

H 109 – Greenstreet: *de gules;* Gough: *de gulez.* According to Gough, p. 154, "Thomas" may be for Maurice, the latter's son. The father's arms are blazoned above (item 99).

H 110 – Greenstreet: *tourtaus;* Gough: *tourtaux.* The Wrest Park copy reads: *torteaux.*

H 111 – Greenstreet: *engrele;* Gough: *engrelee.* The Wrest Park copy reads: *engreile.*

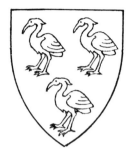

VII The Nativity Roll

[10 *a*]

> *Ce sount les nommes de chevallier que . . . le lundi devaunt la Nativité de Nostre Damme, c'est assavoir:*

1. Sir Payn Tibtot porte d'argent ou le sauter engrelé de gules.
2. Sir John Mowbray port de gulez ou ung lion ramphaunt d'argent.
3. Sir Henry de Beaumund porte d'azure fluretté d'or ou le leon rampaunt ou ung baston d'argent et de gulez gobané.
4. Sir John de Crombwell porte de gules ou sis aneletz d'or.
5. Sir Geffrey Loterell porte d'azure ou la bend d'argent ou sis merletts d'argent.
6. Sir Richard Folliot porte de gulez ou la bend d'argent.
7. Sir William Vauvassour porte d'or ou ung daunse de sable.
8. Sir Richard Archat porte d'argent ou la bend de gulez ou trois florettz d'or ou deux lysteaus[1] de gulez ou la bordure de gulez.
9. Sir Henry le Scrope port d'azure ou le bend d'or et en la bend ung leonseus de purpure.
10. Sir Nicolas Malmains[2] port d'argent ou la bend de purpure.
11. Sir William Deyncourt porte d'argent odve[3] la daunce de sable byletté de sable.
12. William le FitzWilliam porte masklee d'argent et de gulez.
13. Sir Nicol de Gray porte barré d'azure et d'argent odve la bend d'or et de gulez goboné.
14. Sir Richard le Gray port barré d'azure et d'argent fluretté d'or.
15. Sir Edmund Folyott port de gulez ou la bende d'argent ou sis cressaunts d'argent.
16. Sir Adam de Hudilston porte de gulez fretté d'argent ou le lable d'azure.
17. Sir Robert Haunsard port de gulez ou trois moletez d'argent.
18. Sir John Mauleverer port de gulez le chef d'or la bend d'azure et d'argent goubonez.
19. Sir Thomas de Colvyll porte d'or ou le feez de gulez et en la feez trois leonseux d'argent.

1. *lytteg* (an s-shaped sign is superscribed above the *g*).
2. *Malmans* (there is a titulus over the *n*).
3. *porte odve.*

20. Sir Nicol Vepount port d'or odve seez anelettez de gulez.
21. Sir Roger Heroun port d'azure ou trois herouns d'argent petiz beestez d'or.
22. Sir Godard Heron port d'azure ou trois herouns d'argent petiz beestez d'or.
23. Sir Robert de Manners por d'or ou deux barres d'azure ou le chef de gulez.
24. Sir Thomas Gray port de gulez ou le leon d'argent ou le bordure d'argen endenté et ung baston d'azure.
25. Sir Roger Mauduyt port d'ermyne deux barres de gulez.
26. Sir Wauter de Styrkeland port de sable ou trois scalopes d'argent.
27. Sir Gerard de Rodes, chevalier de Fraunce, port de gules
28. Sir William de Stopham port d'argent ou . . . de gulez.
29. Sir William de Rye port de gules ou la bend d'ermyn ou la[4] labell d'azure.
30. Sir Roger de Swynnston port d'argent croys patté de sable.
31. Sir William [de Vaux] port[5] d'argent odve lez merleste de gulez ou escucheon de gulez.
32. Sir John Chandes port d'argent et ung peus[6] de gulez et la label d'azure.
33. Sir John de Seynt Lo port de gulez ou une fesse[7] d'argent ou trois escaloppez d'argent.
34. Sir Richard de Perreres port quarteré d'argent et de sable en la cantel d'argent une molette[8] de gulez.
35. Sir Thomas le Latymer porte de gulez ou la crois paté d'or la labell d'azure.
36. Sir Robert le FitzRauff port burellé d'azure et d'argent ou trois chapaus de roses et la lable de gulez.
37. Sir Geffrey de Meaus port d'azure odve setz gryffounz d'or.
38. Sir Peres de Mauley port d'argent ou la bend de[9] sable le lable de gules.
39. Sir Robert Tillyolf por de gules odve leon d'argent le baston d'azure.
40. Sir Herberd Saynt Quintyn port d'or ou trois cheverons de gulez le chieff verre.
41. Sir Geffray Saynt Quintyn port d'or ou ung cheveron de gulez le cheff verre.
42. Sir John de Sutton port d'or ou le lyon de gulez le cheff de verre.
43. Sir Henr de Lekburne port d'argent ou ung cheveron de sable crusulé de sable.
44. Sir Adam de Everyngham port de gulez ou le leon rampaunt de verre.
45. Sir Robert de Perponcet port d'argent ou ung leon de sable ou ung baston d'or.
46. Sir John de Euer port quartelé d'or et de gulez ou la bend de sable et en la bend trois escallopez d'argent.

4. A blot makes this word difficult to read.
5. *William . . . port.*
6. *ung penn.*
7. *ou vij fesses.*
8. *vij molettez.*
9. The words *Sr* (for *Sir*) and *de* are obscured by blots.

47. Sir Robert Hyldyerd port d'azure ou trois moletz d'or.
48. Sir Gilbert de Atton port de gulez ou ung croys paté d'argent.
49. Sir Thomas Newmarche port d'argent ou la fesse engrelee de gulez.
50. Sir Henry le FitzHugh port d'azure ou le chef d'or fretté d'or.
51. Sir Rauff de Bulmer port de gulez ou le leon rampaunt d'or billetté d'or.
52. Sir Thomas de Ros port de gulez ou le fez de verre et trois bouces d'or.
53. Sir Phillip de Mowbray d'Escoce port de gulez ou ung lyon d'argent et ung bend engrelé de sable.
54. Sir John de Laundeles port d'azure ou ung escuchiun percé d'or.
55. Sir Richard de Blamminstre porte d'argent fretté de gules.
56. Sir John Darcy port d'argent ou la quintefoil de gulez ou le bordour endenté de gulez.
57. Adam de Everingham port d'argent ou ung feez d'azure ou le label d'azure.
58. Sir Thomas de Richemond port de gules le chef d'or ou quatre gemmeus d'or.
59. Sir Adam de Swymelygton port d'argent ou ung cheveron d'azure le labell de gulez.
60. Thomas de Berkeyng port chekeré d'argent et de gulez ou le baston d'azure.
61. Sir Andrew de Harcla port d'argent ou la croys de gules passant, en la cantel[10] une merlettz de sable.
62. Sir John de Haverington porte de sable fretté d'argent.
63. Sir Michel de Haverington port mesmes les armes ou le lable de gules.
64. Sir Gerard de Ufflete port d'argent ou ung fez de sable et en la fez trois flourez de lys d'or.
65. Sir Geffray de Upsal port d'argent ou ung croys passens[11] de sable.
66. Sir Dunkan Makdonell d'Escoce por d'or ou trois leonseux de sable.
67. Sir Waultre Faucomberge port d'argent ou le leon d'azure le baston goboné d'or et de gulez.
68. Sir William le Latymer Bouchard port de gules ou la croys paté d'or, en le lable de sable besante d'or.[12]
69. Sir John de Latymer Bouchard porte mesmes lez armes ou le lable de sable fluretté d'or.[12]
70. Sir William de Kyme port de gulez ou ung cheveron d'or crusilé d'or ou ung label d'azure.
71. Sir John de Vepount port de gules ou sis anelettez d'or ou ung label d'azure.
72. Sir John de Walkyngham port de verre ou deux barres de gulez.
73. Sir Walter de Lyle port d'or ou ung cheveron de gulez trois foulez de gulez ou ung label d'azure.
74. Sir John de Saint Omer port d'azure ou la crois passaunt d'or et en la croys cinc molettes de gules.[13]

10. *de gules en la cantel.* The word *passant* is superscribed between *gules* and *en* with the aid of a caret.
11. The last two letters of the word are difficult to read.
12. Items 68 and 69 are connected with a brace in the left-hand margin.
13. *gule.* The last letter of this word has disappeared as the edge of the page has worn away.

75. Sir Richard de Hudilston port de gulez fretté de argent.[14]
76. Richard Buroun port d'argent ou trois bendez de gulez ou ung labell d'azure.
77. Sir William Conestable port quartelé de verre et de gulez.[15]
78. Sir Robert le Conestable port mesmes lez armez mes la bende est engrelé d'or.[16]
79. Sir Runerard de Bloy port de gulez ou deux molettez d'or le cauntel d'ermyne.[17]

Remarks

1. Concordance

Greenstreet:　James Greenstreet, "The 'Nativity' Roll of Arms, Temp. Edward I," *Jewitt's Reliquary,* 15 (1875), 228-230 (items arranged alphabetically).

M	Greenstreet	M	Greenstreet
1	72	28	66
2	52	29	60
3	4	30	70
4	14	31	79
5	43	32	10
6	23	33	65
7	75	34	56
8	1	35	40
9	61	36	21
10	46	37	51
11	18	38	50
12	22	39	71
13	25	40	63
14	26	41	62
15	24	42	68
16	34	43	42
17	31	44	16
18	49	45	55
19	11	46	15
20	77	47	36
21	33	48	3
22	32	49	54
23	48	50	20
24	27	51	8
25	47	52	59
26	67	53	53
27	58	54	41

14. *de argen.* The last letters of the words *de* and *argent* have disappeared as the edge of the page has worn away.

15. *quartele de verre de gule.* The last letter of the word *gulez* has disappeared as the edge of the page has worn away.

16. Items 77 and 78 are connected with a brace in the left-hand margin.

17. The letter *n* in this word is blotted out.

M	Greenstreet	M	Greenstreet
55	6	68	38
56	2	69	39
57	17	70	37
58	57	71	76
59	69	72	78
60	5	73	44
61	28	74	61
62	29	75	35
63	30	76	9
64	73	77	12
65	74	78	13
66	45	79	31
67	19		

2. Abbreviations

chr (there is a horizontal stroke through the shaft of the *h*), for *chevalier:* 27.

d'arg. , for *d'argent:* 30 (the word *d'argent* is spelled out everywhere else; cf. 75: *de argent*).

nre (there is a horizontal stroke over the *r*), for *Nostre:* incipit.

Robrt (there is a horizontal stroke through the shaft of the *b*), for *Robert:* 17, 23, 36, 39, 45, 47, 78.

S^r for *Sir:* begins every item except 12, 57, 60, and 76.

Thoms (there is a conventional sign for *a*, consisting, in part, of a horizontal stroke, above the *m*): 49, 52, 58, 60 (the name *Thomas* is spelled out: 19, 24, 35).

Willm (there is a horizontal stroke through the shaft of the *l*'s ending with the conventional sign for *a* above the *m*): 68, 77 (the name *William* is spelled out: 7, 11, 29, 31, 70).

3. Numbers

ii, for *deux:* 8, 25, 72 (the word *deux* is spelled out: 23, 79).

iii, for *trois:* 8, 17, 19, 21, 22, 26, 33, 36, 46, 52, 64, 66, 73, 76 (the word *trois* is spelled out: 40, 47).

v, for *cinc:* 74.

vi, for *sis:* 4, 5, 15, 71.

vii, for *set:* 33, 34 (in both cases an error for *une*; cf. 20: *seez;* 37: *setz*).

Also:

for 1, *ung:* everywhere, whether the following word is masculine or feminine, except 61: *une*.

for 4, *quatre:* 58.

4. Tricks

Marginal tricks of the entire shield: 3, 27, 49, 50, 61.

5. Notes

M 8 – *lysteaus* or *listeaus* is the plural of Old French *listel,* a derivative of *liste* 'cotice'.

M 10 – on this knight, see N. Denholm-Young, *History and Heraldry 1254 to 1310. A Study of the Historical Value of the Rolls of Arms* (Oxford, 1965), p. 88. Other medieval sources specify a bend *engrailed* and provide variant forms for the name (e.g., *Malveroures* and *Malheureux*); see *Papworth's Ordinary,* p. 183.

M 11 – I have provided the tincture of the field on the basis of other medieval examples of these arms cited by *Papworth's Ordinary,* p. 701.

M 20 – although the form *seez* is probably intended for the number 'seven' (cf. the Anglo-Norman digraph *ae* for *e* in the form *saet* 'seven' cited by M. K. Pope, *From Latin to Modern French with Especial Consideration of Anglo-Norman* [Manchester: Manchester University Press, 1966, para. 1219.]), the Vipont arms are known from this roll (*M* 71) and from several other contemporary sources to have featured six annulets; see *Aspilogia II*, 134; *Papworth's Ordinary*, p. 6; and cf. *setz* in *M* 37 (see below). London believes these arms were "undoubtedly canting", *vi points* (i.e., six annulets) being a pun on the family name (*Aspilogia II*, p. 108). Cf. the arms of Sir John Cromwell (*M* 4) who married the daughter of Robert de Vipont and adopted a variant of the Vipont coat (Greenstreet, p. 229, note).

M 21-22 – the *petiz beestez* in the blazon of the Heron arms doubtless refers to the legs and beak of the bird in that coat. On these arms, see *Aspilogia II*, p. 158.

M 26 – a "Walter de Styrcheslegh" served as sheriff, 1272-1285; see Denholm-Young, *History and Heraldry*, p. 154.

M 27 – according to Denholm-Young, *History and Heraldry*, p. 83, Gerard de Rodes, "a well-known English knight", is listed as no. 301 in the Dering Roll. The only person bearing this surname who is mentioned in this roll, however, is *William de Rode* whose arms (*azure, a lion rampant or*) do not include the only tincture mentioned here (*gules*). For a summary of what is known about this knight, consult C. Moor, *Knights of Edward I* (London, 1929-1932), IV, 132-133 [*Harleian Society*]. Although he is said by the compiler of this roll to be a French knight (*chevalier de Fraunce*), Gerard de Rodes was probably Flemish. The thirteenth-century French Wijnbergen Roll (item 1243) includes among its painted shields a group of unlabeled but readily identifiable Flemish coats, one of which is blazoned by Dr. Paul Adam-Even as *azure, a lion rampant or, a bend gules* and identified by him as the arms of John de Rodes, lord of Ingelmunster near Roulers (Roeselare) in western Belgium. Identical arms are listed for *William de Rodes* in the Camden Roll (painted shield no. 77, verbal blazon no. 74) while the bend is omitted in the shield ascribed to *de Rode* in the Heralds' Roll (item 376), the disposition we noted above for *William de Rode* in the Dering Roll. According to *Burke's Extinct and Dormant Baronetcies*, 2nd ed. (London, 1844), p. 448, Gerard de Rodes' capital seat was Horn Castle in Lincolnshire.

M 28 – Johan de Stopham bore *argent, a bend sable with a label of 5 pendants gules* in Segar's Roll (item 19). The label is omitted for William de Stopham in the Parliamentary Roll (item 728) but is given for his son John (item 729). According to the Ashmolean Roll (items 201-202), Stopham was in debate with Ralph Paynell over the right to bear these arms; see also Thomas Jenyns' Book. For other early attestations, consult *Papworth's Ordinary*, p. 183.

M 31 – the arms of William de Vaux are found in the Parliamentary Roll (item 558: *Sire William de Vaus, de argent a un escuchoun de goules od la bordure de merlos de goules*); for other contemporary attestations, consult *Papworth's Ordinary*, p. 686.

M 32 – Greenstreet, who prints the surname as *Chandos* (the manuscript actually reads *Chandes*), notes: "The word 'penn' in the roll evidently means a pennon, which is now considered, by many, to be the object originally intended to have been represented by the device in heraldry which we are accustomed to call a pile" (p. 228). The word *penn*, however, is doubtless a scribal error for *peus*, a form of Old French *pel* 'pale'.

M 33 – for the single fess in the Saint Lo arms, see the evidence cited by *Papworth's Ordinary*, p. 749. The scribe generally uses the form *ung* for the article, regardless of the gender of the following noun, but in one case does use the feminine *une* (*M* 61). I have, consequently, emended *vij*] *une*, although the form *ung* is equally defensible. Cf. below, note to *M* 34.

M 34 – for the single mullet in the Pereres' arms, see *Papworth's Ordinary*, p. 1040. On the emendation *vij*] *une*, see above, note to *M* 33.

M 37 – the word *setz* in this blazon should be interpreted as 'six'. For the six griffins, see the Ashmolean Roll (item 411: *Monsire Johan de Meus, d'azure a vj greffons d'or*). Other early evidence may be found in *Papworth's Ordinary*, p. 989.

M 65 – Greenstreet reads: *ou ung croys passeur.*

M 73 – the "leaves" (*foulez*) in the Lyle arms are described as *iij foilles de gletners* in the Parliamentary Roll (item 234), merely adding to the confusion; see also *Papworth's Ordinary*, pp. 453-454. Were the mysterious *iij foulez* perhaps originally unnumbered trefoils? For another explanation, see Barstow, pp. 325-327.

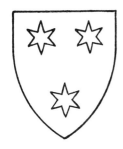

VIII The Siege of Caerlauerock

[23 *b*]
En cronicles[1] de granz moustiers
Truef l'en ke rois[2] Edewars li ters
El milem treicentime an
De grace, au jour de Seint Johan, 4
Fu a Carduel e tint grant court
E commanda ke a terme court
Tuit si homme se apparellassent
E ensemble ovec[3] li alassent 8
Sur les Escos ses enemis.
Dedens le jour ke lour fu mis
Fu preste toute le ost banie.
E li roys o sa grant maisnie 12
Tanttost se vint[4] vers les Escos
Non pas en cotes e sourcos
Mes sur les granz chevaus de pris
[Por ceo qu'il ne feussent surpris][5] 16
Armé ben e seürement.
La ot meint riche guarnement
Brodé sur sendaus e samis,
Meint beau penon en lance mis, 20
Meinte baniere[6] deploié.
Se estoit la noise loign oié
De hennissemens de chevaus:
Par tout estoient mons e vaus 24

1. *n cronicles.* Space has been allowed for a large initial letter. In the left-hand margin, the letter *e* is written twice in a different hand.
2. *truef ke rois.* The word *len* has been added in the left-hand margin in a different hand. A caret between *truef* and *ke* indicates where *len* is to be inserted.
3. *E ensem ovec.* The letters *ble* have been added in the left-hand margin in a different hand. A caret between *ensem* and *ovec* indicates where *ble* is to be inserted.
4. In the left-hand margin the word *vunt* has been written in a different hand. Oxford copy: *vint.*
5. Missing verse in *K* restored according to the Oxford copy.
6. *meint bainer.* Oxford copy: *meint baniere.*

Plein de somiers e de charroi
O la vitaile e le conroi
De tentis e de pavelloins.
E li jour estoit beaus e lons 28
Se erroint petites journees
En quatre echeles ordenés
Lequeles vos deviserai
Ke nule ne en trespasserai. 32
Ainz vous diray des compaignons
Toutes les armes, e le nons
De banerez nomeëment[7]
[24 *a*]
Si vous volez oïr coment. 36

Henris[8] li bons quens de Nicole,
Ki prouesce enbrasce e acole
E en son cuer le a soveraine
Menans le eschele premeraine, 40
Baner out de un cendal safrin
O un lïoun rampant purprin.
O lui Robert le FizWater,
Ke ben sout dez armes le mester, 44
Se en fesoit kanques il devoit,
En la baner jaune avoit
Fesse entre deus cheverons vermaus.
E Guillemes[9] li Marescaus 48
Dont en Irlande ot la baillie
La bende de or engreellie
Portoit en la rouge baniere.
Hue Bardoul de grant maniere, 52
Riches homs e preus e cortois,
En asure[10] quintfullez trois
Portoit de fin or esmeré.
Un[11] grant seignour mult honnoré 56
Pus je ben nomer le cinkime,
Phelippe le seignur de Kyme,
Ky portoit rouge o un cheveron
De or croissillié tot environ. 60
Henri de Graï vi je la
Ki ben e noblement ala
Ovec son bon seignour le conte;
Banier avoit e par droit conte 64
De sis pecys la vous mesur
Barree de argent e de asur.
Robert de Monhaut i estout

7. *nomement.* Oxford copy: *Des banieres nomement.*
8. *Enris.* Space has been allowed for a large initial letter. The letter *h* has been added in the left-hand margin in a different hand.
9. *Guillems.* Oxford copy: *Guillemes.*
10. *asur.* Oxford copy: *asure.*
11. *une.* Oxford copy: *un.*

Ky mult haute entent metoit 68
De faire a haute honur atainte;
[Baniere avoit en asur teinte] [12]
O un lÿoun rampant de argent.
Acompainïez a cel gent 72
Thomas de Moultone se fu
Ky avoit baner e escu
De argent o treis barres de goulys.
Ses armes ne furent par soules 76
D'esïente en le apparellement
Kar teles ot resemblantment
Johans de Langcastre entre meins
Mes ke en lieu de une barre meins 80
Quartier rouge e jaune lupart.
E de cele meïsme part [13]
Fu Guillames li Vavasours
Ky de armes ne est muet ne sours; 84
Baner avoit ben conoissable
De or fyn o la dance de sable.
Johans de Odilstane ensement
Ky ben e adesseëment [14] 88
Va de armes toutes les saisons.
Au conte estoit, si est raisons
Ke nomez soit entyr sa gent:
Rouge portoit frettez de argent. 92
Le bon Robert le FizRoger
Vi je sa baniere arenger
Lez cele au conte en cele alee:
De or e de rouge esquartelee 96
O un bende tainte en noir.
La Johan, son filz e son hoir,
Ky de Claveringhe a surnoun,
Ne estoit diverse de rien noun 100
Fors de un label vert soulement.
Se estoient du retenement
Le bon conte e le ben amé
Tuit cil ke ci vous ai nomé. 104
Ses compaigns fu li conestables,
Joefnes homs riches e mettables,
Ky quens estoit de Herefort.

[24 *b*]
Baniere out de inde cendal fort 108
O une blanche bende lee
De deus costices entrealee

12. Missing verse in *K* restored according to the Oxford copy except that the latter's
asure, which results in a hypermetric line, has been emended to *asur*.
13. *E fe cele meis part*. Corrupt verse emended with the aid of the Oxford copy
which reads: *E de celle mesme part*, which is hypometric.
14. *Ki ben e adesscement*. This verse is hypometric in the Oxford copy also: *Ki bien
e adessement*.

De or fin dont au dehors asis
[Ot en rampant lÿonceaus sis.] [15] 112
Nicholas de Segrave o li,
Ke nature avoit embeli
De cors e enrichi de cuer,
Vallant pere ot ki getta puer 116
Les garbes e le lÿon prist.
A ses enfans ensi aprist
Les coragous a resembler
E o les nobles assembler. 120
Cil ot la baniere[16] son pere
Au label rouge por son frere
Johan, ki li ainsnez estoit,
E ki entiere la portoit. 124
Li peres ot de sa moillier
Cink fiz ke estoient chivalier
Preus e hardi e defensable.
O un lÿoun de argent en sable 128
Rampant e de or fin couronné
Fu la baniere[16] de l'ainsné
Ke li quens Mareschaus avoit
Mis el service ke il devoit 132
Por ce ke il ne i pöoit venir.
Il ne me puet[17] pas souvenir
Ke baneret i fuissent plus
Mes si le voir vous en conclus 136
Bons bachelers i ot ben cent
Dont nuls en ostel ne descent
Nule foiz tant ke il aient touz
Cerchiez les passages doutouz. 140
O eus chevauchent chescun jour
Li marescal, li herbirgour
Ki livrent places a logier
A ceus ke devent herberger. 144
Par tant ai dit de l'avant garde,
Ki sont dedenz e ki la guarde.

Johans,[18] li bons quens de Warenne,
De l'autre chel avoit la renne 148
A justicer e governer
Cum cil ky bien savoit mener
Gent segnourie e honnouree.
De or e de asur eschequeré 152
Fu sa baniere noblement.
E ot en son assemblement
Henri de Perci, son nevou,

15. Missing verse in *K* restored according to the Oxford copy.
16. *baner.* Oxford copy: *baniere.*
17. *Il ne puet.* Oxford copy: *Il ne me puet.*
18. *ohans.* Space has been allowed for a large initial letter. Oxford copy: *Johans.*

De ky sembloit ke eust fait vou 156
De aler les Escos derompant.
Jaune o un bleu lÿon rampant
Fu sa baniere[19] bien vuable.
Robert le FizPaien sievable 160
Ot sa baniere[20] flanc a flanc
Rouge a passans lÿons de blanc
Trois, de un bastoun bleu surgettez.
Wautiers de Moncy ajoustez 164
Estoit en cele compaigneye
Kar tuit furent de une maisnie.
Cil ot baner eschequeree
De blanc e rouge coulouré. 168
De Walence Aymars, li vaillans,
Bele baniere i fu baillans
De argent e de asur burelee
O la bordure poralee 172
Tout entour de rouges merlos.
Un vaillant home e de grant los

[25 a]
O lui, Nichole de Karru,
Dont meinte foiz orent paru 176
Li fait en couvert e en lande
[Sur la felloune gent d'Irlande][21]
Baniere ot jaune bien passablie[22]
O treis lÿouns passans de sable. 180
Rogers de la Ware ovec eus,
Uns chevaliers sagis e preus,
Ki les armes ot vermellettis
O blonc lÿoun e croissellettes. 184
De Warewick le conte Guy,
Coment ke en ma rime le guy,
Ne avoit vesyn de luy mellour:
Baner ot de rouge colour 188
O fesse de or e croissillie.
Jaune o crois noire egreellie
La portoit Johans de Möoun.
Cele de Tateshale a oun 192
Por sa valour o eus tiree
De or e de rouge eschequeré
Au chef de ermine outreëment.
[Rauf le FitzGuilleme autrement][23] 196
Ke cil de Valence portoit
Car en lieu des merlos mettoit
Trois chapeaus de rosis vermelles

19. *baner.* Oxford copy: *baniere.*
20. *baner.* Oxford copy: *baniere.*
21. Missing verse in *K* restored according to the Oxford copy.
22. Oxford copy: *passable.*
23. Missing verse in *K* restored according to the Oxford copy.

Ki bien avienent a[24] mervellez. 200
Guillemes de Ros assemblans
I fu en rouge o trois bouz blans.
E la baniere Huë Poinz
Estoit barree de uit[25] poinz 204
De or e de goules ovelment.
Johans de Beuchamp propirment
Portoit la baniere de vair
Au douz tens e au souëf air.[26] 208
Prestes a bascier les ventailes
Ensi se aroutent les batailes
Dont ja de deus oï avez
E de la terce oïr devez. 212

Edewars,[27] sires de Irois,
De Escos e de Engleter rois,
Princes Galois,[28] ducs de Aquitaine,
La terce eschel un poi loingtaine[29] 216
Conduit e guye arreëment
Si bel e si serreëment
Ke nuls de autre ne se depart.
En sa baniere[30] trois lupart 220
De or fin estoient mis en rouge
Courant, feloun, fier e harouge.
Par tel signifiance mis
Ke ansi est vers ses enemis 224
Li rois fiers, felons, e haustans,
Car sa morsure ne est tastans
Nuls ke ne en soit envenimez
Nonporquant tost est ralumez 228
De douce debonaireté
Kant il requerent se amisté
E a sa pais vuellent venir.
Tel prince doit bien avenir 232
De granz genz estre chievetaine.
Son nevou Johan de Bretaigne,
Porce ke plus est de li pres,
Doi je plus tost nomer aprés. 236
Si le avoit il ben deservi
Cum cil ki son oncle ot servi
De se enfance peniblement

24. *avienent mervellez.* The word *a* is superscribed between these two terms in a different hand with the aid of a caret.
25. *viiij.* Oxford copy: *viij.*
26. *air air.* The first word is partially erased and also crossed out.
27. *dewars.* Space has been allowed for a large initial letter. In the left-hand margin, the letter *e* is written in a different hand.
28. *Princes Galois.* The word *de* is superscribed between these two terms in a different hand but results in a hypometric verse. It is not found in the Oxford copy.
29. *loingtai.* The last part of this word has disappeared as the edge of the page has worn off. Oxford copy: *loingtaine.*
30. *banier.* Oxford copy: *baniere.*

E deguerpi outreëment 240
Son pere e son autre lignage
Por demourer de son maisnage

[25 *b*]
Kant li rois ot besoigne de gens.
E il ki estoit beaus e gens 244
Baniere avoit cointe e paree
De or e de asur eschequeré
A rouge ourle o jaunes lupars,
De ermine estoit la quarte[31] pars. 248
Johans de Bar iluec estoit
Ke en la baner inde portoit
Deuz bars de or e fu croissilie
O la rouge ourle engreellie. 252
Guillemes de Grantson palee
De argent e de asur suralee
De bende rouge o trois eigleaus
Portoit de or fin bien fais e beaus. 256
Bien doi mettere en mon serventois
Ke Elys de Aubigni, li courtois,
Baniere ot rouge ou entallie
Ot fesse blanche engreellie. 260
Mes Eumenïous de la Brette
La baner ot toute[32] rougette.
Aprés ceus ci truis en mon conte
Huë de Ver, le filz au conte 264
De Oxinfort, e frere son hoir.
O le ourle endentee de noir
Avoit baniere e longe e lee
De ore e de rouge esquartelee, 268
De bon cendal non pas de toyle,
E devant une blanche estoyle.
Johans de Riviers le appareil
Ot masclé de or e de vermeil 272
E par tant comparé le a on
Au bon Morice de Cröon.
Robert, le seignour de Cliffort,
A ki raisons donne confort 276
De ses enemis emcombrer
Toutes le foiz ki remembrer
Ki[33] puet de son noble lignage,
Escoce pregn a teismoignage 280
Ke ben e noblement commence
Cum cil ki est de la semence
Le conte Mareschal le noble
Ki par dela Costentinoble 284
A l'unicorn se combati

31. *quart.* Oxford copy: *quarte.*
32. *tout.* Oxford copy: *toute.*
33. The Oxford copy reads: *li.*

E desouz li mort le abati.
De li de par mere est venus
A ki fu ben pareil tenus 288
Li bons Rogers, pere son pere,
Mes ne ot value[34] ki ne apere
Resuscitee el filz del filz.
Par coi ben sai ke onques ne en fiz 292
Loenge dont il ne soit dignes
Car en li est ausi bon signes
De estre preudom ke en nul ke envoie.[35]
Le roi son bon seignour convoie 296
Sa baniere mout honouree
De or e de asur eschequeré
O une fesse vermellette.
Si je estoie une pucellette 300
Je li donroie quer e cors
Tant est de li bons li recors.
Du bon Huë le Despensier
Ki vassaument sur le coursier 304
Savoit desrompre une mellee
Fu la baniere esquartelee
Du un[36] noir bastoun sur blanc getté
E de vermeil jaune fretté. 308
Del bon Huë de Courtenay
La baniere oubliee ne ay

[26 *a*]
De or fin o trois rouges rondeaus
E asurins fu li labeaus. 312
E le Amauri de Saint Amant
Ki va prouesce reclamant
De or e de noir fretté, au chief
O trois gasteaus[37] de or derechief. 316
Johans de Engaigne le ot jolie:
Rouge dance de or croissillie.
Puis i ot Watiers de Beauchamp
Sis merlos de or el rouge champ 320
O une fesse en lieu de dance.
[Chivallier, selon ma cuidance,][38]
Uns des mellours fust entre touz
Se il ne fust trop fiers e estouz. 324
Mes vous ne orrez parler jamés
De senescal ki ne ait un[39] mes.
Cil ke a tout bien faire a cuer lie

34. The Oxford copy reads: *prouesse.*
35. The Oxford copy reads: *ken nul convoie.*
36. *une.* The Oxford copy also reads *une* which we have, however, emended to *un* in order to avoid a hypermetric verse. Cf. v. 326. The following word is written *noier* but the *e* was scratched out and expunctuated.
37. The Oxford copy reads: *rondeaus.*
38. Missing verse in *K* restored according to the Oxford copy.
39. *une.* Same remark as in note to v. 307.

A un[40] sautour noir engreellie 328
Jaune baniere ot e penon,
Johans Boutetourte ot a noun.
Baniere bel apparellie
Jaune o crois rouge engreellie 332
La Eustace de Hache estoit.
Adam de Welle la portoit
Jaune o un noir lÿoun rampant
Dont la coue en double se espant. 336
Robert de Scales bel e gent
Le ot rouge o cokilles de argent.
Thouchez,[41] chevaliers de bon los,
Le ot vermeille a jaunes merlos. 340
Cele au conte de Laönois
Rouge o un blanc lÿoun conois
E blanche en estoit le ourleüre
A roses de l'enchampeüre. 344
Patrik de Dunbar, fiz le conte,
Ne la portoit par nul aconte
Fors de un[42] label de inde diverse.
Richart Suwart, ke o eus converse, 348
Noire baniere ot aprestee
O crois blanche o bouz flouretee.
Symon Fresel de cele gent
Le ot noire a rosettes de argent. 352
Le beau Brian le FilzAleyn
De courtoisie e de honnour pleyn
I vi o baniere barree
De or e de goules bien paree 356
Dont de chalenge estoit li poinz
Par entre li e Huë Poinz
Ki portoit tel ne plus ne meins
Dont merveille avoit meinte e meins. 360
Puis i fu Rogiers de Mortaigne,
Ki se peine ke honnour ataigne,
Jaune le ot o sis bleus lÿons
Dont les coues doubles dioms. 364
E de Hontercombe li beaus
De ermine o deus rouges jumeaus.
Guilleme de Ridre i estoit
Ke en la baniere inde portoit 368
Les croissans de or enluminez.
Avoec eus fu acheminez
Li beaus Thomas de Fourneval
Ki quant seoit sur le cheval 372

40. *Au.* The Oxford copy also reads *Au* which we have, however, emended to read *A*
un in order to avoid a hypometric verse. For the phrasing, cf. v. 712.
41. *Thouchez.* The word *Emlam* is superscribed above this name in a different hand
with the aid of a caret. This addition, which results in a hypermetric verse, is not
found in the Oxford copy.
42. *une.* Oxford copy: *un.* The latter reads *de asure* where *K* has *de inde.*

Ne sembloit home ki someille.
Sis merlos e bende vermeille
Portoit en la baniere blanche.
Johans de la Mare une manche 376
Portoit de argent en rouge ouvree.
Johans le Estrange le ot livree
Rouge o deuz blans lÿons passans.

[26 b]
Oncore i fui je conoissans 380
Johan de Graÿ ki virree
I ot sa baniere barree
De argent e de asur entallie
O bende rouge engreellie. 384
E Guillemes de Cantelo,
Ke je par ceste raison lo
Ke en honnour a touz tens vescu,
Fesse vaire ot el rouge escu 388
De trois flours de lis de or espars
Naissans de testes de lupars.
E puis Huë de Mortemer,
Ki bien se savoit fere amer, 392
O deus fesses de vair levoit
La baniere ke rouge avoit.
Mes a Symon de Montagu,
Ki avoit baniere e escu 396
De inde au grifoun rampant de or fin,
[Pernoit la terce eschiele fin.]⁴³
La⁴⁴ quarte eschiele o son conroi
Conduit Edewars, li fielz le roy, 400
Jovenceaus de dis e set ans
E de nouvell armes portans.
De cors fu beaus e aligniez,
De cuer courtois e ensegniez, 404
E desirans de ben trouver
Ou peüst sa force esprouver.
Si chevauchoit merveilles bel
E portoit o un bleu label 408
Les armes le bon roi son pere.
Or li doint Dieus grace ke il pere
Ausi vaillans e non pas meins
Lors porront chaïr en ses meins 412
Tel ki nel bëent faire oän.
Li preus Johans de Saint Johan
Fu par tout o lui assemblans
Ki sur touz ses guarnemens blancs⁴⁵ 416
El chief rouge ot de or deus molectes.

43. Missing verse in *K* restored according to the Oxford copy except that the latter's
tiers eschiel, which results in a hypometric line. has been emended to *terce eschiele*.
44. *a*. Space has been allowed for a large initial letter. Oxford copy: *La*.
45. *blans*. The letter *c* is superscribed between the *a* and the *n* with the aid of a caret.

Blanche cote e blanches alectes,
Escu blanc e baniere blanche
Portoit o la vermeille manche 420
Robers de Tony, ki bien signe
Ke il est du Chevaler au Cigne.
Baniere ot Henris li Tyois
Plus blanche de un poli lyois 424
O un chievron vermeil en mi.
Prouesce, ke avoit fait ami
De Guilleme le Latimier
Ki la crois patee de or mier 428
Portoit en rouge bien pourtraite,
Sa baniere ot cele part traite.
Guillemes de Leybourne ausi,
Vaillans homs sanz mes e sanz si, 432
Baniere i ot o larges pans
De inde o sis blans lÿouns rampans.
E puis Rogiers de Mortemer,
Ki deça⁴⁶ mer e dela mer 436
A porté quel part ke ait alé
L'escu barré au chief palé
E les cornieres gyronnees
De or e de asur enluminees 440
O le escuchon vuidié de ermine,
Ovoec les autres se achemine,
Car il e li devant nomez
Au filz le roy furent remez 444
De son frein guyour e guardein.
Mes comment ke je les ordein,

[27 a]
Li Sains Johans, li Latimiers,
Baillié li furent des primers 448
Ki se eschiele areër devoient
Cum cil ki plus de ce savoient.
Car quere aillours ne seroit preus
Deuz plus vaillans ne deuz plus preus. 452
Ami lour furent e veisin
Deuz frere au filz le roi cousin,
Thomas e Henri les nome on
Ki furent filz monsire Eymon, 456
Frere le roi le mielz⁴⁷ amé
Ke onques oisse ensi nomé.
Thomas de Langcastre estoit contes,
Se est de ses armes teus li contes: 460
De Engletere au label de France,
E ne vuel plus mettre en sousfrance.
Ke de Henri ne vous redie
Ki touz jours toute se estudie 464

46. *beca.* Oxford copy: *desa.*
47. *roi mielz.* Oxford copy: *roi le mieus.*

Mist a resembler son bon pere
E portoit les armes son frere
Au bleu bastoun sanz le label.
Guillemes de Ferieres bel 468
E noblement i fu remez
De armes vermeilles ben armés
O mascles de or del champ voidiés.
Cely dont bien furent aidiés 472
E achievees les amours
Aprés granz doutez e cremours
Tant ke Dieus le en volt delivre estre
Por la contesse de Gloucestre, 476
Por ki long tens souffri granz maus.
De or fin o trois chiverons vermaus
I ut baniere soulement;
Si ne faisoit pas malement 480
Kant ses propres armes vestoit:
Jaunes ou le egle verde estoit,
Se avoit non Rauf de Monthermer.
Aprés li vi je tout premier 484
Le vaillant Robert de la Warde
Ki ben sa baniere[48] rewarde,
Vairie est de blanc e de noir.
Johans de[49] Seint Johan, son hoir, 488
Lour ot baillié a compaignon,
Ki de son pere avoit le non
E les armes au bleu label.
Richart, le conte de Arondel, 492
Beau chevalier e bien amé
I vi je richement armé
En rouge au lÿon rampant de or.
Aleyn de la Souche tresor 496
Signefioit ke fust brisans
Sa rouge baniere o besans,
Kar bien sai ke il a despendu
Tresour plus ke en bourse pendu. 500
Par amours e par compagnie
O eus fu jointe la maisnie
Le noble eveske de Dureaume,
Le plus vaillant clerk du roiaume 504
Voire voir de crestienté.
Si vous en dirai verité
Por coi, se entendre me volez.
Sages fu e bien enparlez, 508
Atemprez, droituriers e chastes.
Ne onques riche home ne aprochastes
Ki plus bel ordenast[50] sa vie.

48. *banier.* Oxford copy: *baniere.*
49. *Johans seint Johan.* The word *de* is superscribed between the names *Johans* and *Seint* in a different hand with the aid of a caret. Oxford copy: *Johan de Saint John.*
50. *ordenaste.* Oxford copy: *ordenast.*

Orguel, covetise e envie[51] 512
Avoit il del tout getté puer;
Nonporquant hautein ot le quer

[27 *b*]
Por ses droitures meintenir
Si ke il ne lessoit convenir 516
Ses enemis par pacience,
Car de une propre conscience
Si hautement se conseilloit
Ke checuns se en semerveilloit.[52] 520
En toutes les guerres le roi
Avoit esté de noble aroi
A grant gens e a grans coustages.[53]
Mes je ne sai par queus outrages 524
Dont uns plais li fu[54] entamés;
En Engletere estoit remés
Si ke en Escoce lors ne vint.
Nonporquant si bien li souvint 528
Du roi ke emprise la voi a,
Ke de ses gens li envoia
Cent e seisante homes a armes.
Onques Arturs por touz ses charmes 532
Si beau present ne ot de Merlyn.
Wermeille o un fer de molyn
De ermine i envoia se ensegne.
Celuy ki tot honnour enseigne, 536
Johan de Hastingues a non,
La devoit conduire en son non,[55]
Car il estoit o li remez
Li plus privez, li plus amez, 540
De kanques il en i avoit.
E voir bien estre le devoit
Kar conneus estoit de touz:
Au fait de armes fiers[56] e estous, 544
En ostel douz e debonaires.
Ne onques ne fu justice en aires
Plus volentris de droit jugier.
Escu avoit fort e legier 548
E baniere de oevre pareile
De or fin o la manche vermeille.
Eymons, ses freres, li vaillans,

51. After *envie,* the scribe started the next word then crossed it out, having written the first letter only (*A*).
52. The Oxford copy reads: *Ke chescuns s'en esmerveilloit.*
53. After *coustages,* the scribe inadvertently skipped a line and started v. 525. Noticing his error after writing *Dont uns plais,* he expunged these words and proceeded with v. 524.
54. *uns plais fu.* Oxford copy: *uns plais li fu.*
55. The Oxford copy reads: *Li conduit o meint compaignon.*
56. *Au fair des armes feris.* Corrupt verse emended according to the Oxford copy. On the phrasing, cf. v. 855.

Le label noir i fu cuellans, 552
A ki pas ne devoit faillir
Honnours dont se penoit cueillir.
Un bacheler jolif e cointe,
De amours e de armes bien acointe 556
Avoint il a compaignon,
Johans Paignel avoit a non,
Ke en la baniere verde teinte[57]
Portoit de or fin la manche peinte. 560
E quant li bons Eymons Deincourt
Ne pout mie venir a court
Ses deuz bons filz en son leu mist
E sa baniere o eus tramist 564
De inde coulour de or billetee
O une dance surgetté.
De Johan le FizMermenduk,
Ke tuit prisoient prince e duc 568
E autre ke li conoissoient,
La baniere renbellissoient
La fesse e li trois papegaiz
Ke a daviser blancs en rouge ai. 572
E Morices de Berkelee,
Ki compaigns fu de cele alee,
Baniere ot vermeille cum sanc
Croissillie o un chievron blanc 576
Ou un label de asur avoit
Porce que ses peres[58] vivoit.
Mes Allissandres de Bailloel,
Ke a tout bien faire gettoit le oel, 580
Blanche banier avoit el champ

[28 *a*]
Al rouge escu voidié du champ.
A cestui daërein nomé
Ai sanz les doubles assomé 584
Seissant e vint e set banieres
Ki tienent les voies plenieres
Au chastel de Karlaverok.
Ne pas ne ert pris de eschek de rok 588
Ainz i aura trait e lancié,
Engin[59] levé e balancié,
Cum nous vous en aviseroms.
Kant le assaut en deviseroms. 592
Karlaverok[60] chasteaus estoit

57. *peinte.* Oxford copy: *tainte.*
58. *por ce peres.* A letter (*s*?) following the *e* in *ce* has been erased. In the left-hand margin, the words *que ses* have been added in the same hand. Oxford copy: *porce que ces peres.*
59. *Engine.* Oxford copy: *Engin.*
60. *arlaverok.* Space has been allowed for a large initial letter. In the left-hand margin, the letter *k* is written in a different hand.

Si fors ke siege ne doutoit
Ainz ke li rois iluec venist
Car rendre ne le convenist 596
Jamés mes ke il fust a son droit,
Guarnys, kant besoigns en vendroit,
De gens, de engins e de vitaile.
Cum uns escus estoit de taile 600
Car ne ot ke trois costez entour
E en chescun angle une tour,
Mes ke le une estoit jumelee,
Tant haute e[61] tant longue e tant lee 604
Ke par desouz estoit la porte
A pont tourniz bien fait e fort
E autres deffenses assez.
Se avoit bons murs e bons fossez 608
Trestouz pleins de eawe rez a rez.
E croi ke jamés ne verrez
Chastel plus bel de lui sëoir
Car al vules puet on vëoir 612
Devers le west la mer de Irlande
E vers le north la bele lande
De un bras de mer avironné
Si ke il ne est creature nee 616
Ki de deuz pars puist aprismer
Sanz soi metrre en peril de mer.
Devers le su legier ne est pas
Car il i a meint mauvais pas 620
De bois, de more, e de trenchiés
Si cum la mer les a cerchiés
Ou seult la riviere encontrer.
E por ce convint le ost entrer 624
Vers le est ou pendans est li mons.
E iluec a li rois somons
Ses batailes a arengier
En troes con devoit herbergier. 628
Lors[62] se arengierent banëour,
Si vëist on meint poignëour
Iluec son cheval esprouver.
E püest on iluec trouver 632
Troi mil homes de armee gent.
Si vëist[63] on le or e le argent
E de toutes riches coulours
Les plus nobles e les mellours 636
Trestout le val enluminer
Par coi ben croi ke adeviner
Cil du chastel peüssent donques
Ke en tel peril ne furent onques 640

61. *Tant haut.* Oxford copy: *Tant haute e.*
62. *ors.* Space has been allowed for a large initial letter. In the left-hand margin, the letter *L* is written in a different hand.
63. *vest.* Oxford copy: *veist.*

Dont il lour peüst souvenir
Kant ensi nous virent venir.
E tant cum si fumes rengié
Marescal orent herbergié 644
E tout par tout places liverees
Lors vëist on maisons ouvrees

[28 *b*]
Sanz charpentiers e sanz masons
De mult de diverses façons 648
De toile blanche e toile tainte.
La ot tendue corde meinte,
Meint poisson en tere fiché,
Maint grant arbre a tere trenchié 652
Por fere loges e fuellies,
Herbes e flours es bois cueillies
Dont furent joinchies dedenz
E lors descendirent nos genz 656
A ki tantost si bien avint
Ke la navie a tere vint
O les engins e la vitaile
E ja commençoit la pietaile 660
Au devant du chastel aler.
Si vëist on entre eus voler
Pieres, sajettes, e quareaus.
Mes tant chier changent lour meraus 664
Cil de dedenz a ceus dehors
Ke en petite houre plusours cors
I ot e blesciez⁶⁴ e navrez
E ne sai quanz a mort livrez. 668

Mes kant⁶⁵ les genz de armes perçurent
Ke li sergant tels maus reçurent
Ki commencié orent le assaut,
Meint en i court, meint en i saut, 672
E meint si haste si de aler
Ke a nulli ne en daigne parler.
Lors i peüst on reveoir
Ausi espés pieres chäoir 676
Cum si on en deüst poudrer,
Chapeaus e heaumes effrondrer,
Escus e targes depescier,
Car de tuer e de blescier 680
Estoit li ju dont cil juoient
Ki a granz cris se entrehuoient
Kant mal vëoient avenir.
La vi je tout primer venir 684
Le bon Bertram de Montbouchier.

64. *ot blesciez.* Oxford copy: *ot et blesciez.*
65. *kant.* Space has been allowed for a large initial letter before this word. Oxford copy: *Mes quant.*

De goules furent trois pichier
En son escu de argent luisant,
En le ourle noire li besant. 688
Gerard de Gondronvile o li,
Bacheler legier e joli,
Le escu ot vair ne plus ne meins.
Cist ne orent pas oiseuses[66] meins 692
Car meinte pere amont offrirent
E meint pesant coup i soffrirent.[67]
Bretouns estoit li primerains
E li secunds fu Loherains 696
Dont nuls ne troeve le autre lent
Ainz donnent baudour e talent
As autres de se i acuellier.[68]
Lors vint le chastel assaillir 700
Li FizMermenduc a baniere
O une grant route e pleniere
De bons bachelers esleüs.
Robert de Wileby veüs 704
I fu en or de inde fretté.
Robert de Hamsart tout apresté
I vi venir o bele gent,
Rouge o trois estoiles de argent 708
Tenant le escu par les enarmes.
Henri de Graham unes armes
Avoit vermeilles cumme sanc
O un sautour e au chief blanc 712
Ou ot trois vermeilles cokilles.
Thomas de Richemont, ki killes

[29 a]
Fesoit de lances derechief,
O deus jumeaus de or e au chief, 716
Avoit vermeilles armeüres.
Cist ne vont pas cum gens meüres
Ne cum genz de sen alumees
Mes cum arses e enfumés 720
De orguel e de malencolie
Car droit ont lour voie acuellie
Juk a la rive du fossé.
E cil de Richemont passé 724
A meintenant juques au pont.
Le entré demande, on li respont
De grosses pieres e cornues.
Wilebi en ses avenues 728
Ot une piere enmi le pis
Dont bien devroit porter le pis
Son escu, si le daignoit faire.

66. *oiseus.* Oxford copy: *oiseuses.*
67. *coup soffrirent.* Oxford copy: *coup i soffrirent.*
68. The Oxford copy reads: *acuellir.*

Li FizMermenduc tel affaire 732
Tant entreprist a endurer
Cum li autre i porent durer
Car il estut cum une estache
Mes sa baniere ot meinte[69] tache 736
E meint pertuis mal a recoustre.
Hamsart tant noblement se i moustre
Ke de son escu mult souvent
Voit on voler le taint au vent 740
Car il e cil de Richemont
Ruent lour pieres contremont
Cum si ce fust as enviales,
E cil dedenz a desfiailes 744
Lour enchargent testes e cous
De l'emcombrance de granz cups.
Cil de Graham ne fu pas quites
Car ne vaudra deus pomes quites 748
Kanques entere enportera
De l'escu kant s'en partira.
Es vous la noise commencié
Ovoec eus se est entrelancié 752
De genz le roi une grant masse
Dont si je touz les nons nomasse
E recontaisse les bons fais
Trop m'en seroit pesans li fais 756
Tant furent e tant bien le firent.
E nonporquant pas ne souffirent
Sanz la maisnie au fiz le roi
Ki mult i vint de noble aroi, 760
Kar meinte targe freschement
Peinte e guarnie richement,
Meinte heaume e meint chapeau burni,
Meint riche gamboison guarni 764
De soi e cadas e coton
En lour venue vëist on
De diverses tailles e forges.
Ilueques vi je Rauf de Gorges 768
Chevalier nouvel adoubé
De peres a tere tumbé
E defoulé plus de une foiz
Car tant estoit de grant bufoiz 772
Ke il ne s'en deignoit departir.
Tout son harnois e son atire
Avoit masclé de or e de asur.
Ceus ki estoient sur le mur 776
Robert de Tony mult grevoit
Car en sa compaignie avoit
Le bon Richart de la Rokele,
Ki ceus dedenz si enparkele 780

69. *meint.* Oxford copy: *meinte.*

Ke mult souvent les fait retraire
Cil ot son escu fait portraire

[29 *b*]
Masclé de goules e de ermine.
Adam de la Forde au mur mine 784
En tel maniere⁷⁰ cum il puet
Car ausi dru cum pluie pluet
Volent ses pieres enz e hors
Dont mult fu defoulez li ors 788
De trois lÿonceaus couronnez
Ke il ot rampans en inde nez.
Le bon baroun de Wiguetone
Merveilleis est ke tout ne estone 792
Li fais des coups ke il i reçoit
Car ja ce ke venus i soit
Sanz segnour hors de retenance
Ja plus n'en a la contenance 796
Esbahie ne espöentee.
Cil portoit bordure endentee
O trois estoiles de or en sable.
Meinte pesant piere e quaissable 800
Cil de Kirkebride i porta
Mes le⁷¹ escu blanc devant bouta
O la crois verde engreellie
Si ke mult fu bien asallie 804
De li la porte du chastel,
Car onques fevres de martel
Si sur son fer ne martela⁷²
Cum il e li sien firent la. 808
Nonporquant tant i ont esté
De grosses pieres tempesté
E de quareaus e de sagettes
Ke de blessures e plaiettes 812
Sont si las e si amorti
Ke a mult grant peine sont parti.

Mes⁷³ ainz ke il se en fussent partiz
Cil de Cliffort cum avertiz 816
E cum cil ki ne a eu pourpos
Ke cil dedenz aient repos
I a sa baniere envoié
E tant cum bien le a convoié 820
De Badelsmere Bartholmieius.
Johans de Cromewelle au mieus
Ke puet i a mise se entente.
Car nuls de ceus ne fait atente 824

70. *maner.* Oxford copy: *maniere.*
71. *les.* Oxford copy: *le.*
72. *fer martela.* Oxford copy: *fer ne martela.*
73. *es.* Space has been allowed for a large initial letter. Oxford copy: *Mes.*

De abessier e pieres cuellier[74]
E de ruer e de assaillir
Tant cum durer lour puet aleine.
Mes les genz a la chasteleine 828
Ne lour lessent avoir soujour.
Badelsmere, ki tout le jour
Iluec se contint bien e bel,
Portoit en blanc au bleu label 832
Fesse rouge entre deuz jumeaus.
Cromewelle, li preus, li beaus,
Ke entre le pieres va tripant,
En inde ot blanc lẏon rampant 836
Couronné de or o double coue
(Mes ne croi pas ke il la rescoue
Ke iluec ne li soit recoupee
Tant fu de pieres estampé 840
E broié ainz ke il se en ala!).
Aprés ceus deuz revindrent la
La Warde e Johans de Graẏ
Ki de nouvel ont envaẏ 844
Ceus de dedenz[75] ki bien atendent
E ars e arbalestes tendent
E traient de lour espringaut
E bien se tienent paringaut 848
E au getter e au lancier.
Puis vont le assaut recommencier

[30 *a*]
Le gens monsegnour de Bretaigne,
Cum li lẏon de la montaigne 852
Corajouses e empernans,
E sont chescun jour apernans
Le fait de armes e le mestier.
Mult tost conurent li portier 856
Du chastel lour acointement
Car autre plus felounement
Ainz ne les orent assilli.
Nonporquant ne ont mie failli 860
Ke ki ke pres viegne ne ait part
De lour livree ainz ke il se enpart
Tant ke plus ke assez li en semble.
E aprés ceus iluec se assemble 864
La gent monsegnour de Hastingues
Ou je vi Johan de Cretingues
En peril de perdre un cheval
Kant sur li un vint contreval 868
Esperonnant au saietiz

74. The Oxford copy reads: *cueillir.*
75. An oil stain renders this word nearly illegible. Oxford copy: *dedenz* (in the latter manuscript, however, the word *de*, which precedes this term, has been conflated with *dedenz,* resulting in a hypometric line).

Mes pas ne semble estre faintiz
Ki tant se haste au fait ateindre.
En son blanc escu ot fait teindre 872
Un chievron rouge o trois molettes.
Cil ki porte dance e bilettes
De or en asur a l'assaut court,
Johans avoit a non Daincourt, 876
Ki mult bien i fist son devoir.
Ansi le firent bien por voir
En recevant meinte colee
Li bon frere de Berkelee 880
E li frere[76] Basset ausi
Dont li ainsnez portoit ensi
De ermine au chief rouge endenté
De trois molettes de or enté, 884
Li autres de cokilles trois.
Chemins trouveroient estrois
Cil de dedenz se or s'en alassent,
Car touz jours cum li un se lassent 888
Autre i revienent fres e froit.
Mes por quanques on lour offroit[77]
De tels assaus, ne se rendirent
Cil dedenz ainz se deffendirent 892
E se tindrent, ki ke il anuit,
Tout cel jour e toute[78] la nuit
E l'endemein juques a terce.
Mes durement eus e lour fierce 896
Entre les assaus esmaia
Frere Robert, ki envoia
Meinte piere par robinet,
Juk au soir des le matinet 900
Le jour devant cessé ne avoit.
De autre part oncore i levoit
Trois autres enginz mult plus granz.
E il, penibles e engrans, 904
Ke le chastel du tout confonde
Tent e retent, met piere en fonde,
Descoche e quanques ateint fent,
A ses coups rien ne se deffent 908
Bors de bretesche ne gros fus.
Nonporquant n'en firent refus
Ainz tindrent touz ses enviaus
Cil de dedenz, tant ke enmi aus 912
En fu uns ferus a la mort.
Mes lors checuns de eus se remort
De son orguel e se esbahi,

76. *E li frere.* The Roman numeral *.ij.*, for *dui* 'two' is superscribed between the
words *li* and *frere* in a different hand with the aid of a caret. This addition is not
found in the Oxford copy.
77. *offrit.* Oxford copy: *offroit.*
78. *tout.* Oxford copy: *toute.*

Car ausi li combles chaÿ 916
Par tout par ou la piere entra.
E kant acun de eus encontra,

[30 b]
Chapeaus de fer, targe de fust
Ne sauva ke blesciez ne fust. 920
E quant virent ke plus durer
Ne porrent ne plus endurer,
Pes requistrent[79] li compaignon
E bouterent hors un penon. 924
Mes celuy ki hors le bouta
Ne sai ques sergans sajeta
Parmi la mein juk en la face.
Lors requist c'on plus ne li face 928
Car le chastel au roi rendront
E en sa grace hors vendront.
E marechaus e conestables,
Ke adés iluec furent estables, 932
A cel mot le assaut deffendirent
E cil le chastel lour rendirent.
Lors s'en issirent, ce est la some,
Ke de uns ke de autres seisant home. 936
A grant merveille resguardé
Mes tenu furent e guardé
Tant ke li rois en ordena
Ki vie e menbre lour dona 940
E a chescun robe nouvele.
Lors fu joiouse la nouvele
A toute le ost du chastel pris,
Ki tant estoit de noble pris. 944
Puis fist li rois porter amont
Sa baniere e la Seint Eymont,
La Seint George, e la Seint Edwart,
E o celes, par droit eswart, 948
La Segrave e la Herefort,
E cel au seignour de Cliffort
A ki li chasteaus fu donnez.
E puis a li rois ordenez, 952
Cum cils ki de guere est mut sages,
Touz ses chemins e ses passages
Comment ira parmi[80] Gawee,
Cele forte tere löee. 956

Ci finist le Siege de Karlaverok.

79. *requiterent.* Oxford copy: *requistrent.*
80. *par mie.* Oxford copy: *par mi.*

Remarks

1. Concordance

The numeration of the verses in *K* agrees with that found in *The Roll of Arms of the Princes, Barons and Knights who Attended King Edward I to the Siege of Caerlaverock, in 1300,* ed. Thomas Wright (London, 1864).

2. Abbreviation

The only abbreviation which presents a problem in this manuscript is *ml't* which we have everywhere transcribed as *mult* (vv. 68, 648, 739, 760, 777, 781, 788, 804, 814, 856, 877, 903), the spelling found in verse 56 (cf. v. 297: *mout*; v. 953: *mut*).

3. Numbers

ij, for *dui:* v. 881 (but here an error).

viiij, for *nuef:* v. 204 (but here an error for *uit*).

Also:

for 1, *un* or *une:* everywhere.

for 2, *deus:* vv. 47, 110, 211, 393, 417, 716 (cf. *deuz:* vv. 251, 379, 454, 563, 617, 833, 842).

for 3, *trois:* vv. 54, 163, 199, 202, 220, 255, 311, 316, 389, 478, 571, 601, 686, 708, 713, 789, 799, 873, 884, 885, 903 (cf. *treis:* vv. 75, 180; *troes:* v. 628; see also below, for 3000).

for 4, *quatre:* v. 30.

for 5, *cink:* v. 126.

for 6, *sis:* vv. 65, 112, 320, 363, 374, 434.

for 17, *dis e set:* v. 401.

for 60, *seisant:* v. 936 (see also below, for 87 and 160).

for 87, *seissant e vint e set:* v. 585.

for 100, *cent:* v. 137.

for 160, *cent e seisante:* v. 531.

for 3000, *troi mil:* v. 633.

The following ordinal numbers are also found:

for 1, *primerains:* v. 695.

for 2, *secunds:* v. 696.

for 3, *terce:* vv. 216, [398], 895 (cf. *ters:* v. 2).

for 4, *quarte:* v. 399.

for 5, *cinkime:* v. 57.

for 1300, *milem treicentime:* v. 3.

4. Notes

The language in which the original of this poem was written is said to be Old French, not Anglo-Norman; see Johan Vising, *Anglo-Norman Language & Literature* (1923; rpt. Westport, Conn.: Greenwood Press, 1970), p. 67; *CEMRA*, p. 29; Denholm-Young, "The Song of Carlaverock," p. 255; *History and Heraldry*, p. 59. However, the situation is not that simple. While the version in the Glover copies is in Old French, the British Museum manuscript contains a version in which the Old French poem reveals a number of Anglo-Norman characteristics including faulty declension, effacement of mute *e*, post-tonic *i* for *e* in the ending *-is*, and velarization of nasal *a*.

In the present state of research, it is impossible to say with certitude which version is closer to the original. It appears likely that an Anglo-Norman scribe copied an Old French original, consciously or unconsciously introducing modifications as he went along. This explanation has the advantage of accounting for the independent Old French version which exists in the Glover copies. The reverse procedure seems less probable, namely that the original, composed in a mixture of Old French and

Anglo-Norman from which the British Museum manuscript was copied, would later have been transcribed by a copyist who removed the most prominent insular characteristics.

If the original was in Old French, the British Museum version may, in spite of its Anglo-Norman traits, still be more reliable. Several verses have dropped out of each version (fortunately, these are preserved in the alternate tradition; see Brault, "The Hatton-Dugdale Facsimile," p. 48) but in at least one passage the British Museum manuscript provides a correct blazon where the Glover copies are corrupt. In vv. 581-582, the arms of Alexander de Balliol are *argent, an orle gules* in the former (*Blanche banier avoit el champ* / *Al rouge escu voidié du champ*), while the latter blazon the banner *Or, an orle gules* (Oxford copy: *Jaune baniere avoit el champ* / *Au rouge escu voidié du champ*). In a review of Wright's edition entitled "The Siege of Carlaverock in 1300," *Herald and Genealogist*, 2, 383, John Gough Nichols made the curious claim that Glover's version was the correct one: "the Cottonian MS. substitutes, as the tincture of the field, *blanche* instead of *jaune*, which is the reading of Glover's manuscript. Now the roll of Henry III and other authorities describe the field of Baliol as *or*, and not *argent*; and thus, in this case also, Glover's appears to be the preferable reading." The arms of Alexander de Balliol, pace Nichols, are *argent, an orle gules* (see *H* 28 and Henry Gough, *Scotland in 1298*, p. 136, citing St. George's Roll and Charles's Roll). For the other variant, involving only a minor slip on the part of the British Museum scribe, see, below, note to *K*, v. 204.

At any rate, the version represented by the British Museum copy is certainly interesting in its own right and it is the one on which scholarly attention has been focused since Wright's edition. This is, then, the version we have given here. In the notes which follow, I have indicated some of the Anglo-Norman characteristics of this copy. The rules of French versification *c.* 1300 are too complicated to set forth here, in particular those concerning the scansion of words containing a mute *e*. Useful information in this regard is to be found in Georges Lote, *Histoire du vers français*, III (Paris: Hatier, 1955), pp. 73-133. For Anglo-Norman metre, which is also involved here, consult Vising, pp. 79-88.

K, v. 27 – *tentis;* cf. vv. 182: *sagis;* 183: *vermellettis;* 199: *rosis;* see also vv. 75: *goulys;* 792: *merveilleis.* On Anglo-Norman post-tonic *i* for *e*, see Vising, p. 29.

K, v. 35 – *nomement*] *nomeëment.* Cf. v. 88. On the effacement of Anglo-Norman *e* in hiatus, see Pope, *From Latin to Modern French*, paras. 1089, 1288.

K, v. 42 – *lïoun;* cf. vv. 100: *noun;* 163, 307, 467: *bastoun;* 222: *feloun;* 397: *grifoun*, etc. Use of the digraph *ou* for oral and nasal *u* in Anglo-Norman is discussed by Pope, paras. 1085, 1220.

K, v. 56 – *une*] *un.* On the disintegration of declension in articles in Anglo-Norman, see Pope, para. 1253; cf vv. 307, 347.

K, v. 61 – for the pronunciation of the diphthong *ai* in this name, an Anglo-Norman trait, see Pope, para. 1157.

K, v. 65 – *pecys* (Oxford copy: *piecis*). The development *ie* ⟩ *e* in Anglo-Norman is cited by Pope, para. 1155.

K, vv. 67-68 – *estout* features a western form of termination for the imperfect indicative, an Anglo-Norman characteristic (Pope, para. 1277). Cf. the rhyme *metoit.*

K, v. 88 – *adesscement*] *adesseëment.* See above, note to v. 35.

K, vv. 121-124 – London, *Aspilogia II*, p. 149, neglects to mention the gules label in citing this passage.

K, v. 126 – *chivalier;* on the raising of *che-* to *chi-* in Anglo-Norman, see Vising, p. 32; Pope, para. 1200.

K, v. 130 – *baner*] *baniere.* The suppression of final post-consonantal *e* in Anglo-Norman is discussed by Pope, para. 1135. This is frequently found in this copy.

K, vv. 165-166 – on the reduction of triphthongs in Anglo-Norman, see Pope, para. 1090. Cf. vv. 501-502.

K, vv. 179-180 – on the interchangeability of the symbols *ie* for *e* in such circumstances, cited as an Anglo-Norman feature, see Pope, para. 1223. The rhyme *ie* / *e* is listed by Vising, p. 32.

K, v. 184 – *blonc;* on the velarisation of nasal *a* in Anglo-Norman, see Pope, para. 1152.

K, v. 186 – for the conjectures of Nicolas concerning this verse, see Introduction, p. 12, n. 23.

K, v. 187 – *vesyn* (Oxford copy: *voisin*); cf. v. 453: *veisin.* On the levelling of *ei* to *e* in Anglo-Norman, see Pope, para. 1158.

K, v. 190 – *egreellie,* for *engreellie.* The suppression of pre-consonantal nasals in Anglo-Norman is mentioned by Pope, para. 1151.

K, v. 204 – a barry of 8 for Hugh Pointz is attested in several contemporary sources; see *Papworth's Ordinary,* p. 54. This error in the British Museum copy was noted by Nichols in his review of Wright (p. 383). On the controversy involving this knight and Brian FitzAlan, see Sir Anthony Wagner, *Heralds and Heraldry in the Middle Ages,* 2nd ed. (Oxford: Oxford University Press, 1956), pp. 19, 21, 122.

K, v. 341 – *Laönois* was the Old French name for Lothian, a region in southern Scotland; see G. D. West, *An Index of Proper Names in French Arthurian Verse Romances 1150-1300* (Toronto: University of Toronto Press, 1969), p. 104, s.v. *Loënois.* This identification is ascribed to Riddell in 1841 by Nichols in his review of Wright (pp. 386-387). The latter followed Nicolas who mistranslated the title as the "Earl of Lennox".

K, v. 398 – for the orthography of *eschiele,* cf. v. 399; for *terce,* see vv. 212 and 216.

K, v. 347 – see above, note to v. 56.

K, v. 384 – Gough, *Scotland in 1298,* p. 138: "In the Poem of Carlaverock the bend [in John Grey's arms] is described as *engrailed,* which seems to be merely an error of the rhymer." Cf. *H* 37.

K, v. 441 – on the term *escuchon vuidié* 'voided escutcheon, i.e. orle, but here meaning escutcheon', see my article entitled "Heraldic Terminology and Legendary Material in the *Siege of Caerlaverock* (*c.* 1300)" (cited above, p. 12), pp. 15-16.

K, v. 520 – the metathesis *es,* ⟩ *se-* in the word *semerveilloit* was perhaps influenced by the frequent confusion of the prefixes *es-* and *en-* in Anglo-Norman; see Pope, para. 1177.

K, vv. 571-572 – on the effacement of final unsupported *z* in Anglo-Norman, see Pope, para. 1203.

K, v. 578 – the scribe may have confused *ces* for *ses* before making the correction (see note); on this Anglo-Norman trait, see Pope, paras. 1231, 1261.

K, vv. 581-582 – on this blazon, see above, p. 124.

K, v. 609 – *eawe.* The fricative labio-velar *w,* which evolved in such words on the Continent, persisted in insular French; see Pope, para. 1180.

K, v. 678 – Nicolas and Wright both read the first part of this verse as follows: *E chapeaus,* which results in a hypermetric line. The manuscript actually reads *Cchapeaus,* the double c merely being a way of indicating a capital letter c. Cf. v. 769: *Cchevalier.* A similar system is used in this copy for capital letter f in vv. 5 *(ffu)* and 833 *(ffesse).*

K, vv. 699-700 – on the rhyme *ier* / *ir,* see the note to vv. 179-180. The same rhyme is found in vv. 825-826.

K, vv. 825-826 – see the preceding note.

K, v. 955 – the inorganic *e* in *parmi* (see note) may be a hypercorrection occasioned by the frequent suppression of final post-consonantal *e* in Anglo-Norman (see above, note to v. 130).

Table of Proper Names

N. B. List of the persons whose arms are blazoned in the Bigot Roll *(BA)*; Glover's Roll, St. George's Version, copy *a (Ba)* and copy *b (Bb)*; Walford's Roll, Charles's Version *(C)* and Leland's Version, copy *a (Cl)* and copy *b (Cd)*; the Camden Roll *(D)*; the Chifflet-Prinet Roll *(CP)*; the Falkirk Roll, Thevet's Version *(H)*; the Nativity Roll *(M)*; and the *Siege of Caerlaverock (K)*. Entries under one name may refer to different individuals.

Aa, Thierry of, *BA* 49.
Abbeville, Count of, *CP* 4.
Abrenes, see Braine.
Achard, Pierre, *BA* 279.
Achi, see Assé.
Acre, see Jerusalem.
Aguillon, Robert, *Ba* 42, *Bb* 42, *C* 154, *Cl* 158, *Cd* 90, *D* 108.
Ainghien, see Enghien.
Aion, see Anjou.
Albemarle, see Aumale.
Albret, Amanieu d', *H* 57, *K*, v. 261.
Alemaine, see Germany.
Alfonso, see England.
Alftere, Hermann, Marshall of Cologne, *BA* 56.
Almaine, Almayne, see Germany.
Alseque, see Alftere.
Amboise, Pierre d', *CP* 117.
Ancenis, Geoffroi d', *CP* 145.
Anevaul, see Esneval.
Angenya, Angevyn, see Aguillon.
Angletere, see England.
Angus, Earl of, *D* 103, *H* 24.
Anjou, see Sicily.
Anthenaise, Amauri d', *BA* 243.
Antoine, Sire d', *D* 70.
Ap Adam, John, *H* 72.
Aquimegny, see Gymnich.
Aragon, James I, King of, *C* 7, *Cl* 9, *Cd* 9.
 Peter III, *D* 6.
Archat, Richard, *M* 8.
Archevesk, see Parthenay.
Arcy, see Darcy.
Argentine, Gilles d', *D* 140.
Armenia, King of, *C* 14, *Cl* 20, *Cd* 37, *D* 14.

Armenters, John de, *D* 109.
Artois, Count of, *C* 29 (error), *Cl* 31, *Cd* 48.
Arundel, see FitzAlan.
 Richard, Earl of, *K*, v. 492.
Ascele, Asceles, Asscele, see Athol.
Asche, Sire d', *D* 56.
Assé-le-Boisne, Geoffroi, senechal d', *BA* 226.
Astley, Andrew de, *H* 47.
Athol, Earl of, *C* 52, *Cl* 62, *Cd* 149, *D* 162.
Atton, Gilbert de, *M* 48.
Aubemarle, see Aumale.
Auberchicourt, Wautier d', *BA* 139.
Aubemer, see Aumale.
Aubigny, Elie d', *K*, v. 258.
Auchoire, see Auxerre.
Audedoyle, see Audley.
Audenarde, Jean d', *BA* 69.
 Sire d', *D* 55.
Audley, James de, *Ba* 35.
 Nicholas de, *H* 21.
 William de, *D* 96.
Aumale, William de Forz, Count of, *Ba* 7, *Bb* 7.
 Thomas de Forz, Count of, *C* 50, *Cl* 60, *Cd* 147, *D* 128.
Aunfour, see Alfonso.
Austria, Duke of, *C* 74, *Cl* 47, *Cd* 25.
Autrèches, Gaucher d', *CP* 61.
Auvergne, Count of, *C* 34, *Cl* 36, *Cd* 14.
Auxerre, Count of, *CP* 6.
Averton, Geoffroi d', *CP* 129.
 Guillaume d', *BA* 241.
Awans, William of, *BA* 87.

Badeham, see Ap Adam.
Badlesmere, Bartholomew de, *K*, vv. 821, 830.
 Guncelyn de, *D* 172.
Bailleul, Enguerrand de, *CP* 45.
 Jean de, *CP* 114.
 Pierre de, *CP* 46.
Baire, see Buir.
Balliol, Alexander de, *D* 130.
 Alexander de. *H* 28, *K*, v. 579.
 Eustace de, *C* 115, *Cl* 142, *Cd* 75.
 Hugh de, *Ba* 24, Bb 24.
 John de, *Ba* 23, *Bb* 23.
Bar, Count of, *C* 29, *Cl* 30, *Cd* 47.
 Jean de, *H* 53, *K*, v. 249.
Bardolf, Hugh, *H* 10, *K*, v. 52.
 Thomas, *C* 110, *Cl* 137, *Cd* 61.
 William, *Ba* 49, *Bb* 49.
 William, son of William, *C* 111, *Cl* 138, *Cd* 62, *D* 150.
Barking, Thomas de, *M* 60.
Barnaige le Weede, Aernoult de, *C* 89, *Cl* 77, *Cd* 164.
Barnam, see Bornhem.
Barralle, Wagon de, *BA* 170.
Basores, Basseches, Basseger, see Bazoches.
Basset, Edmund, *K*, vv. 881, 885.
 John, *K*, vv. 881, 882.

Philip, *D* 124.
Ralph, *C* 131, *Cl* 92, *Cd* 102, *D* 115, *H* 29.
Bassingbourne, Warin de, *Ba* 22, *Bb* 22, *C* 109, *Cl* 136, *Cd* 136, *D* 122.
Batale, see Barralle.
Baucey, Hugh de, *C* 172, *Cl* 177, *Cd* 74, *CP* 128; see also Baussay.
Baudesen, Baunstersein, Bausterseyn, see Bautersem.
Baussay-le-Noble, see Baucey.
 Guillaume de, *BA* 249.
 Pierre de, *BA* 248.
Bautersem, Henri de, *BA* 45, *C* 179, *Cl* 184.
 Sire de, *D* 43.
Bavaria, Duke of, *BA* 10, *C* 75, *Cl* 48, *Cd* 26; see also Beveren.
Bayon, Jacques de, *CP* 93.
Bazoches, Henry de, *D* 73.
 Robert de, *C* 176, *Cl* 181.
Bazeilles, Pierre de, *BA* 208.
 Raoul de, *BA* 207.
Bealme, see Bohemia.
Beauchamp, Geoffrey de, *C* 139, *Cl* 150, *Cd* 83.
 Guy de, see Warwick,
 John de, *H* 105, *K*, v. 206.
 Walter de, *C* 117, *Cl* 147, *Cd* 80.
 Walter de, *H* 83, *K* v. 319.
 William de, *Ba* 34, *Bb* 34.
Beaumanoir, Jean de, *CP* 141.
Beaumont, Henry de, *M* 3.
 Jean de, *CP* 108.
 Louis, vicomte de, *BA* 238.
 Mathieu de, *BA* 276.
Beaussart, Gui de, *CP* 55.
Beauval, Sire de, *CP* 58.
Beiaune, see Bayon.
Bek, Anthony, Bishop of Durham, *H* 22, *K*, v. 503.
Belingne, Belygne, see Dillingen.
Bellens, see Boisleux.
Belleville, Maurice de, *CP* 134.
Benestede, John de, *H* 87.
Benteham, Seclinng of, *BA* 86.
Bérard, Geoffroi, *BA* 222.
Berg, Adolphe VII, Count of, *BA* 8.
 Adolphe VIII, Count of, *C* 61, *Cl* 116, *Cd* 127.
Berginnes, Guillaume de, BA 136.
Berg-op-Zoom, Gilles de, *BA* 112.
Bergue, see Berg-op-Zoom.
Bergues, Châtelain de, *CP* 72.
Berkeley, Maurice de, *D* 171, *K*, v. 573; see also Thomas (error).
 Thomas de, *H* 99 and 109 (error for Maurice), *K*, v. 578.
Berkyng, see Barking.
Berlo, Eustache de, *BA* 146.
 Fastre de, *BA* 147.
Bernam, see Bornhem.
Berners, John de, *C* 119, *Cl* 149, *Cd* 82.
Berthout, Gautier, *C* 180, *Cl* 185.
 Louis, *D* 57.
Bertram, see Berthout.
Bertrand, Robert, *CP* 81.
Béthune, William de, *D* 51.

Beveren, Duke of, *D* 23; see also Bavaria.
 Sire de, *D* 58.
Beyvere, see Beveren.
Bierbais (Bierbeeck), Thierry of, *BA* 50.
Bigod, Hugh le, *C* 130, *Cl* 91, *Cd* 101.
 Roger, Earl of Norfolk and Marshall of England, *H* 3.
Bigorre, Eskivat, Count of, *BA* 281.
Blankminster, Richard de, *M* 55.
Blois, Hughes, Count of, *D* 30.
 Jean, Count of, *C* 24, *Cl* 25, *Cd* 42.
 Renouard de, *M* 79.
Boeme, Boesme, see Bohemia.
Bohemia, King of, *C* 10, *Cl* 10, *Cd* 10, *D* 11.
Bohun, Henry (error for Humphrey) de, *H* 4; see Hereford.
Boisleux, Robert de, *CP* 69.
Bologne, see Dillingen.
Bordeaux, Piers de, *H* 90.
Borgne, Geoffroi le, *CP* 138.
 (incomplete), *BA* 174.
Born, Gossuin II of, *BA* 29.
Bornheim, Schilling of, *BA* 86, but see note.
 Wilhelm Schillinck of, *BA* 60.
Bornhem, Henry of, *C* 90, *Cl* 78, *Cd* 165.
Botetourt, John, *H* 73, *K*, v. 330.
Botresham, see Bautersem.
Boubers, Gerard de, *CP* 47.
Boulogne, Godefroi, Count of, *CP* 3.
 Robert VI, Count of, *CP* 2.
Boulonnais, Constable of, *CP* 56.
Boussoit-sur-Haine, Jean Sausset de, *CP* 70.
Bouteiller, Anseau le, *CP* 22.
 Gui le, *CP* 21.
Bouville, Hugues II de, *CP* 97.
Bowheme, see Bohemia.
Boys, Ernald de, *C* 122, *Cl* 153, *Cd* 85.
 John de, *D* 133.
Boyvil, William de, *C* 140, *Cl* 100, *Cd* 110.
Brabant, Henry III, Duke of, *BA* 43.
 John I, Duke of, *C* 73, *Cl* 46, *Cd* 24, *D* 18.
 Godefroi de, *D* 176, *CP* 75.
Braine, Count of, *C* 25, *Cl* 26, *Cd* 43.
Braose, see Brewes.
Breban, see Brabant.
Brechin, William of, *C* 81, *Cl* 64, *Cd* 151.
Bréda, Henry III of, *BA* 47.
Brederode, William of, *BA* 57.
Brenes, see Braine.
Brequyn, Breynin, Breyquyn, see Brechin.
Breton, John le, *D* 75.
Brett, see Albret.
Breuse, John de, *C* 141, *Cl* 101, *Cd* 111.
Brewes, William de, *Ba* 36, *Bb* 36, *D* 134, *H* 31.
Brianst, see Beaussart.
Bridas, see Bréda.
Brittany, see Dreux.
 Count of, *C* 23, *Cl* 24, *Cd* 41.
Bruniquel, Guillaume dit Barasc, vicomte de, *CP* 133.

Bruns, li, see Trazegnies.
Brunswick, Duke of, *D* 21.
Brus, Piers de, *Ba* 29, *Bb* 29.
 Robert de, *D* 129.
Bruxelles, Châtelain de, *BA* 48.
 Sire de, *D* 168.
Bruyères, Adam de, *CP* 121.
Buch, the Captal de, *H* 60.
Bucher, see Buch.
Buir, Guillaume de, *BA* 106.
Buirel, see Bures.
Bulmer, Ralph de, *M* 51.
Bures, Hugues de, *BA* 212.
Burgh, John de, *C* 144, *Cl* 104, *Cd* 114, *D* 126.
 Walter de, *C* 164, *Cl* 169, *Cd* 66.
Burgundy, Duke of, *C* 72, *Cl* 112, *Cd* 123.
Burniquet, see Bruniquel.
Buron, Richard, *M* 76.
Bursay, see Boussoit.
Busignies, Gerard de, *BA* 157.
 Gilles de, *BA* 96.
Buttenheim, see Bornheim.

Cabric, Thibaud de, *CP* 147.
Cambrai, (incomplete) de, *BA* 171.
Camoys, John de, *D* 112.
 Ralph de, *Ba* 43, *Bb* 43.
 Ralph, son of Ralph de, *C* 120, *Cl* 151, *Cd* 84.
Canny, Flament de, *CP* 52.
Cardonnoy, Adam du, *CP* 50.
Carew, Nicholas de, *K*, v. 175.
Carrick, Earl of, *D* 163.
Casa Nova, Othes de, *H* 91.
Casenave, Cazeneuve, see Casa Cova.
Castelnuef, see Châteauneuf.
Castile, Alphonso the Wise, King of, *Cl* 7, *Cd* 7; see also Spain.
Castilton, see Châtillon.
Caumont, Hugues de, *CP* 48.
Cauni, see Canny.
Cauntelo, George de, *D* 94.
 John de, *D* 64, *H* 38.
 William de, *Ba* 15, *Bb* 15.
 William de, *H* 71, *K*, v. 385.
Cecyle, see Sicily.
Cervoise, Guillaume de, *BA* 220.
Cessun, see Soissons.
Chalon, Count of, *C* 55, *Cl* 69, *Cd* 156, *D* 83.
Châlons, Vidame de, *CP* 111.
Chamberlain, William de, *D* 166.
Chambly, Oudard de, *CP* 29.
 Pierre de, *CP* 27.
 Pierre, son of Pierre de, *CP* 28.
Champagne, Count of, *C* 40, *Cl* 42, *Cd* 20.
Champvent, see Chavent.
Chandos, John, *M* 32.
Chaorzel, see Sourches.
Charbogne, Nicholas de, *CP* 79.

Charni, Jean de, *CP* 131.
Chartres, Guillaume, vidame de, *CP* 125.
Chastelle, see Castile.
Châteauneuf, Josiaume de, BA 285.
Châtelier, Jean du, *CP* 106.
Châtillon, Gui III de, Count of St. Pol-sur-Ternoise, *C* 26, *Cl* 27, *Cd* 44, *D* 32.
 Pointz de, *H 58*.
Chauvigny, Guillaume II de, *BA* 290, *C* 177, *Cl* 182.
 Jean de, *BA* 291.
Chavael, Gervais de, *BA* 184.
Chavent, Piers de, *H* 84.
Chaworth, Patrick de, *Ba* 37, *Bb* 37, *D* 135.
Chebé, Guillaume de, *BA* 193.
Chelé, see Chebé.
Chemillé, Gui de, *CP* 124.
Chepillen, Amauri of, *BA* 37.
Chester, Earl of, see England.
Cheures, see Chaworth.
Chevreuse, Anseau de, *CP* 20.
 Henri de, *C* 150, *Cl* 110, *Cd* 120.
 N. de, *Cd* 121.
Chieze, Nicolas de, *BA* 210.
Chipre, see Cyprus.
Choisel, Anseau de, *CP* 24.
Choiseul, Jean de, *CP* 23.
Chourses, Sire de, *CP* 110.
Clare, Thomas de, *C* 85, *Cl* 73, *Cd* 160, *D* 38.
Clavering, John de, *H* 17, *K*, vv. 98-99.
Cieres, Jean de, *CP* 101.
Clermont-les-Nandrin, Libert de, *BA* 110.
Cleves, Henri de (error for Thierry, who became Count of Cleves in 1260), *BA* 20.
 Thierry VI (1202-1260), Count of, *BA* 19.
 Thierry VIII (1275-1305), Count of, *C* 58, *Cl* 113, *Cd* 124.
 Thierry le Louf de, *BA* 14.
Clifford, Robert de, *C* 147, *Cl* 107, *Cd* 117.
 Robert, grandson of Roger de, *H* 56, *K*, vv. 275, 950.
 Roger, nephew of Walter and grandfather of Robert de, *Ba* 18, *Bb* 18, *D* 81.
 Roger, son of Roger de, *D* 86.
 Walter de, *Ba* 17, *Bb* 17.
Clinchamps, Sire de, *BA* 236.
Cockfield, Robert de, *D* 182.
Coismes, see Coymes.
Cockerel, Arangue Briseteste de, *BA* 104.
 Robert Briseteste de, *BA* 103.
Colesteyn, Count of, *C* 67, *Cl* 122, *Cd* 133.
Coleville, Thomas de, *M* 19.
Comyn, John, *C* 84, *Cl* 70, *Cd* 157, *D* 167.
Constable of France, Raoul de Clermont, *CP* 41.
Constable, Robert le, *M* 78.
 William le, *M* 77.
Constantinople, Emperor of, *C* 2, *Cl* 12, *Cd* 29.
Corbet, Piers, *H* 27, *D* 62.
Cormes, Guillaume le Maire de, *BA* 189.
 Jean de, *BA* 190.
Corneuil, Pierre de, *CP* 115.
Cornwall, Earl of, *C* 99, *Cl* 124, *Cd* 135, *D* 33.
Cortene, Garin de, *BA* 240.

Corterne, see Couterne.
Coscy, see Coucy.
Couardon, Payen de, *BA* 198.
Coucy, Enguerrand de, *CP* 66.
 Thomas de, *C* 175, *Cl* 180.
Couliedre, Geoffroi de, *BA* 214.
Courtenay, Hugh de, *H* 111, *K*, v. 309.
 Jean de, *CP* 95.
Couterne, Gervais de, *BA* 206.
Coymes, Payen de, *BA* 200.
Cransun, see Grandison.
Craon, Maurice de, *K*, v. 274.
Creke, Baldwin de, *Cl* 166, *Cd* 98.
Crepilly, Wistasse de, *BA* 166.
Cresèques, Robert de, *C* 171, *Cl* 176, *Cd* 73.
Crespin, Guillaume, *C* 148, *Cl* 108, *Cd* 118, *CP* 15.
 Guillaume, son of Guillaume, *CP* 16.
 Jean, *CP* 17.
Creting, Adam de, *D* 137.
 John de, *K*, v. 866.
Crevequer, Hamo de, *Ba* 40, *Bb* 40.
 Robert de, *D* 127.
Cromwell, John de, *M* 4, *K*, vv. 822, 834.
Culant, Renaud II de, *BA* 288.
Cyprus, King of, *C* 13, *Cl* 16, *Cd* 33, *D* 10.

Dae, see Dunbar.
Dakeny, Baldwin, *Ba* 27, *Bb* 27.
Dam, Gautier van den, *BA* 101.
Dammartin, Count of, *C* 71, *Cl* 127, *Cd* 51.
 Renaud de, *CP* 33.
Danguel, Geoffroi de, *BA* 202.
 Geoffroi, son of Geoffroi de, *BA* 203.
 Robert de, *BA* 201.
Daon, Foulques de, *BA* 247.
Darcy, John, *M* 56.
 Philip, *H* 39.
Daubeney, William, *Ba* 47, *Bb* 47.
Daun, Weri of, *BA* 2.
Deincourt, Edmund, *H* 46, *K*, v. 561.
 John, *K*, v. 876.
 William, *M* 11.
Deiville, John, *D* 67, *H* 100.
De la Mare, John, *H* 70, *K*, v. 376.
De la Ware, Roger, *K*, v. 181.
Denisy, Sire de, *CP* 105.
Denmark, King of, *C* 15, *Cl* 18, *Cd* 35, *D* 15.
Despenser, Hugh le, *D* 131, *H* 55, *K*, v. 303.
Devereux, William, *Ba* 26, *Bb* 26.
Diest, Arnold IV, sire de, *BA* 28, *D* 80.
Dillingen, Count of, *C* 45, *Cl* 53, *Cd* 140.
Donjon, Geoffroi du, *BA* 294.
Doon, see Daon.
Doucelles, Gilles de, *BA* 239.
 Sire de, *CP* 143; see also Puisane.
Drestre, see Diest.
Dreux, Jean de, son of Jean II, Duke of Brittany, *H* 52, *K*, v. 234.

Droxford, John, *H* 86.
Dunbar, Patrick de, Earl of Lothian, see Lothian.
 Patrick de, son of the Earl of Lothian, *K*, v. 345.
Dunei, see Daun.

Echingham, William de, *D* 141.
Edmund, Saint, *K*, v. 946.
Edward the Confessor, King of the English, *D* 16, *K*, v. 947.
Elzee, Thibaud d', *BA* 109.
Emboise, see Amboise.
Empire, the, *C* 1, *Cl* 1, *Cd* 1, *D* 2.
Engaine, Hugh de, *C* 135, *Cl* 96, *Cd* 106.
 John de, *K*, v. 317.
Enghien, Gerard d', *BA* 73.
 Roger d' (error for Arnold), *BA* 71.
 Wautier d', *BA* 72.
England, King of, *C* 4, *Cl* 3, *Cd* 3.
 Alfonso, son of Edward I, *D* 25.
 Edmund Crouchback, Earl of Chester, *Ba* 1, *Bb* 1, *C* 54, *Cl* 65, *Cd* 152.
 Edward I, *D* 7, *H* 49, *K*, vv. 213, 409, 461, 945.
 Edward of Caernarvon, Prince of Wales, *K*, v. 400.
Engleter, see England.
Ercainne, see Schendelbecke.
Ermenie, Ermenye, see Armenia.
Ernée, Levour d', *BA* 228.
Escaufourt, Gervais d', *BA* 168.
Eschosce, Escoce, see Scotland.
Escluse, see Dam.
Esegney, Esegni, see Iseghem.
Esguiemes, see Schinnen.
Esneval, Gui d', *CP* 85.
Espagne, Elinans d', *BA* 223.
Espaine, see Spain.
Esteley, see Astley.
Esterlinghen, see Teylingen.
Estotevile, see Stuteville.
Estrange, see Strange.
Eure, John de, *M* 46.
Evereus, see Devereux.
Everingham, Adam de, *M* 44.
 Adam de, *M* 57.
Eu, Jean I, Count of, *C* 27, *Cl* 28, *Cd* 45.
 Jean II, Count of, *CP* 1.
Ewill, Eyvile, see Deiville.

Fauconberge, Walter de, *C* 129, *Cl* 90, *Cd* 177.
 Walter, son of Walter de, *M* 67.
Fauquemont, Thierry II de, *BA* 30.
Ferme (Faime), Favre de, *BA* 143.
 Gilles de, *BA* 144.
Ferrers, Count of, *Ba* 8, Bb 8, *D* 138.
 William de, *D* 147, *H* 60, *K*, v. 468.
Ferrières, Sire de, *CP* 76.
Ferté-Bernard, Bernard de la, *BA* 244.
Fieyagnen, see Oettingen.
FitzAlan, Brian le, *H* 30, *K*, v. 353.
 Richard le, Earl of Arundel, *H* 97.

FitzGerald, Maurice le, *C* 166, *Cl* 171, *Cd* 68, *D* 179.
FitzHugh, Henry le, *M* 50.
FitzHumphrey, Walter le, *D* 164.
FitzJohn, John le, *Ba* 16, *Bb* 16, *C* 80, *Cl* 59, *Cd* 146.
 Richard le, *D* 136.
FitzMarmaduke, John le, *H* 36, *K*, v. 567.
FitzMarmion, see FitzWarin.
FitzNichol, Richard le, *C* 96, *Cl* 84, *Cd* 171.
FitzOthes, Hugh le, *D* 116.
FitzPayne, Robert le, *H* 64, *K*, v. 160.
FitzPiers, Reynold le, *Ba* 55, *Bb* 55, *D* 121.
FitzRalph, Robert le, *M* 36.
FitzRoger, Robert le, *D* 84, *H* 5, *K*, v. 93.
FitzWalter, Robert le, *D* 88, *K* , v. 43; see also Roger.
 Roger (error for Robert) le, *H* 6.
FitzWarin, Philip le, *C* 156, *Cl* 162, *Cd* 94.
FitzWilliam, Ralph le, *H* 40, *K*, v. 196.
 William le, *H* 80, *M* 12.
Flakeraing, see Fleckenstein.
Flanders, Gui de Dampierre, Count of, *C* 28, *Cl* 29, *Cd* 46, *D* 34.
 William de, *D* 177.
Flasqueraing, see Fleckenstein.
Fleckenstein, Godefrey of (error for Rudolf?), *BA* 77.
 Wolfram II of, *BA* 1.
Foliot, Edmund, *M* 15.
 Richard, *M* 6.
Fontaine, Olivier de, *BA* 163.
Ford, Adam de la, *K*, v. 784.
Forest d'Armaillé, Jean de la, *BA* 197.
Forez, Count of, *C* 35, *Cl* 37, *Cd* 15, *CP* 6.
Fornewil, see Solre.
France, Philip III le Hardi, King of, *C* 5, *Cl* 2, *Cd* 2, *D* 5.
 Philip IV le Bel, *K*, v. 461.
Fraser, Simon, *H* 79, *K*, v. 351.
Freiburg, Count of, *C* 63, *Cl* 118, *Cd* 129.
Fresel, see Fraser.
Freté, see Ferté.
Fréteval, Nevelon IV de, *BA* 267.
Freville, Baldwin de, *C* 152, *Cl* 156, *Cd* 88.
Froburg, Count of, *C* 48, *Cl* 56, *Cd* 143.
Frokes, *BA* 183.
Frysell, see Fraser.
Furnival, Thomas de, *H* 68, *K*, v. 371.
 Walter de, *C* 93, *Cl* 81, *Cd* 168.

Gallerande, Gui de, *BA* 218.
Garancières, Yon de, *CP* 120.
Garein, see Warenne.
Garlande, see Gallerande.
Gaunt, Geoffrey de, *C* 125, *Cl* 86, *Cd* 173.
 Gilbert de, *Ba* 50, *Bb* 50.
Gavre, Rasse III de, *D* 59.
 Jean de, *D* 77.
Gelre, see Gueldre.
Geneville, Geoffrey de, *C* 146, *Cl* 106, *Cd* 116, *D* 156; see also Joinville.
George, Saint, *K*, v. 947.
Germany, King of, *C* 3, *Cl* 8, *Cd* 8.
 Rudolf of Habsburg, *D* 4.

Gesves, Robert of, *BA* 35.
Geust, see Gesves.
Ghistelle, Gautier of, *C* 92, *Cl* 80, *Cd* 167.
Giffard, John, *C* 145, *Cl* 105, *Cd* 115, *D* 63.
Giré, Guillaume, *BA* 205.
Glingeham, see Elzee.
Gloucester, Gilbert de Clare, Earl of, *D* 26.
 Joan, daughter of King Edward I, widow of Gilbert de Clare, Earl of, *K,* v. 476.
Goisencourt, see Gossoncourt.
Gondreville, Gerard de, *K,* v. 689.
Gorges, Ralph de, *K,* v. 768.
Gossoncourt, Renier de, *BA* 51.
Gournay, John de, *C* 94, *Cl* 82, *Cd* 169.
Graham, Henry de, *K,* v. 710.
Grandchamp, Warin de, *BA* 182.
Grandin, William, *D* 161.
Grandison, Otho de, *D* 40.
 William de, *H* 89, *K,* v. 253.
Grandpré, Count of, *C* 33, *Cl* 35, *Cd* 13.
Graveteaus, Jean, *BA* 100.
Gray, see Grey.
Greece, see Griffonie.
Grendon, Ralph de, *H* 108.
Grelley, Thomas de, *Ba* 51, *Bb* 51.
Grey, Henry de, *H* 16, *K,* v. 61.
 John de, *H* 37, *K,* v. 381.
 Nicholas de, *M* 13.
 Reginald de, *D* 118, *H* 61.
 Richard de, *D* 159, *M* 14.
 Thomas de, *M* 24.
Griffonie (Greece), King of, *D* 12.
Gueldre, Otto II, Count of, *BA* 15.
 Renaud I, Count of, *D* 47.
Guensenille, Henri de, *BA* 108.
Guerd, see Werd.
Guimegny, Gumgniegny, see Gymnich.
Guînes, Arnold III, Count of, *C* 37, *Cl* 39, *Cd* 17, *D* 69.
 Arnold de, *D* 72.
 Aunsel de, *D* 48.
Guisnes, Guissnes, see Guînes.
Guseyne, see Sayn.
Gymnich, Henry of, *BA* 75.
 Henry li Soulas of, *BA* 80.
 Wuinemans of, *BA* 81.

Hache, Eustace de, *H* 74, *K,* v. 333.
Haie, see Hay.
Haie-Joulain, Hardouin de la, *CP* 109.
Hainault, Countess of, *C* 38, *Cl* 40, *Cd* 18.
Hamaide, Arnould de la, *BA* 90.
 Gerard de la, *BA* 91.
Hamal, William of, *BA* 34.
Hamequerke, see Heemskerke.
Handlo, Nichol de, *D* 155.
Hansard, Gilbert, *Ba* 53, *Bb* 53.
 Robert, *M* 17, *K,* v. 706.
 William, *C* 82, *Cl* 67, *Cd* 154.
Harclay, Andrew de, *M* 61.

Harcourt, Guillaume d', *CP* 90.
 Jean II d', *CP* 89.
 John de, *C* 168, *Cl* 173, *Cd* 70.
 Richard de, *Ba* 48, *Bb* 48.
Hartaing, Godefroi de, *BA* 88.
Harvaing, Fastre de, *BA* 93.
 Jean de, *BA* 95.
 Juames de, *BA* 94.
 Morel de, *BA* 92.
Hastings, Edmund de, *H* 35, *K*, v. 551.
 Henry de, *D* 125.
 John de, *K*, v. 537.
Hangest, Aubert IV de, *CP* 49.
Havering, John de, *H* 88.
Haverington, John de, *M* 62.
 Michael de, *M* 63.
Haverskerque, Gilles de, *CP* 74.
 Jean de, *CP* 73.
Hay, John de la, *D* 78.
 Ralph de la, *C* 132, *Cl* 93, *Cd* 103.
Heemskerke, Arnold of, *BA* 83.
Heilly, Jean de, *CP* 60.
Henneberg, Count of, *BA* 64.
Hereford, Humphrey de Bohun (died 1275), Earl of, *Ba* 4, *Bb* 4, *C* 98, *Cl* 123,
 Cd 134.
 Humphrey de Bohun (died 1298), Earl of, *D* 28, *H* 2.
 Humphrey de Bohun, *H* 4 (erroneously listed as Henry); on 31 December 1298 be-
 came Earl of, *K*, vv. 107, 949.
Heringaud, William, *D* 183.
Heripont, Wistasse de, *BA* 165.
Herlames, Gilles de, *BA* 167.
Heron, Godard, *M* 22.
 Roger, *M* 21.
Heslington, Richard de, *C* 165, *Cl* 170, *Cd* 67.
Hever, William de, *D* 184.
Hierges, Gilles de, *BA* 40.
Hilton, Robert de, *H* 41.
Hilyard, Robert, *M* 47.
Hochstaden, Alegre of, *BA* 65.
Hoddelston, Adam de, *M 16.*
 John de, *H* 19, *K*, v. 87.
 Richard de, *M* 75.
Hodemake, see Rodemack.
Hoingreng, see Houtain.
Holain, Ernise of, *BA* 84.
Holland, Count of, *BA* 21.
Hondschoote, Sire de, *D* 45.
Hornes, Guillaume III, de, *BA* 119.
Hospital, the, *C* 20, *Cl* 22, *Cd* 39.
Hostade, see Hochstaden.
Hostaing, see Houtain.
Hotot, Vincent (error for Nicolas) de, *CP* 127.
Houdequierke, see Odenkirchen.
Houffalize, Henry of, *BA* 41.
Housay, Renaud de, *BA* 219.
Houtain, Gautier de, *BA* 53.
 Jean de, *BA* 111.

Hozemont, Henri de, *BA* 162.
Hu, see Eu.
Hudilston, see Hoddelston.
Huineberghe, see Henneberg.
Huissemale, see Wesemael.
Hundiscote, see Hondschoote.
Hungary, King of, *C* 12, *Cl* 11, *Cd* 11, *D* 87.
Huntercombe, Walter de, *H* 34, *K*, v. 365.
Hurges, see Hierges.
Hussey, Hugh de, *C* 158, *Cl* 161, *Cd* 93.
Huy, Sire de, *BA* 164.

Ildle, see Lisle.
Ille, see Reviers.
Illiers, Guillaume II d', *BA* 275.
Iseghem, Sire d', *C* 91, *Cl* 79, *Cd* 166.
Isenburg, Gerlach of, *BA* 3.
Isle-Adam, Anseau de l', *CP* 18.
 Jean de l', *CP* 19.
Isle-Bouchard, Barthélemy de l', *BA* 262.
 Olivier de l', *BA* 263.
Isle-sous-Brulon, Renaud de l', *BA* 266.
Ivry, Guillaume d', *CP* 35, 86, 88.

Jerkanville, Davy de, *D* 146.
Jerusalem, Hugh de Lusignan, King of, *Cl* 14, *Cd* 31, *D* 1.
Joeny, see Joigny.
Joigny, John I, Count of, *C* 42, *Cl* 44, *Cd* 22, *D* 165.
Joinville, Jean de, *CP* 40; see also Geneville.
Judoigne, Simon de, *BA* 133.
 Simon li Joules, *BA* 135.
Juillé, Robert de, *BA* 194.
Juin, see Juillé.
Juliers, Waleran of, *BA* 24.
 William IV of, *BA* 23.
Jungi, see Joigny.

Kantelo, see Cauntelo.
Karquetone, see Kerdeston.
Karrik, see Carrick.
Karru, see Carew.
Kent, Earl of, *Ba* 10, *Bb* 10.
Kerdeston, Fulk de, *C* 112, *Cl* 139, *Cd* 63.
Kerpen, Gerard of, *BA* 4.
Kirkbride, Richard de, *K*, v. 801.
Kuggeho, Nichol de, *D* 186.
Kyburg, Count of, *C* 62, *Cl* 117, *Cd* 128.
Kyme, Philip de, *K*, v. 58.
 William de, *M* 70.

Lais, see Walais.
Lalaing, Simon de, *CP* 34.
Lamburg, see Limburg.
Lanane, see Laval.
Lancaster, Henry de, *H* 51, *K*, v. 463.
 John de, *K*, v. 79.
 Thomas, Earl of, *H* 50, *K*, v. 459.

Landebeke, Arnould de, *BA* 153.
Landerode, see Randrot.
Landris, Libert de, *BA* 145.
Landskron, Arnould de, *BA* 132.
Langley, Sire de, *D* 152.
Laonois, see Lothian.
Lascy, see Lucy.
Lasser, Alan, *Cl* 66, *Cd* 153.
Latimer, Thomas le, *M* 35.
 William le, *H* 63, *K*, v. 427.
 William, son of William le, *H* 103.
Latimer Bouchard, John le, *M* 69.
 William le, *M* 68.
Latinne, Othes de, *BA* 105.
La Tour, Landry de, *BA* 254.
Laundeles, John de, *M* 54.
Launoy, Philippe de, *BA* 215.
Laval, Gui VII de, *BA* 242, *CP* 36.
Leck, Henry I of, *BA* 61.
Leicester, Simon de Montfort, Earl of, *Ba* 2, *Bb* 2.
L'Enfant, Amauri, *BA* 209.
 Foulques, *BA* 229.
Léon, Hervé de, *CP* 98.
 Hervé, son of Hervé de, *CP* 99.
Leuch, see Wulven.
Lewknore, Roger de, *D* 158.
Leyburn, Henry de, *M* 43.
 Robert de, *C* 86, *Cl* 74, *Cd* 161.
 Roger de, *D* 102.
 William de, *D* 107, *K*, v. 431.
Liederkerke, Rasse of, *BA* 67.
Liers, Bertrand de, *BA* 107; see also Molembais.
Ligne, Gautier de, *CP* 104.
Limburg, see Montjoie.
 Waleran IV, Duke of, *BA* 22, *C* 78, *Cl* 51, *Cd* 138.
Lincoln, Henry de Lacy, Earl of, *D* 24, *H* 1, *K*, v. 37.
Lindekerque, see Liedekerke.
Lindsay, Alexander de, *H* 48.
Lisle, Gerard de, *D* 42.
 Robert de, *D* 98.
 Walter de, *M* 72.
Loncastre, see Lancaster.
Longespée, Stephen, *C* 88, *Cl* 76, *Cd* 163.
 William, *C* 87, *Cl* 75, *Cd* 162.
Lonray, Gui de, *BA* 273.
Lonvillers, Sire de, *CP* 65.
Looz, Arnold V, Count of, *BA* 38.
 Gerard de, *CP* 112.
Lorraine, Henry III, Duke of, *C* 77, *Cl* 50, *Cd* 28, *D* 19.
Loterell, Geoffrey, *M* 5.
Lothian (Laonois), Patrick de Dunbar, Earl of, *C* 51, *Cl* 61, *Cd* 148.
 Patrick, son of Patrick de Dunbar, Earl of, *H* 23, *K*, v. 341.
Loudon, Geoffroi de, *BA* 188.
 Robert de, *BA* 187.
Loumens, Guillaume de, *BA* 192.
Louvain, Godefroi de, *BA* 74.
 Sire de, *D* 49.

Lovel, John, *D* 174.
..John (succ. 1286), *H* 13.
Löwenstein, Count of, *C* 49, *Cl* 57, *Cd* 144.
Lucy, Amaury de, *D* 79.
..Geoffrey de, *C* 108, *Cl* 134, *Cd* 58, *D* 99.
Luerton, see Averton.
Lufirs, see Cleves.
Limburg, Duke of, *D* 22.
Luneburg, see Limburg.
Luselborc, see Luxemburg.
Lusignan, Count of, *C* 56, *Cl* 71, *Cd* 158.
Lusser, see Lasser.
Lützelstein, Count of, *C* 47, *Cl* 55, *Cd* 142.
Luxemburg, Gerard of, *BA* 18.
..Henry II, Count of, *BA* 17, *C* 59, *Cl* 114, *Cd* 125.

Macdonald d'Escoce, Duncan, *M* 66.
Machaut, Pierre de, *CP* 30.
Machecoul, Jean de, *CP* 146.
Maignelay, Jean de, *CP* 59.
Maillé, Hardouin V de, *BA* 252, *CP* 37, 122.
..Hugues de, *BA* 250.
..Simon de, *CP* 62.
Maimeroles, Rochelin de, *BA* 268.
Malduist, Maldust, see Mauduit.
Malet, Jean, *CP* 83.
Malo-Nido, Etudes de, *BA* 251.
Malmains, Nichol, *D* 148.
..Nicholas, *M* 10.
Man, King of, *C* 17, *Cl* 19, *Cd* 36, *D* 17.
Mancourt, see Wancourt.
Mandeville, William de, *Ba* 21, *Bb* 21.
Manle, Jean de, *BA* 213.
Manley, Piers de, *H* 26.
Manners, Robert, *M* 23.
Mans, see Berg.
Mar, Earl of, *C* 53, *Cl* 63, *Cd* 150.
Marbais, Guillaume de, *BA* 160.
..Pierre de, *BA* 46.
..Pierre de, *BA* 131.
Marche, Count de la, *CP* 5; see also Lusignan.
Mare, see De la Mare.
Marly, Bouchard de, *CP* 13.
Marmande, Bouchard de, *BA* 259.
..Jean de, *BA* 260.
Marmion, Philip, *C* 155, *Cl* 159, *Cd* 91.
..Philip, *D* 111.
..William, *Ba* 28, *Bb* 28.
..William, *D* 61.
Marshal, William, Earl, *K*, v. 48.
Martel, Guillaume, *CP* 84.
Martell, Walter, *C* 124, *Cl* 155, *Cd* 87.
Martin, William, *H* 43.
Martyn, see Mauduit.
Mathefelon, Thibaud de, *CP* 107.
Mauclerk, Piers, *C* 162, *Cl* 167, *Cd* 99.

Mauduit, Roger, *M* 25.
 Walter, *C* 121, *Cl* 152, *Cd* 85.
 William, *Ba* 44, *Bb* 44.
Maule, see Manle.
Mauleverer, John, *M* 18.
Mauley, Piers de, *M* 38.
Mauny, see Malo-Nido.
Meaus, Geoffrey de, *M* 37.
Meer, Libous de, *BA* 118.
Meinill, Nicholas de, *H* 77.
Meissen, Margrave of, *BA* 13.
Mello, Dreux de, *CP* 68.
Melun, Adam IV, vicomte de, *CP* 11.
 Simon de, *CP* 12.
Merck, Ingram de, *C* 123, *Cl* 154, *Cd* 86.
Merdogne, Itier de, *CP* 130.
Merle, see Meer.
 Foucaud de, *CP* 92.
Meulan, Amauri II de, *C* 149, *Cl* 109, *Cd* 119, *CP* 14.
Milly, Dreux de, *CP* 57.
Mirmande, see Marmande.
Misse, see Meissen.
Moels, John de, *H* 62.
Mohaut, Robert de, *H* 15, *K*, v. 67.
Mohun, John de, *H* 111, *K*, v. 191.
 Reynold de, *Ba* 41, *Bb* 41.
Molembais, Waleran de, *BA* 134.
Moncy, Walter de, *K*, v. 164.
Monemeuwe, see Monmouth.
Monjoye, see Froburg.
Monmouth, John de, *C* 127, *Cl* 88, *Cd* 175.
Monsablon, see Montchablon.
Monsyrolle, see Montreuil.
Montabon, Geoffroi de, *BA* 232.
Montagu, Simon de, *H* 92, *K*, v. 395.
Montalt, see Mohaut.
Montbazon, Sire de, *CP* 118.
Montbourcher, Bertrand de, *K*, v. 685.
Montchablon, Gobert de, *CP* 80.
Montcheysi, see Munchensy.
Monte, see Berg.
Monteacu, see Montagu.
Montferrant, Adam de, *BA* 52.
Montfort, Philip de, *C* 178, *Cl* 183.
 Piers de, *D* 104.
 Robert de, *D* 149.
 Simon de, *D* 123.
Montfort-le-Rotrou, a brother of Rotrou de, *BA* 235.
 Rotrou IV de, *BA* 237.
Montfort-sur-Meu, Raoul VI de, *CP* 139.
Monthermer, Ralph de, *H* 95, *K*, v. 483.
Montjean, Armand (error for Briand) de, *BA* 180.
 Briand de, *CP* 135.
Montjoie, Waleran II of, *BA* 36.
Montmorency, Jean de, *C* 151, *Cl* 111, *Cd* 122.
 Mathieu le Grand, Count of, *CP* 10.
Montreuil, Eschalard de, *C* 174, *Cl* 179.

Monttyrelle, see Montreuil.
More, Richard de la, *C* 114, *Cl* 141, *Cd* 65.
Morea, Prince of, *D* 54.
Moreuil, Bernard de, *CP* 53.
Morialmé, Godescaus de, *BA* 97.
 Wautier de, *BA* 98.
Morley, John de, *H* 104.
Mortemer, Guillaume de, *CP* 126.
Morteyn, Roger de, *K*, v. 361.
Mortimer, Hugh, *H* 76, *K*, v. 391.
 Robert, *C* 128, *Cl* 89, *Cd* 176, *D* 145.
 Roger, *C* 142, *Cl* 102, *Cd* 112, *D* 97.
 Roger, *H* 67, *K*, v. 435.
Mouncy, Walter de, *H* 12.
Mowbray, John, *M* 2.
 Roger de, *Ba* 52, *Bb* 52, *C* 104, *Cl* 131, *Cd* 55.
Mowbray d'Escoce, Philip, *M* 53.
Multon, Thomas de, *H* 45, *K*, v. 73.
Muncels, Waleran de, *D* 160.
Munchensy, Warin de, *Ba* 14, *Bb* 14, *C* 126, *Cl* 87, *Cd* 174.
 William de, *D* 117.
Munford, see Montfort.
Munteney, Robert de, *D* 65.
Muscegros, Robert de, *D* 170.
Musein, Musoin, see Sayn.
Myreffiye, see Froburg.

Naillac, Guillaume de, *BA* 292.
Namur, Count of, *BA* 42.
Navarre, Henry III, Count of Champagne and King of, *C* 9, *Cl* 6, *Cd* 6.
 King of, *D* 9.
Nellac, see Naillac.
Nesle, Gui de, *CP* 42.
Neuenahr, Gerard of, *BA* 7.
Neville, Geoffrey de, *C* 79, *Cl* 58, *Cd* 145.
 Hugh de, *C* 106, *Cl* 133, *Cd* 57.
 Robert de, *Ba* 38, *Bb* 38, *C* 107, *Cl* 135, *Cd* 59.
Newmarch, Thomas, *M* 49.
Nichole, see Lincoln.
Nonvillier, see Longvillers.
Normanville, Ralph de, *D* 175.
Norway, King of, *C* 16, *Cl* 17, *Cd* 34.
 King of, *D* 13.
Nuelle, see Welle.

Odelstone, see Hoddelston.
Odenkirchen, Gerard of, *BA* 63.
Odingeseles, William de, *C* 153, *Cl* 157, *Cd* 89.
Oettingen, Count of, *C* 66, *Cl* 121, *Cd* 132.
Offord, see Ufford.
Olehaun, Arguelms of, *BA* 32.
Olfendop, Glidoup d', *BA* 123.
 Lidoup d', *BA* 124.
Oppeln, Duke of, *BA* 12.
Orléans, Payen d', *BA* 280.
Orlenstone, William de, *D* 153.

Ostriche, see Austria.
Ottoncourt, Adam d', *BA* 121.
 Gilles d', *BA* 122.
 Renier d', *BA* 120.
Oudenarde, see Audenarde.
Oxford, see Vere.
 Hugh de Vere, Earl of, *Ba* 5, *Bb* 5.
 Robert de Vere, Earl of, *D* 29.

Parthenay, Hugh III dit l'Archevêque, Lord of, *C* 169, *Cl* 174, *Cd* 71.
Patrick, see Dunbar.
Patry, Raoul, *CP* 91.
Paveley, Edward de, *C* 157, *Cl* 160, *Cd* 92.
Paynel, John, *H* 42, *K*, v. 558.
Pecche, Baldwin, *C* 161, *Cl* 165, *Cd* 97.
 Gilbert, *Ba* 39, *Bb* 39, *D* 142.
 Robert (error for Gilbert), *H* 81.
Peisters, see Poitou.
Pelu, see Raugraf.
Pembridge, Henry de, *D* 53.
Pembroke, Earl of, *C* 101, *Cl* 143, *Cd* 76.
Penchester, Stephen de, *D* 110.
Perche, Jacques de Château Gontier, Count of, *BA* 272.
Percy, Henry de, *D* 76, *H* 98, *K*, v. 155.
Perie, see Prie.
Périgord, Vicomte de, *BA* 282.
Perponcet, Robert de, *M* 45.
Perreres, Richard de, *M* 34.
Persijn, John, *BA* 62.
Perwez, Godfrey of, *BA* 44.
Pesans, see Pezaz.
Petite Pierre, see Lützelstein.
Peyferer, William, *D* 50.
Pezaz, Robert, *BA* 186.
Pichford, Geoffrey de, *D* 82.
Picquigny, Jean, vidame de, *CP* 43.
 Renaud de, *CP* 44.
Pigot, Piers, *C* 95, *Cl* 83, *Cd* 170.
Pingnons, see Pinon.
Pinkeney, Henry de, *H* 69.
Pinon, Robert de, *CP* 67.
Pipard, Ralph, *H* 106.
Plescy, John de, *Ba* 12, *Bb* 12.
 John de, *C* 116, *Cl* 145, *Cd* 78.
Plokenet, Alan de, *D* 114.
Pointz, Hugh, *H* 107, *K*, vv. 203, 358.
Poiteres, see Poitou.
Poitou, Count of, *C* 22, *Cl* 23, *Cd* 40.
Poix, Sire de, *CP* 64.
Poland, Duke of, *C* 76, *Cl* 49, *Cd* 27.
Ponthieu, Count of, *D* 31.
Pont-Remy, Vicomte de, *CP* 54.
Portugal, King of, *C* 18, *Cl* 126, *Cd* 137.
Praele, Hubert de, *BA* 293.
 Nicholas de, *BA* 155.
Praiaus, see Préaux.
Préaux, Pierre de, *CP* 113.

Prechenig, see Pressigny.
Presins, see Persijn.
Pressigny, Aubri (error for Josbert) de, *BA* 257.
 Renaud de, *BA* 256.
 Renaud, son of Renaud de, *CP* 38.
Preuilly, Eschivars de, *BA* 255.
Prez-en-Pail, Foulques dit Payen de, *BA* 199.
Prie, Jean de, *BA* 295.
Prinekin de Rosin, Robert, *BA* 142.
Pruillé, Gervais de, *BA* 196.
 Sire de, *CP* 63.
Puisane (perhaps for Doucelles), Roteline de, *BA* 231.
Purrewés, see Perwez.

Quaderebbe, Gilles de, *BA* 113.
 Jean de, *BA* 114.
Quatre Ponts, Count of, *BA* 31.
Quenare, see Neuenahr.
Quepeni, see Kerpen.
Quincy, Robert de, *D* 66.

Radelay (Raderai), Guillaume de, *BA* 225.
Raineval, Jean de, *CP* 51.
Rajasse, Pierre de la, *BA* 253.
Ramerne, Sire de, *D* 52.
Ramestaing, Aidelames of, *BA* 76.
Rampsshroyke, Rampsvile, see Rapperswil.
Randrot, Gerard III of, *BA* 59.
Ranecourt, see Auberchicourt.
Rapperswil, Count of, *C* 46, *Cl* 54, *Cd* 141.
Raugraf, Robert II, *BA* 9.
Reifferscheid, Henry of, *BA* 27.
Remeval, see Raineval.
Repen, Clarenbaus de, *BA* 89.
Restel, Restelle, see Rethel.
Rethel, Count of, *C* 41, *Cl* 43, *Cd* 21.
Revel, Foukel, *BA* 195.
Reviers, Baldwin de, Lord of the Isle of Wight, *Ba* 6, *Bb* 6,
 Isabel de, *C* 103, *Cl* 146, *Cd* 79, *D* 120.
Rianwelz, Othes de, *BA* 99.
Riboul, Herbert, *BA* 224.
Richebourg, Pierre de, *CP* 87.
Richmond, John II, Earl of, *D* 35.
 Thomas de, *M* 58, *K*, v. 714.
Ridre, see Rithre.
Rige, see Thuringia.
Rionvuel, see Rianwelz.
Ripesee, see Reifferscheid.
Rithre, William de, *H* 85, *K*, v. 367.
 William de, *M* 29.
Rivers, John de, *H* 93, *K*, v. 271.
Roche, see Oppeln.
 Gui de la, *CP* 32.
 Richard de la, *CP* 100.
Rochechouart, Amauri IX de, *BA* 283.
Roche Dire, Renaud de la, *BA* 278.
Rochefort, Thibaud de, *CP* 142.

Rochford, Guy de, *C* 118, *Cl* 148, *Cd* 81.
 Guy de, *D* 143.
Rodemack, Arnould II de, *BA* 102.
Rodes, Gerard de, *M* 27.
 William de, *D* 74.
Rokele, see Rokley.
Rokley, Richard de, *K*, v. 779.
Ros, Robert de, *Ba* 46, *Bb* 46, *C* 105, *Cl* 132, *Cd* 56, *D* 180.
 Thomas de, *M* 52.
 William de, *Ba* 45, *Bb* 45,
 William de, *C* 83, *Cl* 68, *Cd* 155.
 William de, *H* 32, *K*, v. 201.
Rostelers, see Rotzelaer.
Rostrenen, Pierre de, *CP* 140.
Rotelen, see Rostrenen.
Rotzelaer, Arnold V of, *BA* 66.
 Arnold, son of Arnold V of, *BA* 125.
 Robert of, *BA* 126.
Rouchi, see Rougé.
Roucy, Count of, *C* 31, *Cl* 33, *Cd* 50.
Rouge, Olivier de, *CP* 144.
Rouson, Geoffroi de, *BA* 191.
Rouvray, Jean de, *CP* 116.
Rummesvile, see Rapperswil.
Rye, see Rithre.
Ryver, see Rivers.

Sailly, Li Fou Archiers de, *BA* 227.
St. Amand, Amauri de, *K*, v. 313.
St. Aubin-de-Jocquenay, Herbert, *BA* 233.
St. John, John de, *C* 159, *Cl* 163, *Cd* 159, *D* 105, *H* 102, *K*, vv. 414, 488, 490.
 Walter de, *C* 163, *Cl* 168, *Cd* 100.
St. Leger, Ralph de, *D* 173.
St. Lignaen, Sire de, *CP* 132.
St. Lo, John de, *M* 33.
St. Mard, Lancelot de, *C* 173, *Cl* 178.
St. Martin, Jean de, *CP* 102.
St. Omer, John de, *M* 74.
St. Per, (incomplete) de, *BA* 277.
St. Pol, see Chatillon.
St. Quentin, Geoffrey de, *M* 41.
 Herbert de, *M* 40.
St. Souplais, Gerard de, *BA* 137.
 Jacques de, *BA* 138.
St. Venant, Sire de, *CP* 71.
Ste. Maure, Guillaume de, *BA* 265.
 Guillaume de, *CP* 119.
Saintirs, Haude de, *BA* 33.
Salisbury, Earl of, *Ba* 11, *Bb* 11.
Sampson, William, *H* 33.
Sancerre, Etienne II, Count of, *CP* 8.
 Jean I, Count of, *BA* 286.
Sandwich, John de, *D* 151.
Sandford, Nicholas de, *C* 113, *Cl* 140, *Cd* 64.
Sans Avoir, Hugh, *D* 139.
Sansoire, Sansuerre, see Sancerre.
Sarcé, Guillaume de, *BA* 181.

Sarsael, see Sarcé.
Sassenau, see Casa Nova.
Sauvage, see Wildgraf.
Say, William de, *D* 37.
Sayn, Count of, *C* 60, *Cl* 115, *Cd* 126.
Scales, Robert de, *H* 82, *K*, v. 337.
Scaxfors, see Escaufourt.
Schendelbecke, Gilles de, *BA* 129.
 Jean de, *BA* 128.
Schinnen, Tielmann of, *BA* 78.
 Winand of, *BA* 79.
Schoisel, see Choisel, Choiseul.
Scotland, King of, *C* 11, *Cl* 15, *Cd* 32.
Scrope, Henry le, *M* 9.
Scypre, see Cyprus.
Segrave, Geoffrey de, *C* 137, *Cl* 98, *Cd* 108.
 Gilbert de, *K*, v. 116.
 John de, *H* 8, *K*, v. 123.
 Nicholas de, *D* 100.
 Nicholas de, *H* 11, *K*, vv. 113, 949.
Seillers, see Zuylen.
Seingeine, Sengayne, Sengsygne, see Engaine.
Serbonne, see Charbogne.
Sergines, Geoffrey de, *C* 170, *Cl* 175, *Cd* 72.
Setru, see Zetrud.
Sicily, Charles, Count of Anjou, *BA* 246; in 1266 King of, *C* 8, *Cl* 5, *Cd* 5, *D* 8.
Sierck, Arnold III of, *BA* 39.
Siward, Richard, *D* 157, *H* 78, *K*, v. 348.
Soave, see Swabia.
Solre, Gerard de, *BA* 156.
Soissons, Jean III, Count of, *C* 36, *Cl* 16, *Cd* 16, *D* 91.
 Raoul de, *CP* 31, 39.
Somery, Roger de, *Ba* 20, *Bb* 20.
 Roger, son of Roger de, *C* 134, *Cl* 95, *Cd* 105.
Sorly, see Sully.
Souche, see Zouche.
Soudac, Hugues de, *BA* 221.
Sourches, Favri (error for Patrice) de, *BA* 270.
 Payen de, *BA* 271.
 Pierre de, *BA* 269.
Spain, Alphonso the Wise, King of, *C* 6, *Cl* 4, *Cd* 4, *D* 3; see also Castile.
Stafford, Robert de, *Ba* 32, *Bb* 32.
Stirkeland, Walter de, *M* 26.
Stopham, William de, *M* 28.
Strange, John le, *D* 71, *K*, v. 378.
Stuteville, Walter de, *C* 97, *Cl* 85, *Cd* 172.
Sugi, Amauri de, *BA* 216.
Suley, Bartholomew de, *D* 144.
Sully, Henri II de, *BA* 287.
Surche, see Zouche.
Sutton, John de, *M* 42.
Swabia, Duke of, *BA* 11.
Swan, Knight of the, *K*, v. 422.
Swillington (Swymelington), Adam de, *M* 59.
Swinnerton (Swynnston), Roger, *M* 30.

Talbot, Richard, *C* 167, *Cl* 172, *Cd* 69.

Tancarville, Robert de, chambellan de Normandie, *CP* 78.
Tateshal, Robert de, *Ba* 30, *Bb* 30.
 Robert, son of Robert de, *C* 138, *Cl* 99, *Cd* 109, *H* 7.
 Robert, grandson of Robert de, *H* 14, *K*, v. 192.
Taunnrier, Hugues de, *BA* 258.
Teil, Gervais du, *BA* 185.
Temple, the, *C* 19, *Cl* 21, *Cd* 38.
Teylingen, Thierry of, *BA* 58.
Thibouville, Sire de, *CP* 82.
Thil-Châtel, Sire de, *CP* 94.
Tholosa, see Toulouse.
Thorigné-en-Charnie, Fouquerant de, *BA* 204.
 Payen de, *BA* 245.
Thouarée, Hughes de, *BA* 211.
Thouars, Gui II, vicomte de, *CP* 136.
Thoucet, William, *K*, v. 339.
Thuin, Gerard de, *BA* 158.
Thuringia, see *BA* 64, note.
 Count of, *C* 43, *Cl* 45, *Cd* 23.
Thweng, Marmaduke de, *C* 143, *Cl* 103, *Cd* 113.
 Marmaduke de, *H* 36, note.
Tibetot, Payn, *M* 1.
 Robert, *D* 68.
Tierstein, Rudolf, Count of, *C* 65, *Cl* 120, *Cd* 131.
 Ulrich of, *BA* 5.
Tillyolf, Robert, *M* 39.
Tongres, Jacques de, *BA* 150.
 Jean de, *BA* 151.
Tony, Robert de, *H* 64, *K*, v. 421.
Toregny, see Thorigné
Touart, see Thouarée, Thouars.
Toukes, see Chourses.
Toulouse, Count of, *C* 39, *Cl* 41, *Cd* 19.
Tours, Eustace de, *Ba* 25, *Bb* 25.
Trager, Thibaud, *BA* 230.
Tranchelion, Esterlas de Pierre la Buffière de, *BA* 284.
Trazegnies, Othes li Bruns de, *BA* 141.
Tregoz, Geoffrey de, *C* 136, *Cl* 97, *Cd* 107.
 Henry de, *D* 181.
 John de, *D* 93, *H* 75.
Trie, Jean dit Billebault de, *C* 69, *Cl* 128, *Cd* 52.
 Mathieu de, *CP* 25.
 Renaud de, *C* 70, *Cl* 129, *Cd* 53, *CP* 26.
Triechastel, see Thil-Châtel.
Trumpington, James de, *D* 178.
 Roger de, *D* 106.
Tuin, see Thuin.
Tulch, see Culant.
Turberville, Hugh de, *D* 89.
Tusi, Guillaume de, *BA* 217.
Tyes, Henry le, *H* 20, *K*, v. 423.

Ucé, Baudouin d', *BA* 261.
Ufflete, Gerard de, *M* 64.
Ufford, Robert de, *D* 85.
Upsale, Geoffrey de, *M* 65.
Usé, see Ucé.

Vak, see Wake.
Valence, Aymer de, *K*, vv. 169, 197.
 William de, *Ba* 13, *Bb* 13, *C* 57, *Cl* 72, *Cd* 159 (in the latter three blazons, this
 person is erroneously referred to as "Count of"), *D* 132.
Valoynes, William de, *D* 185.
Vassenbergue, see Wassemberg.
Vaudémont, Count of, *C* 30, *Cl* 32, *Cd* 49.
Vaudripont, see Waudripont.
Vautorte, Gui de, *BA* 234.
Vaux, John de, *Ba* 19, *Bb* 19, *D* 113.
 Robert de, *C* 160, *Cl* 164, *Cd* 96.
 William de, *M* 31.
Vavasour, William le, *H* 18, *M* 7, *K*, v. 83.
Velles, see Welles.
Velques, see Wiltz.
Vendôme, Bouchard V de Montoire, Count of, *BA* 264.
 Geoffroi de, *CP* 77.
 Jean V de Montoire, Count of, *C* 32, *Cl* 34, *Cd* 12.
Venice, Count of, *CP* 9.
 Doge of, *D* 20.
Verdon, Theobald de, *D* 60.
 Theobald, son of Theobald de, *H* 44.
Vere, Robert de, Earl of Oxford, *H* 96, *K*, vv. 264-265.
 Hugh de, *K*, v. 264.
Vernoil, Eudes le Brun de, *CP* 123.
Vescy, John de, *D* 39.
 William de, *Ba* 54, *Bb* 54.
 William de, *D* 41.
Vian, see Vienne.
Vianden, Count of, *BA* 25.
Viane, see Vianden.
Vidame, see Chartres.
Vienne, Count of, *C* 68, *Cl* 130, *Cd* 54.
 Sire de, *D* 46.
Vieuxpont, Robert II de, *BA* 274.
Vilers, see Juliers.
Vilers-devant-Oryal, Alexandre de, *BA* 117.
Ville, see Villebéon.
Villebéon, Mathieu de, *CP* 96.
Villers-devant-Orval, Guillaume de, *BA* 116.
 Hermann de, *BA* 115.
Vipont, John de, *M* 71.
 Nicholas de, *M* 20.
Voisins, Pierre de, *BA* 289.
Vorst, Hermann de, *BA* 54.
Vuastime, see Woestine.
Vuinguerose, see Wickrode.
Vyan, see Vienne.

Wain, see Awans.
Wake, Baldwin, *D* 95.
 Hugh, *Ba* 31, *Bb* 31.
 John, *H* 25.
Walais (Walhay), Jean de, *BA* 159.
Waldemode, Waldemond, see Vaudémont.
Walence, see Valence.
Wales, Llywelyn ap Gruffydd, Prince of, *C* 21, *Cl* 13, *Cd* 30, *D* 27.

Walesus, Hugues de, *BA* 130.
Walhain, Guillaume de, *BA* 127.
(incomplete), *BA* 173.
Walkingham, John de, *M* 72.
Wancourt, (incomplete), *BA* 172.
Wandom, Wandonie, see Vendôme.
Ward, Robert de la, *D* 154, *H* 101, *K*, v. 485.
Warenne, John, Earl of, *D* 36, *H* 94, *K*, v. 147.
Waresme, Godelon de, *BA* 152.
Warne, see Wasnes.
Gerard de, *BA* 140.
Warwick, see Beauchamp.
Guy de Beauchamp, Earl of, *H* 54, *K*, v. 185.
Thomas, Earl of, *Ba* 9, *Bb* 9, *C* 102, *Cl* 144, *Cd* 77.
William de Beauchamp of Elmley, Earl of, *D* 101.
Wasnes, Jean de, *BA* 169.
Wassenberg, Gerard III of, *BA* 26.
Waudripont, Gilles de, *BA* 154.
Sire de, *D* 44.
Wausse, see Vaux.
Weede, Aernoult de le, see Barnaige.
Welle, Robert de, *Ba* 33, *Bd* 33.
Welles, Adam de, *H* 66, *K*, v. 334.
Werd (Woerth), Count of, *C* 44, *Cl* 52, *Cd* 139.
Wesemael, Arnold of *BA* 68.
Arnold, son of Arnold of, *BA* 69, *CP* 103.
Whitingwen, Whittingwen, see Oettingen.
Wickrode, Count of, *BA* 16.
Wigton, John de, *K*, v. 791.
Wildgraf, Conrad, *BA* 6.
Willoughby, Robert de, *K*, v. 704.
Wiltz, Philippe de, *BA* 148.
Winchester, Earl of, *Ba* 3, *Bb* 3, *C* 100, *Cl* 125, *Cd* 136, *D* 119.
Wircenberg, see Württemberg.
Wistesale, see Tierstein.
Woestine, Gerard of, *BA* 82.
Wulven, Albert of, *BA* 85.
Württemberg, Count of, *C* 64, *Cl* 119, *Cd* 130.

Zetrud, Henri de, *BA* 161.
Zouche, Alan la (died 1270), *C* 133, *Cl* 94, *Cd* 104.
Alan la, *D* 92.
Alan la (succ. 1285), *H* 9, *K*, v. 496.
William la, *D* 90.
Zuylen, Zweder of, *BA* 55.